PARTICULAR PLEASURES

PARTICULAR PLEASURES

BEING A PERSONAL RECORD
OF SOME VARIED ARTS
AND MANY DIFFERENT ARTISTS

BY

J. B. PRIESTLEY

HEINEMANN: LONDON

WILLIAM HEINEMANN LTD
15 QUEEN ST, MAYFAIR, LONDON WIX 8BE
LONDON MELBOURNE TORONTO
JOHANNESBURG AUCKLAND

DESIGNED AND PRODUCED BY
GEORGE RAINBIRD LIMITED
MARBLE ARCH HOUSE
44 EDGWARE ROAD
LONDON W2

PICTURE RESEARCH: MARY ANNE NORBURY

FIRST PUBLISHED 1975

THE TEXT WAS SET AND PRINTED
BY WESTERHAM PRESS LTD
WESTERHAM, KENT

COLOUR ORIGINATED AND PRINTED BY
ALABASTER PASSMORE
MAIDSTONE, KENT

SBN 434 60364 3

Preface

The title and the subtitle of this book offer an exact description of it. Only a few notes are necessary. So, I mean what I say when I call it 'a personal record', for I may occasionally leave out the first person singular – if only to give the reader a rest – but throughout I am writing about these works and these artists in terms of my own thoughts and feelings. No judgments from on high, coming down the sacred mountain on tablets of stone, must be expected here. The kind of criticism that suggests a severe customs-and-excise examination will be missing from these pages. No marks will be awarded or deducted. The arts include painting, music, acting and clowning, without a single paragraph dealing with literature. This is because I have been moving in and out of literary criticism for half a century, and I need a rest from it – and a change. And this seems not much to ask for at my age.

The first two sections, on Painting and Music, are arranged roughly in chronological order. The subjects in the other two sections, being mostly contemporary, are arranged in alphabetical order.

Yet once more – probably alas for the last time – I owe my warmest thanks to my friends John Hadfield (who found the right title for me, as well as much else) and Mary Anne Norbury (Mrs Sanders), the most enthusiastic and indomitable 'image chaser' in London.

Contents

Full details of the illustrations
are on page 191

PAINTING

At the risk of seeming tedious I must declare again that this is a very personal record. This section does not represent an excursion into art criticism. (Even though it may be true, as some people seem to think, that art criticism could do with a few excursions.) Caprice rules here. So for example you will not find Degas, Manet and Monet here, though in fact I have an enormous admiration for these painters. Some big men are left out; some smaller men are brought in; I am indulging my whims; and I can only suggest that *Yours Indignantly* should abandon the book at this point. However, a brief note about the colour reproductions. No matter how much trouble is taken, these are always tricky, and in a few instances it may happen that references to tone or colour in the text may not be confirmed by the reproductions. If so – sorry!

Pieter Bruegel the Elder : Hunters in the Snow

The first large reproduction I ever bought and framed was of this picture by Bruegel. This was years before I saw the original in Vienna. But for a long time I must have kept it close, hanging in my study. Again, a long time ago, it left the study for some distant room or landing, simply because, with increasing prosperity, fairly important originals were arriving in the house and originals and reproductions don't hang well together. Not that I had lost my admiration and affection for the picture and its creator, something I have never done; but by this time I could afford to buy sumptuously illustrated art books and several of them were devoted to old Pieter Bruegel. The reproduction of *Hunters in the Snow*, which I had had framed so long ago, I discovered afterwards to my annoyance had been deliberately left behind during one of our moves. What was I doing when this happened? The answer is at once simple and wretched: I was as usual keeping well away from the move and its chaos, leaving it all to the women of the household, who probably waved away 'that old thing'. But of course this wonderful winter scene vanished neither from my sight nor my memory. There is a great deal of Bruegel that I enjoy and admire, but this picture is easily my first favourite.

Fashion, which can destroy so much, easily disposed of the elder Bruegel for more than two and a half centuries. So far as his existence was recognized at all, he had a tiny vague reputation as a peasant painting peasants for other peasants, which

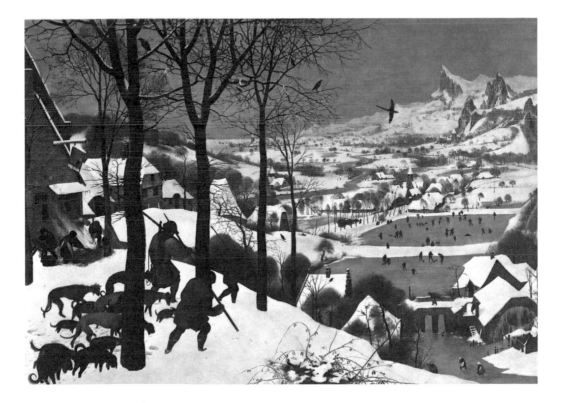

from every point of view is rubbish. He was not a peasant. Being in his right mind, he didn't paint for peasants, whose patronage would never have brought him the price of a couple of brushes. He introduced hundreds of peasants into his pictures because to him, often a severely didactic artist, they represented common humanity, about which he had much to say. (In his more sardonic moods he may have seen these peasants as his official or wealthy patrons 'with the lid off'.) But now let us take a look at him as the painter of the winter scene, beckoning us across the centuries to one of his original visions of this life.

It seems to me the wintriest of his snow pictures. Notice the greyish green that fills the sky and reaches down to the ponds and the river far below. This tone, a triumph, is colder than white, colder than the blue in so many snow scenes: it is coldest of all, a landscape of frozen iron. Such an arctic day bristles with challenges to humanity, and here they are in the picture, with all its diagonals, sharp edges and points. The three trees in the left half of the painting, though slender, might be pillars holding up a sky-roof waiting to let fall ten thousand tons of snow. But they also serve to break the diagonal pattern and to move us from the corner of warm humanity – the cooks at the open fire, the three hunters and their dogs, the tiny women far below – across the menacing frontier of triangular shapes to the frozen wastes ending in those razor peaks. (Bruegel had been to Italy and may have seen the Alps, but these are no Alps but belong to a Low Country painter's dreamland.) Though we see below in the distance all the people skating or playing games on the two frozen ponds, they seem so many pygmies trying to defy the huge icy glare of Nature, for this is above all a picture of the North, a long way from the smiling Italy of the fifteenth- and sixteenth-century masters. And notice last of all the crows, so many cunning black accents to give distance but also hinting at something ominous about such a day. Or, for that matter, notice that the very lances of the hunters add their quota of triangles and sharp points. I imagine at this moment I could give a lecture on the marvellous tone, depth, and wealth of symbolism in this one paint-ing, the creation of an artist who was dismissed or forgotten for hundreds of years. But then I have never been a Mediterranean type. I welcome and instinctively feel for the North, even in its savage February.

Watteau: Gilles

I am jumping back two and a half centuries not in pursuit of an artist but simply to capture one of his subjects, probably painted to earn a few francs. However, I will add a few sentences in passing – remarks intended for the ordinary reader and not for any student of French painting – on the artist himself, Antoine Watteau. We think of him as being essentially French yet in fact he was Flemish, though he lived and worked in France. He suggests an aristocratic background yet again in fact he was of humble birth and he toiled away in Paris for some years before he earned a decent livelihood. We are apt to confuse him with later confectioners of elegant lechery like Boucher and Fragonard, whereas he was a very different kind of painter. We associate him with a large slice of the eighteenth century, but by 1721, racked with tuberculosis and still in his thirties, he was dead.

So now we must consider and take a long look at his *Gilles*. This was the alternative name for Pierrot or the earlier Italian Pedrolino. He was the innocent and amiable fool or dupe. An Italian comedian, joining his fellow countrymen in Paris about 1665, took over the character, enlarged it, and gave it the loose white clothes, the long sleeves and the ruff, that we see in Watteau's portrait. But while the familiar whitened face was already associated with the character, Watteau ignored tradition by giving his *Gilles* some touches of colour. The painting itself had a rather mysterious and certainly far from distinguished early history, for apparently it was used as a mere signboard for a great many years and never fetched a respectable price until the middle of the nineteenth century. Yet it is a remarkable painting, touching in its characterization, with this Pierrot taken away from the theatre or the fairground, removed into the open air and a surprising landscape (for its period) of leaves and billowing clouds that reflect the sunlight. It came to the Louvre, as part of the La Caze bequest, in 1869.

However, Pierrot himself became famous many years before his original portrait entered the Louvre. He left the fairgrounds to become the idol of fashionable Paris. This represented the triumph of one man, Debureau, a mime of genius always to be seen at the Funambules, an obscure home of acrobats and tight-rope walkers until he made it the rage of Paris. It was Debureau who created out of the rustic dupe the Pierrot that haunted nineteenth-century poets, painters, composers and their aesthetic patrons. This was the lunar Pierrot, frail and wistful, who loved and always lost, the dupe not of fellow comedians but of destiny itself, for ever young and for ever doomed. And I may be deceiving myself but I can't help feeling there is some foreshadowing of all this in Watteau's painting, in spite of the whitened face being touched with colour: his *Gilles* suggests an innocent victim, no clumsy fool. And oddly enough there seems to have been a trail of consumption or some wasting disease, of men dying before their time, right from Watteau through Debureau on into the Nineties; as if the Pierrot legend carried a fatal infection.

But not of course in England, the home not of the lunar Pierrot but the seaside

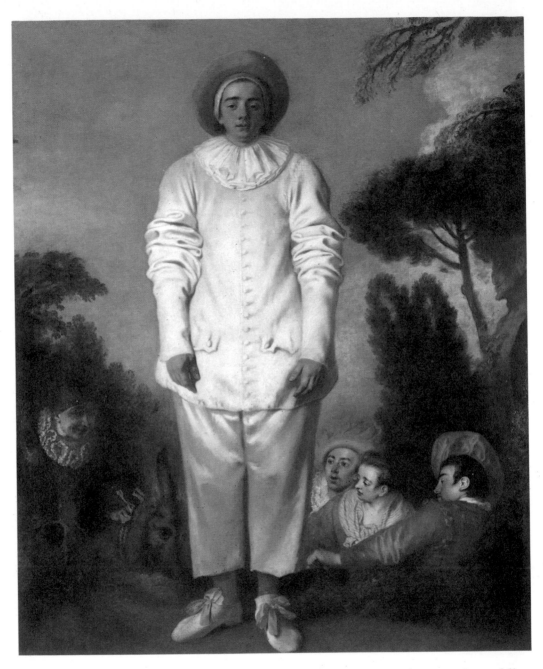

pierrot, a hearty fellow making some use of the traditional costume but adding coloured pompoms and dismissing white-faced poetic-tragic high-art nonsense. These other pierrots kept going, with much success, for two to three generations, though it was not long before they stopped being 'Pierrot Troupes' and called themselves 'Concert Parties', which was rather hard on the comedians. And I once wrote a very long novel about a concert party; but now we are altogether too far removed from Watteau.

Hogarth: The Graham Children

I am always ready to agree with all those distinguished critics who credit Hogarth with so many remarkable gifts. He combined qualities that are rarely found together, for example, a born painter's sense of composition, coming to make full use of his 'serpentine line', together with his astonishing feeling for character and drama. (It is rather as if a subtle artist could successfully run a people's theatre, packed and roaring every Saturday night.) I like the man himself – short, broadly

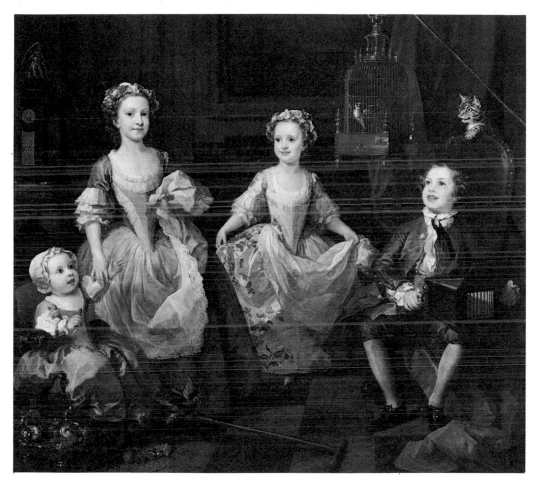

built, with no nonsense about his appearance, his manners, his opinions, a democratic type if there ever was one, anxious to assert himself and his ideas and not to flatter and please anybody important, a notable eighteenth-century weakness in all the arts. I like less his moral fables, his cautionary talks in painting and engraving, chiefly because while they appear to be boldly realistic, thanks to his adroit composition and his sense of character and drama, when coolly examined they prove to be hardly realistic at all. Their descent to beggary or bedlam is altogether too brief and brutal; it has been faked to please the virtuous when they contemplate, not

without a certain sadistic relish, the misfortunes of the wicked. After all, there were plenty of typical eighteenth-century characters who spent freely without being ruined by moneylenders, who enjoyed the charms of young whores without being riddled with syphilis and driven out of their minds. He might occasionally have put Sir Toby's question to his customers: 'Dost thou think, because thou art virtuous, there shall be no more cakes and ale?'

While I would not challenge his admiring critics, I must confess that a good deal of Hogarth's work brings me little or no pleasure. This is true of his portraiture – his *phizmongering* as he called it – which does not seem to me as remarkable as the critics tell us it is. There is of course always the glorious exception of his *Shrimp Girl*, but then it is surprising that having triumphantly achieved such swift broad effects he should not have continued in the same vein.

After some deliberation, there being so much to choose from in Hogarth, I have selected for reproduction his picture, *The Graham Children*, from the Tate Gallery. This belongs to 1742, when Hogarth was in the middle forties. The four children are those of Daniel Graham, Apothecary to Chelsea Hospital, and a close friend of Hogarth's own close friend, the Bishop of Winchester, Dr Hoadly. I would hazard a guess that Hogarth knew this family pretty well and had an affectionate regard for these children. At a first glance, the picture may seem too deliberately composed and even rather theatrical. I do not agree with this view of it. Writing as an old family man, who once had a group of children this age, I believe that young children, once they are well acquainted with a visitor, might easily and quite naturally stage a little performance of this kind, each of them doing something different. It is quite possible of course that Hogarth, who always knew what he was about, brought the baby into the foreground and moved the dancing sister a little into the background, to please the eye of the spectator that travels from the vaguely romping baby to the responsible sister, then from the dancing sister to the brother playing his little hand organ, from him to the cat (superb) to the caged bird. And notice with what astonishing skill Hogarth has caught the different expression on each child's face. The picture is a triumph of various skills mingled with affectionate intimacy and humour.

Highmore: Mr Oldham and his Guests

While political, economic, social problems darken our horizon and almost everybody else's, what am I doing this morning? I am wearing it away trying to solve the riddle of Joseph Highmore, long-lived portrait painter (1692–1780) and prolific solemn author. He was no master of his art, though a dab hand at quick likenesses, often completed at one sitting. Even so, his big conversation piece, *Mr Oldham and his Guests*, has its place in the Tate Gallery. But where is the riddle and why am I bothering about him? Who asked me to involve myself in *The Case of the Humourless Portraitist*? Nobody of course, but the point is that I always find his *Mr Oldham* conversation piece both comical and sharply satirical when few pictures this size make us grin, and when all the evidence suggests that this was far from Joseph Highmore's intention. No humorist was at work here: it is one solemn man painting another solemn man. And yet – and yet – something quite different, perhaps by way of the unconscious, found its way into the smooth brush strokes and the paint.

The little I know about Highmore comes from his entry in the *Dictionary of National Biography*. Not a glimmer of humour or any satirical intention is suggested by his career, which was all dutiful work and solemnity. We are told he was 'noted by his contemporaries for his study of the scientific side of his art, and his sobriety, independence and steadfastness of judgment'. His first important work was a series of portrait drawings of Knights of the Bath. He was commissioned to portray a large number of notables, including members of the Royal Family. He illustrated Richardson's *Pamela* (very stiffly to judge from one specimen) and, as we shall see, painted the author himself, now a close friend: all of which, as the Americans said of Matthew Arnold's lectures, was 'nowhere to go for a laugh'. That he also 'wrote numerous essays on literary and religious questions, some of which were published in the *Gentleman's Magazine*', does nothing to lighten the scene. We are a long way from an ambitious conversation piece that seems to us quite comical.

Now for Mr Oldham. He was a not unfamiliar eighteenth-century type – 'a virtuoso' or wealthy collector of pictures, butterflies, shells, natural curiosities, anything – 'with little taste or judgment', the *D.N.B.* adds severely. He frittered away the large fortune he had inherited and was finally imprisoned for debt, probably dying in the King's Bench prison. Facing us squarely in Highmore's painting, with a biggish face and strongly marked features, he is at a first glance an impressive figure. Behind his left elbow is an artful-looking fellow, ready to agree with anything Oldham says and equally ready to laugh at him elsewhere. On our side of the table and the punch bowl is a massive bewigged clerical type, who looks as if he would disagree with anybody except perhaps Oldham. Well behind the latter's right shoulder, almost haunting the trio round the table, is a vague dandyish figure, perhaps a fellow 'virtuoso'. It is a respectable conversation piece, clearly honouring the artist's patron and friend, Mr Oldham, yet it has always seemed to me comical and satirical. Long before I knew anything about Mr Oldham, I saw him here as a

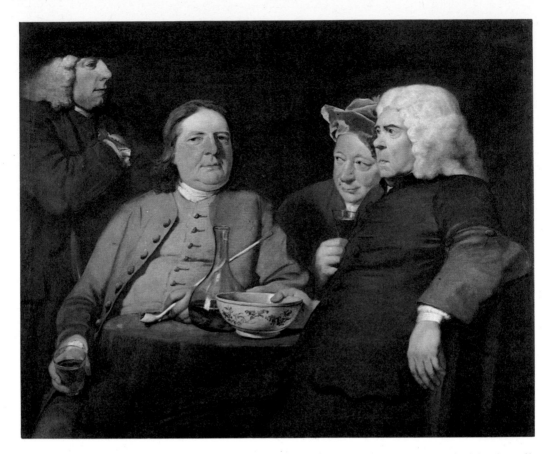

pompous, complacent, self-important ass. (Highmore, again probably in all innocence, shows us his admired friend, Samuel Richardson the novelist, as a self-satisfied, puffed-up little man, impossible to take seriously.) So here is the mystery – apparently a humourless portrait painter, anxious only to admire and to please, who yet succeeds in making at least some of his subjects look ridiculous and contemptible. Was there an unconscious Joseph Highmore who secretly rebelled against all this admiring and pleasing and solemn essays on literary and religious questions? Did this other Highmore spread a little venom on the palette or inject it into the very linseed oil? Well, there is the riddle for you.

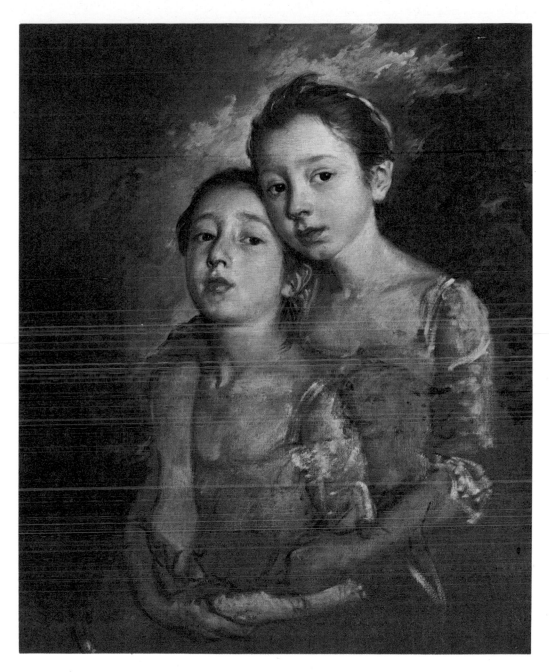

Gainsborough: The Painter's Daughters with a Cat (unfinished)

Gainsborough was a Suffolk man – and stayed one. He lived in Bath, he lived in London, but he took the country with him. He might not be everybody's man, but my heart warms to him. Outside his work and his close personal relationships, he didn't give a damn. He could turn with ease from landscape to portraiture, often combining the two, taking his portrait subjects into a special Gainsborough world,

not quite natural, not entirely artificial, a world outside his own era. He had a passion for music and the theatre, but never even pretended to enjoy literature or the company of writers (except Burke and Sheridan, not a bad choice); and after fifty-five years of writers and their works I am not ready to blame him. He accepted commissions from the Court and the aristocracy, but he cared nothing for high society. He was touchy – as men who work at full stretch are apt to be – but affectionate and generous in all closer relationships, and his letters to his friends are lively and eager. When he was dying he had Reynolds, with whom he had quarrelled, brought to his bedside, and his final whisper deserves the immortality it sketched: 'We are all going to heaven, and Van Dyck is of the party.' This was well said: nevertheless, Gainsborough is the greater painter.

I would cheerfully swap any of his beautiful or formidable duchesses and the like, even his *Blue Boy*, for the unfinished portrait of his two small daughters. It is true that his magnanimous rival, Reynolds, left us some splendid children, but it is also true that by and large the art of painting has not been kind to children. All too often they suggest resentful dwarfs or so many hammered-down adults. Even the prettifying of them, the cuddly cupid aspect, misses essential childhood, and here Gainsborough's portrait is a triumph.

The two little girls – probably about eleven and seven – so clearly and firmly portrayed, with nothing heightened to add beauty or style, stare at us out of an authentic child's world, all the more authentic because the sun and cloud of the countryside can be discovered behind them. One, being four years older, knows a little more than the other, and perhaps is pretending to be more knowing than she really is. No gaiety – just as no dashing high colour – has been thrust on them. They are not a pair of merry little girls, about to entertain us boisterously, and might be said to be caught off-guard, wondering with a touch of melancholy, like real children and not like little folk seen as painters' pets. And yet suffusing the whole painting, unfinished except for the two small clear faces, is an unforced tenderness of which the painter himself, still only in his early thirties, may not have been aware. And if this is not a masterpiece, I ought to stop trying to write about painting at all. Incidentally, to my mind it is far superior to the portrait of these two girls when they were grown up; and it is to be found, where it certainly belongs, in the National Gallery.

Constable: Study for The Hay Wain and Weymouth Bay

I think Constable developed slowly because he was diffident and modest. It was not that he lacked his own vision of this world – it must have been there very early – but that for a comparatively long time he must have imagined that artists with secure reputations knew better than he did. When he realized they didn't, he was off on his own, painting Constables, never to be budged. He was an original genius like Turner but his opposite as a man, sociable where Turner was solitary, open where Turner was secretive, a respectable family man where Turner was up to anything when not working. He greatly admired Wordsworth as the 'poet of Nature' but their idea of Nature was quite different. There was no symbolism, no glints of pantheism, in John Constable's mind, which in these matters enjoyed a pious simplicity. He lived with Nature, not trying to find a way through it into some other reality, but living as Adam might have done in Eden. He accepted his world gratefully and cheerfully; but then, putting an end to simple conformity, he began to look hard at it in his own way and not anybody else's. So, to take an obvious example, he saw that an ordinary field was not a monotonous stretch of any chosen green but could only be brought to life on paper or canvas by cunningly varied patches and tints. This apparently simple man, fond of company, boiled mutton and pudding, practising an art that he said was 'without fal de lal or fiddle de dee', brought the earth and the sky to life, and changed the course of nineteenth-century painting.

We know how Géricault and Delacroix and their friends were startled and then delighted by Constable's *The Hay Wain*. (It is typical of Constable that he never went to Paris to collect their applause.) But what, we wonder, would these French

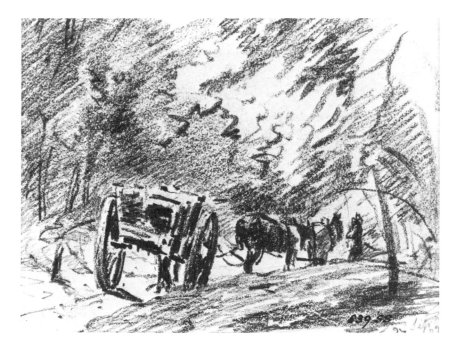

painters have thought if they had been privileged to see not the big 'finished' pictures but the sketches and preliminary studies that we know and marvel at now. The Victoria and Albert Museum has scores of such 'painter's notes', some in oils or watercolours and others just rough pencil jottings like the tiny sketch reproduced at the foot of the previous page. But Constable had a living to earn, a reputation to build up, an Establishment public to capture, so there must be a definite subject, a composition to arrange, together with plenty of 'finish', so that too often something spontaneous and wonderfully fresh, from the changing light above to the glimmer or sparkle below, had been lost. If two or three enthusiastic art dealers and several critics, all educating their eyes, could have taken the place of the Royal Academy (only electing Constable late and grudgingly) what a difference it would have made to the history of nineteenth-century English painting!

So the full-scale sketch, *Study for The Hay Wain* (Victoria and Albert Museum), is more exciting to my eye than the famous finished picture itself. Here the wonderful sky, so freshly caught, provided Constable with the varied highlights that delighted him, puzzled some of his contemporaries, and now delight us. This, I believe, is *our* Constable.

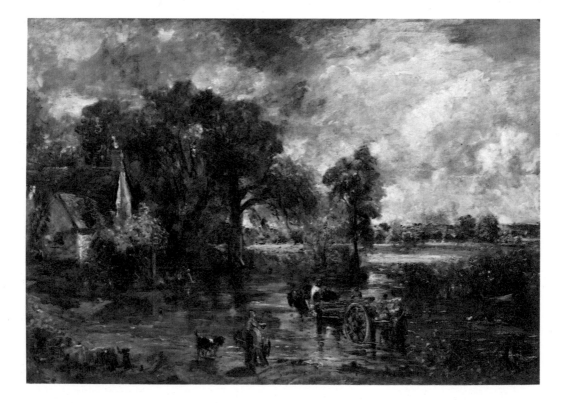

Weymouth Bay, Constable's idea of an ambitious sketch, not a picture, was painted during the autumn of 1816, when he was on his long-delayed honeymoon, staying in a village near Weymouth in Dorset. No traveller, he was now far away from his own beloved countryside, in an alien wasteland. He may or may not have done some of this painting in the open, but he put down what he saw, offering neither too much nor too little detail and making us feel the space between us and the distant hill. Beyond is one of his most magnificent skies. At a first glance we tend to disbelieve it – those arrogant clouds! But we soon accept it and then never quite forget it. How easily he made himself at home in this distant and half-wild autumnal scene, almost impossible to imagine in Suffolk! And what a pity, some of us non-East Anglians feel, that he never followed the example of Girtin, Turner, Cotman and explored the Yorkshire dales and fells. But this is to grizzle against a great painter who knew enough wretched treatment in his lifetime. Even so, in spite of sorrows and many disappointments and the rheumatism and depressions of his last years, John Constable, I feel, had known a happy life, enjoying his long love affair with Nature, wandering through his own Eden and leaving the world a marvellous record of it.

Lawrence: Princess de Lieven

He began as a boy wonder and then soon became a man wonder. There have been better English portrait painters before his time and since but not one with the same gigantic international reputation. Only the best of his fellow portraitists had their doubts and occasionally gave a growl: regal and fashionable Europe adored him. He could work rapidly and strikingly; he spared his distinguished sitters too much paint and insight; he was handsome, well mannered, and flirted gently with the ladies while making them look their best. He ought to have been thoroughly spoiled but does not appear to have been; he was generous with the money he earned so easily and probably spent a fortune on the work of greater painters than himself. Nor was he always superficial and flashy. Now and again something of his own came through, to cling to our memory. So, for example, when I was doing my book on the Regency, *The Prince of Pleasure*, I found myself looking again and again at his small and unfinished portrait of Princess de Lieven, which seemed to me then – and still seems to me now – both to reveal and to adorn the Regency. There is something here that is missing from the portraits of Victorian women.

Dorothea de Lieven was Russian, marrying at a very early age the rather stiff and formal man who became the Tsar's Ambassador at the Court of St James's. St Petersburg and Berlin had bored clever and ambitious Dorothea – she was easily bored and dreaded any threat of *ennui* – but the Regent's London, rich and raffish, enchanted her, and she soon became one of its leaders of fashion. While she was charming when she wanted to be, she was not generally considered a beauty: she was tall, rather thin, and lacked the voluptuous bosom and fine arms of so many Regency beauties. She was a snob of the highest order, forgiving royalty everything and commoners nothing. A taste for political intrigue was common among Russian society women, but Dorothea de Lieven had a passion for it, and by the time she came to leave London, without returning to St Petersburg, this passion took complete possession of her. She was for a time the mistress of Metternich and remained his close friend and unwearying confidante. Before she had reached middle age she had become the best-known political hostess of her time, an archetypal feminine intriguer. Watts painted her not long before she died, in the 1850s, and, looking at his portrait, I feel that it is not simply age and weariness that have taken it such a long dusty way from the face that Lawrence painted: it lacks the nourishment that comes from love, wide compassion, art and music and great literature.

Clearly I am no admirer of Dorothea de Lieven. Yet I can still admire, almost with a touch of nostalgia for the age she was gracing then, that clear face which Lawrence offers us, not without its first traces of the sharp cleverness and the social and political ambition that would consume her in the end, yet also with its suggestion of some Russian wild rose. He makes me wish I could have known her then, and this, with a small unfinished portrait, is evidence of a portrait painter of some stature.

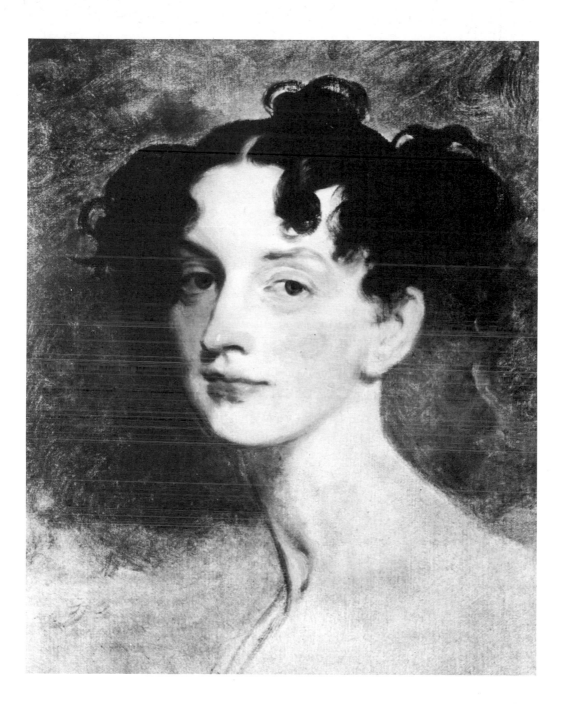

Turner: A First Rate Taking in Stores and
A Tree in a Storm (watercolours)

Joseph Mallord William Turner was first, last and all the time a painter. Though he never had the influence on the artists who followed him that Cézanne had, I take him to be the nineteenth-century's greatest painter. No *avant-garde* left him behind: he has never been caught up with yet, for in his later work he painted the elements themselves – his subjects were earth, air, fire and water. (You can see these elements marvellously merged in the sunset sketch reproduced on page 26, which comes from a notebook of sketches done by Turner at Petworth in Sussex.) And it is far easier to abandon representation altogether and go abstract than it is to convey the power and mystery of these elements. Moreover, not only was he a great man but he was the kind of great man that most of us, if we have any sense, wish we could have met and known. He was generous and genial with fellow artists, and often when he appeared to be unnecessarily suspicious and elusive he was protecting his creative life, the very root of his existence. True, he cared nothing for the Establishment and high society – and until recent times this would always get an artist a black mark – and he had a disreputable habit of vanishing from all respectable circles, turning himself into 'Captain Booth' or 'Puggy', and enjoying merry low company. This led to a rebuke from our *Dictionary of National Biography,* which during its first decades adopted the standpoint of a Victorian

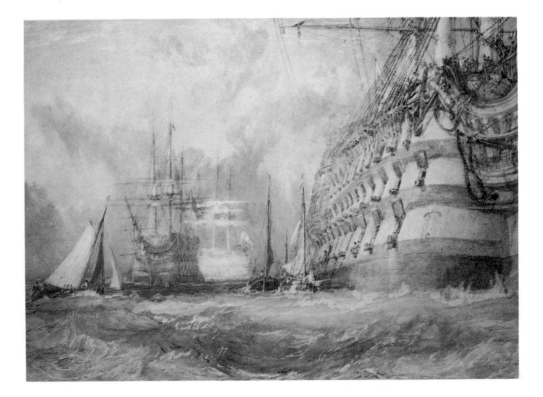

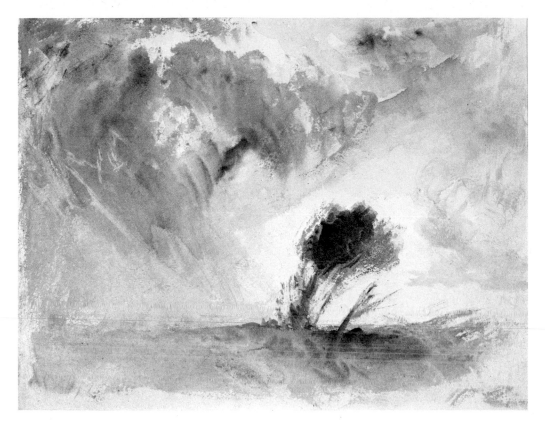

maiden aunt: it dismissed Turner's private life for being 'sordid and sensual'.
Well, sensual it may have been – after all he was a painter, not a monk – but in any
larger sense of the term it was far from being sordid. On many occasions he be-
haved nobly, and noble indeed was his unwearying devotion to his art. We know
how in order to observe a storm he had himself lashed to the mast of a small ship.
We might add that throughout a long life he was always lashed to the mast of his
work.

I have chosen for colour reproduction two watercolours (his more magical
medium) that seem to illuminate both his character and his genius as a painter. The
story of how he came to paint a big battleship (a first rate) entirely from memory is
well known but will stand brief repetition. He was staying with the Fawkes family
at Farnley, and one morning his host asked him if he would do a drawing that
would suggest the size of a man–of–war. Amused, Turner carried off the schoolboy
son to watch him at work. It was done in a morning, the completed picture being
taken to the lunch table. The youngster described afterwards how Turner went to
work in a bewildering frenzy, first damping the paper, then adding or removing
colour hastily, then rubbing or scrubbing away at what seemed a mere chaos, until
at last the great ship and her attendant vessels and the lively sea finally emerged,
with every necessary detail in place, all from memory. And what a battleship this is,
immense and triumphant, a symbol of Britain's worldwide naval power! How the

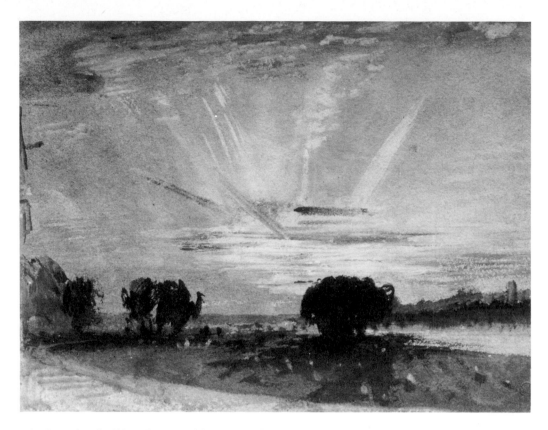

whole episode illuminates this master's character and genius – his good-natured agreement, a certain almost boyish romanticism, his astounding visual memory, probably unequalled, and his characteristic method of working, using anything from a full brush to a thumbnail, to achieve at full speed the effect he wanted to obtain! What a man to have staying in your house!

Painted a few years later, *A Tree in a Storm* is like an explosion in visual art. The energy released by the storm may be said to have raised the painter's own energy to boiling point. He makes us feel he was ready to use anything and do anything to capture the scene: adding oil – and possibly glue – to his watercolour; in places using his fingers instead of brushes. But the thing is composed and not just thrown together. There is the horizon-horizontal of the field in the foreground, and above it the opposed diagonals of the tree and the main stormclouds. And these, together with the bare white paper behind the tree, almost suggest the bursting of a vast shell. Moreover, the touches of pink and the browns against the darkening blue seem to me inspired colouring. The exact date of this watercolour has never been settled, but it is safe to say that now we have here the Turner who began to paint the elements. (See his very late watercolours, done for himself and not for us.) He wrote some bad verse but brought new poetry, a wild vision of elemental things, into the very English art of watercolour. We ought to be proud to be his fellow countrymen.

Cotman: A Dismasted Brig

We know that Cotman was a dutiful, hard-working man, that his good looks and pleasant manner must have furthered his career as a drawing master in East Anglia, and that he was an affectionate if worried family man. And his ability, on many different levels of his art, can never be questioned. But we are also told that his last years, which ought to have been his best years, for he was only in his fifties, were deeply overshadowed by bad health, melancholy, profound fits of depression, so severe that it was rumoured he had gone or was going out of his mind. Clearly this calls for some explanation, and mine, for what it is worth, is that he was like a race-horse that came to be continually employed, year after year, as a drayhorse. We can put it another way and declare that in his deepest nature he was a brilliantly original creative artist, but that he lacked the obduracy, the defiance, the unyielding edge, with which such men have to face the claims of an easy life in this world. So he had to discover himself in exceptionally favourable conditions to do his finest work. This happened to Cotman in his early twenties during his visits to Yorkshire and Durham, when he stayed with or came to know intelligent and affectionate people, for whom he produced masterpieces of watercolour and drawing such as the famous *Greta Bridge*, which is reproduced at the foot of this page.

They were never quite within his grasp again, and the feeling that something had been lost, never to be found again, probably brought on the ill-health and the deepening melancholy of his final years. But I refuse to dismiss – as some critics

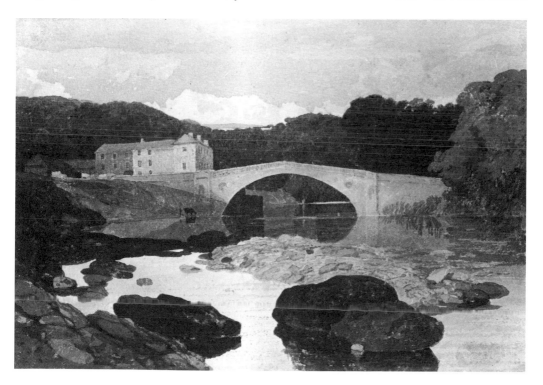

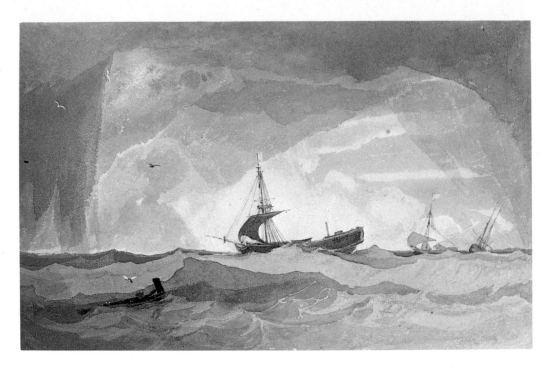

have done – his experiments with almost startling body colour (especially blues) as disastrous attempts to equal the tender shades of his early great period. Something good came out of those holidays in Normandy and all those blues mixed with paste. I know this because I have lived for many years now with his *Landscape in Blue* and would have reproduced it here had I not already done this in *The English*. As it is, I have chosen for reproduction in colour something from his middle period, when he was often living and working in Yarmouth and frequently attempted sea subjects. (Not a natural element for him, I would say, as it was for the far bolder and more determined Turner.) His *Dismasted Brig*, now long in harbour in the British Museum, shows us an experienced hand in the pattern of the waves, but high above them, in the tremendous sky, there is once again the hand of the master of his art: the creative Cotman has suddenly burst out of the shell of the routine instructor.

Corot: Avignon from the West

I have lived long enough to have seen Corot *in*, then *out*, and now *in* again. When I was in my teens, every provincial art lover's idea of a great painter was Corot. All

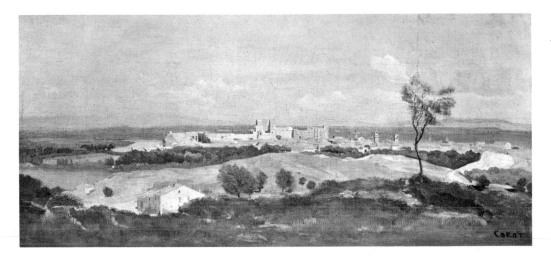

the curators of municipal galleries were trying to lay their hands on his forest pictures, with their graceful foliage, their tender vistas. Yet even then I knew one art dealer, quite different from the other smoothies, a roughneck and a drunk, who was regularly sent to Paris by some mysterious client and came back babbling of Cézannes and Gauguins and other outlandish unknowns. The rest of us, all sober, stood by Corot. Until of course we discovered the Impressionists and then the Post-Impressionists, which meant that Corot was almost forgotten. Now he is back, taking his rightful place in the procession of nineteenth-century painters. It is a good place – for a good man and a splendid versatile artist.

Jean Baptiste Camille Corot was unusually sweet natured, being modest, unfailingly kind and generous. Though not driven by poverty – he was comfortably off – he worked hard all his adult life. He lived until his eightieth year and was Le Père Corot to all the painters in Paris, who knew about his generosity to fellow artists and to the poor. He painted acceptable portraits as well as many varieties of landscape. He was one of the recognized fathers of Impressionism, if only because he stressed the importance of a painter's immediate impression, which must be held in mind throughout the final organization of a picture. Even the grimly fastidious Degas paid a special grateful tribute to Corot. Here was an artist much loved and widely admired. But in Phoebe Pool's lively history of Impressionism we meet one man who was dead against Corot and his Barbizon colleagues. This was Count Nieuwerkerke, Superintendent of Fine Arts in the Second Empire. He declared, 'This is the painting of democrats, of those who don't change their linen and who want to put themselves above men of the world. This art displeases and

disquiets me.' We may be sure that Corot, brought up in well-to-do bourgeois society, changed his linen, but even so the clean-shirt-and-underpants criticism of art is not to be encouraged. That the Superintendent of Fine Arts could be such an ass tells us a good deal about the Second Empire.

Corot's long working life and his versatility make a single choice very difficult, and I must admit I have hesitated for some time before making it. This view of *Avignon from the West*, in the National Gallery, London, is to some extent a compromise between the pure landscape and the architectural sides of his work, showing neither at its very best but combining them in what is a satisfying painting. A few years ago we enjoyed a very pleasant holiday in Provence, making Villeneuve-les-Avignon our headquarters. But the Avignon we saw so often across the river now looked very different from the distant golden place in Corot's painting. But this adds something to the picture. I must declare my belief that when we are enjoying a work of art we are not trying to pass an examination in aesthetics. We are entitled to take far more than the artist knew he was offering us. Somehow Avignon fails to live up to its historic past and the glamour of its name; it disappoints most of us. But now in addition to the characteristic charm and harmonious colouring of Corot's total landscape here, we have a dreamlike lost-world quality in our sight of Avignon itself. Something that has gone has been restored to us. And how glad the gentle and large-hearted Corot would have been to know this!

Daumier: Don Quixote

If I had a list of artist-heroes, somewhere near the top would be Daumier. My admiration for this prodigious man is constantly warmed by affection. He is my kind of chap, if I may say this without any pretence of sharing his ability and his virtues. Hard times never soured him; popularity never spoiled him. He remained a man of the people, whose company he preferred, usually in some cheap wineshop, to that he was offered in elegant salons; and he had a giant's energy and strength and a giant heart. (Forain, a brilliant cruel talent, looking at some of Daumier's work not long after Daumier had died, said, 'Ah – he was different from us. *He had a*

heart.') Along with a contemptuous detestation of canting political bigwigs, lawyers, financiers, all members of the smug bourgeoisie, so prominent in the period 1830–50, he had an unwearying compassion for the poor, for humble workmen, for strolling players and their sort. He worked like ten blacks, producing over 4,000 lithographs, and was the supreme cartoonist and caricaturist of his age, with an astounding range from the tragic or vitriolic to pieces of pure humour. But all this of course is well known.

What is not sufficiently realized is that during his later years Daumier was trying to free himself from the insistent demands of the lithograph, the satirical press, the sardonic and humorous sketches, to reveal himself as a painter (though he was admired by many of his fellow artists.) He was in fact a painter of original genius, often a bold naturalist, making good use of his instinctive feeling for mass and sculptural form, making us in turn feel there is something refreshing about his apparent spontaneity, as if we saw big brushes rapidly building up light and shade. (Yet an earlier sketch for a Don Quixote picture, dating from the 1850s, either contradicts this impression or suggests that he went to work faster ten years later.) Now *Don Quixote* is an old favourite of mine – see *Literature and Western Man* and of all the artists inspired by this masterpiece Daumier remains at their head. Nobody else has shown the same imaginative insight. This ageing but still full-blooded cartoonist-painter makes me feel that he has in his own fashion explored the depths, level after level, of Cervantes' irony.

With only one colour reproduction for Daumier at my disposal, I am finding it hard to decide which Don Quixote picture I should choose. The study sketch may be unfinished, but its two figures, riding before a rocky background, are marvellous, with Sancho, behind his master, all body and solid weight, and the Don himself, all angles and paper thin, seemingly about to take off into the clouds rather than ride on, almost a bodiless creature of spirit and imagination. Then, an alternative, there is the Don charging the windmills, though the painting is dominated by a massive Sancho, clasping his hands and raising his face to cry to heaven in his despair. Or there is the small but wonderfully impressive picture of the knight and squire, not long after early morning light has found its way into some remote place, seeing a dead mule on the path ahead of them: technically a superb job. Reluctantly abandoning these three, I have chosen, as will be seen, the picture of Don Quixote riding alone, a picture that fired the enthusiasm of Van Gogh. Into the maroon-and-ochre desert, under a sky of a strange blue, there he goes erect but featureless, his lance dividing the sky. All the light is falling on his horse, itself fleshless, all sharp bones, a steed out of some fantastic dream, carrying a rider who is himself lost in a dream – of a world worse than this or a better one? The question is not answered here, where there is nothing but a huge silence, even the horse itself without bridle or stirrups not making a sound, we feel, as it moves into a mystery. As a composition, as so much colour and tone, light and shadow, and as an imaginative interpretation, it is a masterpiece. *Illustration overleaf*

31

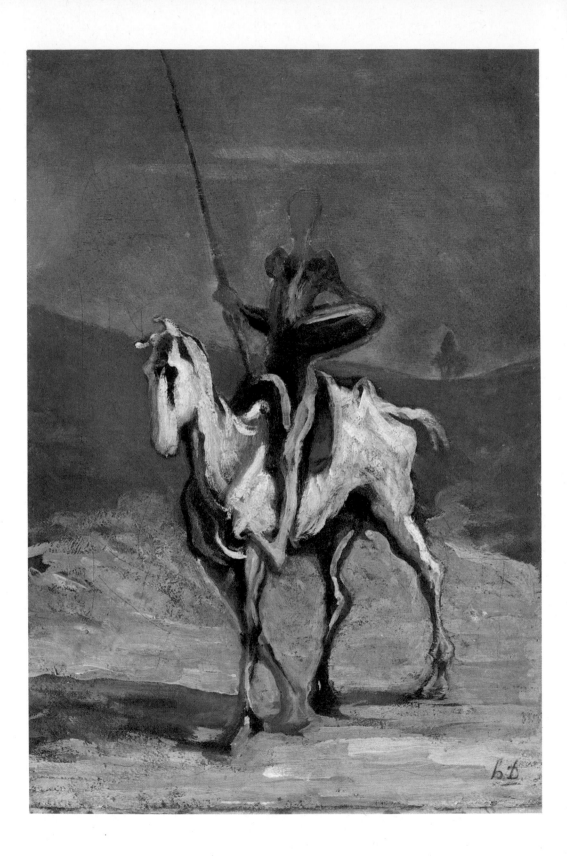

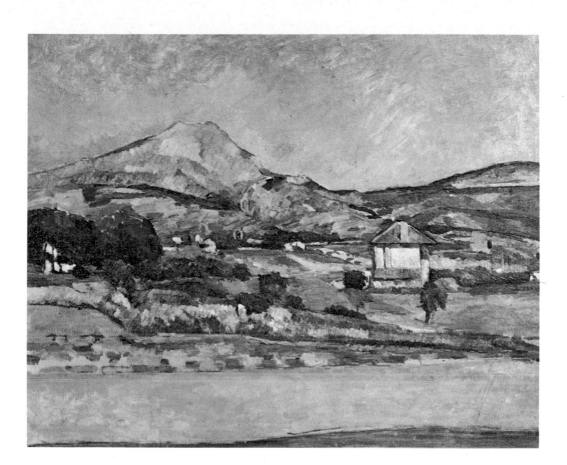

Cézanne: Road near Mont Sainte-Victoire

Somewhere in or near Provence there was a college in the early 1850s that had a students' orchestra, in which Cézanne played the cornet and Zola the flute. It is surprising that Cézanne attended the necessary rehearsals. He must have been a restless and unreliable boy because we know that he was an extremely restless and unreliable young man. Indeed, it was not until he was within sight of middle age that he could be depended upon to settle down anywhere. He would leave Aix-en-Provence for Paris, then suddenly decide to go back to Aix, try Paris again, hastily depart for somewhere else – a kind of shuttlecock. He was much the same with his social engagements – and he had a large acquaintance among good painters, all of them far better than he was at that time. He had an irritating trick of appearing and disappearing for no particular reason anybody could discover. In Paris he was always changing his lodgings. He was never at ease in any company, probably because he was never at ease with himself; but he was shy, not arrogant, though irritatingly capricious, and was generally regarded by his fellow painters as a provincial without much talent and rather a nuisance. He might be compared to an actor hanging about waiting for the great roles that would proclaim his greatness.

Would a few more years see him as a disaster or a genius? Well, we know the answer to that one.

In many respects the second half of his adult life was a dramatic reversal of the first half. Instead of dashing around and producing some messy biggish pictures, he more or less anchored himself and grimly painted on, day after day, year after year, without reward or applause, with no hope of the honours which, oddly enough, he deeply desired. As a man, not as a painter, he was unpredictable to the end. Not at heart unkind and mean, but suffering from public neglect and ill-health (he had diabetes), he became more and more withdrawn and quarrelsome with old friends. It is doubtful if the masterpieces he began to produce, works that changed the course of twentieth-century painting, brought him much joy – only new problems. I have neither the space nor the competence to discuss those problems or the development of his personal vision and technical mastery. But a few points might be made. He began, badly, as a wild romantic: he discovered the classic in himself. Though Pissarro was the painter he spent most time with, he was never really an Impressionist. He began to feel that Impressionism lacked substance, weight, permanence. It was as if it were painted on a brilliant curtain, and he, Paul Cézanne, had to lift that curtain and reveal what was solidly there behind it. Not that the scene had to be real, but the picture had, existing in a world of its own laws. Much has been made of his semi-geometrical theory of form yet it would be true to say that he advanced on several fronts more or less at the same time. And while he might be irritable and sometimes embittered, there was in him a kind of peasant obstinacy and hardihood that took him in the end to the very peak of his profession and worldwide fame.

Yet, while saluting such a master, it is possible to have one's preferences. So I for one take most delight in his landscapes, rather less in his still lifes and considerably less in his portraits and figure paintings. (So, for example, his *Woman with a Coffee Pot*, in the Louvre, seems to be made of wood.) I have chosen for reproduction here a late painting, his wonderful *Road near Mont Sainte-Victoire*, which I first saw either in Leningrad or Moscow. The tremendous solid rock, defying the strange sky itself, can be accepted as a symbol of his final enduring reputation. Probably already ailing, he was yet able to summon up sufficient energy of mind, eye and hand to give this work its astounding force. The curving road is alive; the very foliage is there for ever; and above all, pushing back the sky, is the mountain of impregnable rock, shining in triumph. All those long days in the fields, with the latest rejection adding another bitter flavour, were not spent in vain.

Elmore: Nude

Who wants Alfred Elmore, born in County Cork 1815; died in London 1881? I do, for reasons that will arrive after a brief interval for exposition. He was an R.A. who painted a number of large and impressive pictures prominently displayed in many exhibitions. They enabled him to live in London – no creeping back to County Cork – and to travel abroad, chiefly in Italy. Their subjects range from the usual scenes from Shakespeare, *The Invention of the Stocking Loom*, to *Religious Controversy in the Time of Louis XIV*. Now this may be unfair to Elmore, but I cannot help feeling that if I were offered one of his impressive and esteemed pictures, on condition that I must not part with it but give it permanent houseroom, I would not accept the offer. On the other hand, his watercolour of a Southern nude, done to please himself and his friends without any chance of its being shown in public, had its own corner in our house for many years. I reproduce it here as if introducing my readers to a friend, for this is how I have come to regard this splendid bare wench.

In the face itself and in the positioning of the head, the right arm and hand, I detect some romantic affectation, but all the rest seems to me beautiful plain sailing. Here is a fine sturdy lass, all of her and no nonsense. I struggle only with landscapes myself, but I imagine that satisfying flesh tints are hard to capture in watercolour – and Elmore has pulled it off, helped by some cool tones in his background. I am not pretending that this is a masterpiece but I certainly am saying that having lived alongside it for a great many years I still find it brings me some pleasure. Plenty of honest-to-God sex is there, but it stops well short of the prurient and the 'sexy'. And if it is not altogether well done – allowing for a little affectation – then I have not known how to use my eyes for the last thirty-odd years. Incidentally, it cost me about as much as I would pay now for a dinner for two, largely from tins, and a bottle of claret too young to be allowed out at night.

But I still have a point to make. Away from their studios and their theatrical-historical set pieces, just enjoying themselves with a few brushes and odd sheets of paper, and not having to pull draperies across pudenda, what good painters so many of these boring Victorian Academicians could be! And then we start wondering how much we may have missed, how many happy drawings, studies, sketches-for-fun these men may have crammed into stoves, tossed on to fires, left to char-women to clear out with the rubbish. For there may have gone their art and our potential delight, while we turned more and more of our backs on laborious works like *Rienzi in the Forum*, *The Deathbed of Robert, King of Naples*, *Hotspur and the Fop*, and *Lucretia Borgia*, all of them major set pieces by Elmore, toiling away in the murk of Kensington or Chelsea when he might have been in the sun, a thousand miles away, asking that fine hefty wench to model again without a stitch.

Illustration overleaf

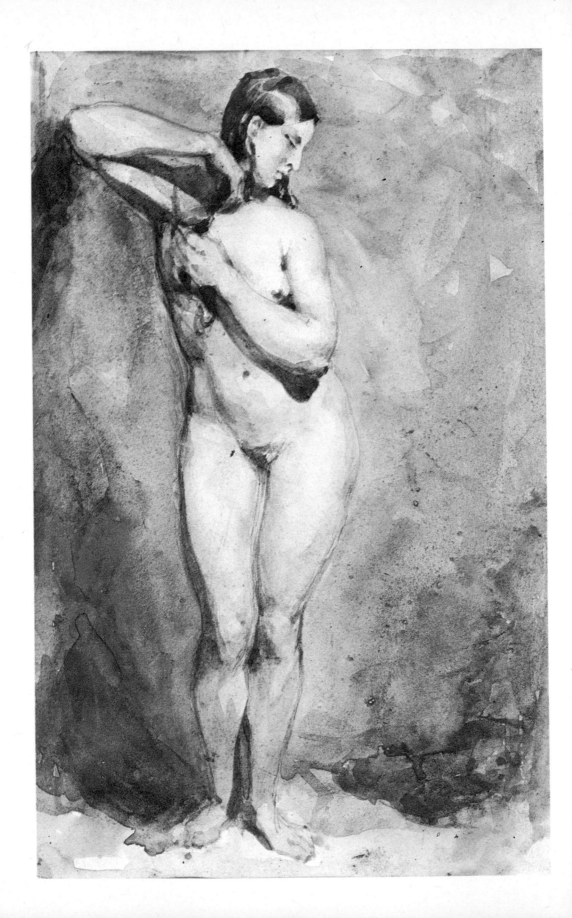

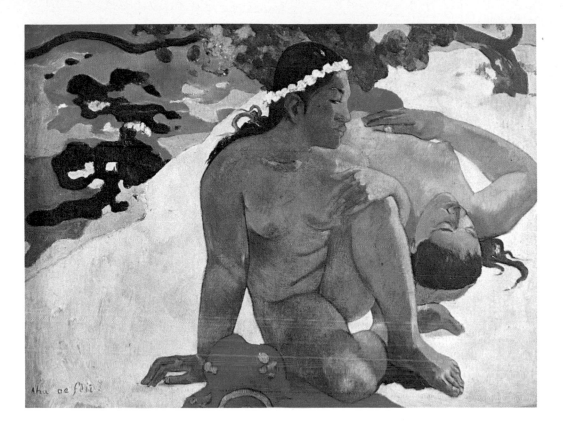

Gauguin: Aha oe feii? What, are you jealous?

A great while ago, well over half a long lifetime, I spent a month between boats at Tahiti. I seem to remember that most of that month I was nowhere near Papeete, with its occasional boatloads of sightseers; so that the Tahiti I saw cannot have been very different from the one Gauguin explored in 1891. I remarked a certain irony in the lives of white men there. If they settled down to a sturdy bourgeois family life, like the American writers, Hall and Nordhoff, all was well. But if they arrived in the South Seas in flight from the narrow existence of the bourgeoisie at home, and remained to defy it, lolling more and more long afternoons away with Polynesian girls, all smiling and accessible, I got the impression that most of them showed signs of deterioration, both physical and mental. They looked older and sloppier than they ought to have done. So now let us consider Paul Gauguin.

He was of course very different from his fellow exiles. He was a great artist. He was a powerful man, both physically and mentally, with the neck and shoulders of a bruiser and the face of a French marshal. Without going into his complicated personal history, we can say that both as a family businessman and as a deeply original painter he had tried his best to cope with the demands of a bourgeois existence, and at last in despair he had fled from them as far as he could go – to the enchanted isles of the South Seas, to Nature and to Freedom. Driven by ill-health

and poverty, he returned to Paris after two years of Tahiti and tried to forget more strokes of bad luck by some riotous living. He returned to the Gauguin of romantic legend by going back to Tahiti in 1896, finally moving on to the remoter and more primitive Marquesas, where he died in 1903, by this time a man who might be wrecked in his eighties instead of his middle fifties. I realize that more of his generally acknowledged masterpieces date from this later period. Yet the price he paid for this return to the South Seas is almost too horrible to contemplate. Any detailed account of his suffering, his mounting embroilments, frustrations, mis-understandings, deepening despair, is heartrending. (For three months he *never painted at all* and not from sheer physical incapacity – that came later – *Gauguin of all men!*) What happened during these years explodes the romantic legend. Nature and Freedom and the dream life are blown to bits. The Polynesians were no longer golden toys; they had to be understood and defended against their bureaucratic white oppressors; with his own health rapidly failing, desperately ekeing out his paints because the next batch had not arrived, he was deeper in local political and social problems than he could ever have been in Paris. And while the masterpieces were there, would they not also have been there, with such mastery of his art, if he had stuck it out at home, all his rewards close at hand? How could he hope to succeed with his dealers and new patrons ten thousand miles away? It was a bad move: his last and worst.

In spite of the greater complexity, in terms of composition, colour and shadow, and the deeper almost mystical feeling of the later pictures, I have chosen one from his earlier stay in Tahiti, one that brings us immediate – though lasting – pleasure. In the harmonious yet exciting relation between the dark and the light figure and the rich pattern of their environment, this picture must have brought Gauguin some of his happiest hours. We are allowed to share that happiness, as I felt at once when I left the dusty concrete of Moscow for the Pushkin Museum and found this picture glowing there like an enormous precious stone.

Sickert: Café Scene

Though some of Sickert's friends were friends of mine, I never met him. (In these circumstances I always feel I am going to run across the man anyhow, without any solemn appointment.) There were two good reasons why, after his death, I felt very sad about this. The first – though less important – was that I knew he was uncommonly good company. There was an actor in him always ready to provide an evening's entertainment. This style of behaviour has much to recommend it if a man is an artist. He can bring out his nonsense in company and then get rid of it before he settles down to work again. Until his very last years, there was no nonsense in Sickert's painting. His years in France, often playing pupil to Degas, taught him to be a serious artist. This is the second and more important reason – that I admired this man's work enormously. I would never at any time have called myself 'a collector' but I did at one time and another own a number of Sickerts. I was particularly interested in what I will call his 'theatre pictures', even though in fact they were paintings of music halls.

These interiors are difficult subjects. They cannot be done on the spot and have to be done in the studio on the basis of a number of quick sketches. (Sickert probably learned a great deal from Degas here.) But over and above the technical method, a painter, I believe, has no hope of succeeding with these strange interiors unless he has an instinctive feeling for theatrical life. Degas had it before Sickert, and so, without being influenced by Sickert, had Spencer Gore. But there was one snag about Sickert's theatre pictures: most of the best known were so dark they needed spotlights to illuminate them. Now this is all very well in a gallery or museum, but in a modest flat or country house this spotlighting looks to my mind quite out of place. So while they still gave me immense pleasure, I let them go, one by one, either to mansions or public galleries. All those audience faces, caught in the stage lighting below, vanished, to be enjoyed by far more people elsewhere. The one I kept – and still have – is a theatre picture of sorts that is not too dark, being a painting of the elder Goossens conducting at Covent Garden. I had half a mind to reproduce it here but then decided in favour of another Sickert I happen to possess, quite different in style and tone.

This Café Scene, which I take it to be, belongs to the period when Sickert began to lighten his palette, and the dress of the woman, cut in half by the edge of the picture, suggests it was painted during the First World War, either in London or Dieppe, to which Sickert returned for some time. And indeed the scene looks more French than English – both the man playing and his instrument, an accordion. While I would not claim it to be one of Sickert's masterpieces, I have lived with it for nearly twenty years and still find delight in its browns and pinks and those inspired flashes of light green.

Illustration overleaf

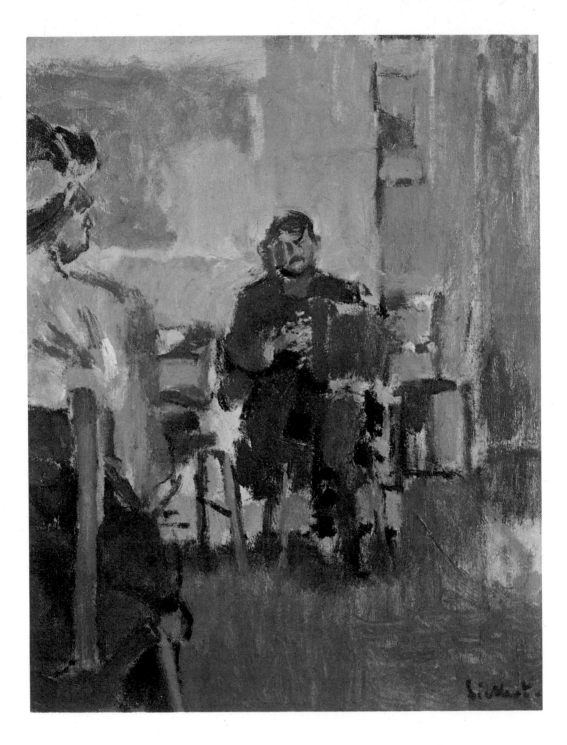

Bonnard: La Table

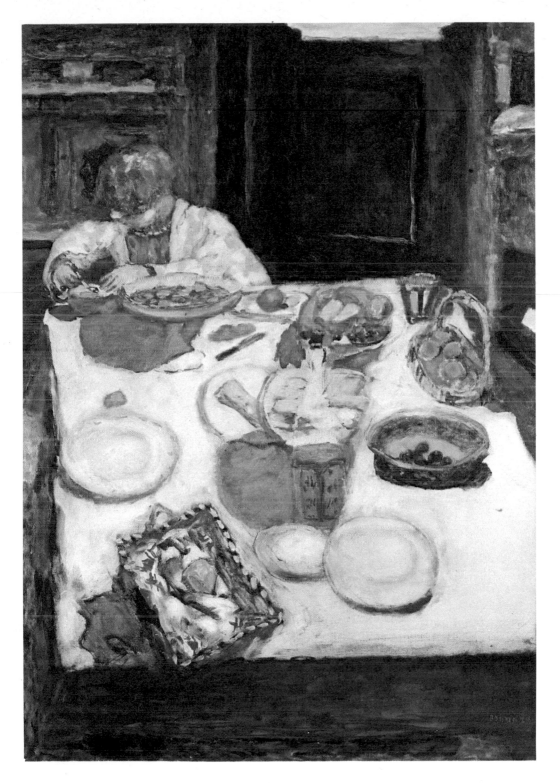

I take Pierre Bonnard to have been a complicated character, bristling with contradictions. Shy and very diffident in the general view, yet renowned among his intimates for his vitality, eagerness, humour. He produced an immense amount of work and yet became increasingly reluctant to consider any painting finally completed, often keeping one by him for years and even going to shows of his work to add a few last touches. He spent his early years doing whatever came along, painting anything, drawing anything, designing anything, quite at home with various media, yet gradually developed into one of the most fastidious painters of this century. He was no theorist, no *avant-garde-manifesto* man, yet continued making his own private experiments to the end of his long life. No bohemian, a bourgeois type outside his work, yet apparently indifferent to what the French bourgeoisie prize above everything – money, reputation, honours. Probably enormous comfort comes next, and Bonnard seems to have cared nothing about this, spending all his later years in a small bare house in a village above Cannes. Yet here in its tiny studio, littered with rolled-up sketches and watercolours, and half-finished oils, there painted unceasingly the greatest deliberate charmer of modern art, who could bring sorcery to a lunch table and transform a bathroom into luminous poetry.

From that tremendous Royal Academy Winter Exhibition devoted to Bonnard, in 1966, I brought away a montage of images, golden or rosy, of nude women, in or out of baths, that still haunts me. But I don't remember them – and indeed never saw them – as so many delicious sexual objects. They and their surroundings, in some extraordinary give-and-take of light, were sensuously portrayed, by a man entranced by the whole visible world. Yet here we were a long way from the later Renoir, who, with his intense sexuality, is asking us to start stroking and caressing his women, to begin eating them as if they were ripe fruit. Bonnard is making no appeal to the male in us. All their sisters are invited to stand and stare too, to enjoy the whole sensuous scene itself and the crafty experiment there that the painter will have been making. And indeed with this in mind, I have deliberately chosen for reproduction here a painting without a nude, one in which we move from the bathroom into the dining room, with the table itself the hero of the piece. So the woman, probably his wife, is turned away, looking down as if she might be giving a dog or cat a titbit. We don't meet her eye; she is putting herself out of the scene, to give more glory to the table itself. And in order to make this more effective, the viewpoint and perspective have been artfully shifted. We are now above the table, which is coming forward and offering more and more of itself, so that we may fully enjoy its variety and bounty. And every cunning tone in the background and the foreground is at work to persuade our eye to glorify the table, immediately to enjoy it and then remember it. This was painted in 1925 and Bonnard was to celebrate his joyous acceptance of the visible world, and to make one secret experiment after another to capture the painterly idea with which he always began, throughout the twenty-odd years that came afterwards. Indeed, he was still at work and making plans in his eightieth year. An odd contradictory character – but what a man!

Vuillard: Indoor Scene with Children

Edouard Vuillard was a quiet man. Though we shall not be able to read his diaries and private papers until 1980, it is doubtful if they will reveal any tempestuous affairs or scenes of scorching drama. For most of his adult life he lived cosily and comfortably at home with his mother, two typical members of the Parisian bourgeois. Unlike most painters, he travelled hardly at all: Paris was good enough for him. (But it wasn't the greedy roaring place we know now.) In his earlier years not only did he attempt, successfully too, all manner of work that came to hand, but he kept his place, if a quiet one, among his fellow Nabis and also attended Mallarmé's famous Tuesday evenings, not without some influence on his art. Again, he owed something at first to Degas and later to Gauguin, but it was not long before he was his own man, often painting on grey cardboard to prove it.

I shrink from disagreeing with a French art critic, but I must reject the following:

Vuillard was a true painter of his era, catering for the taste of his admirers and painting society as it actually was during the first decades of this century – that is to say, the ladies in their drawing rooms, the writers, statesmen, artists, businessmen, surgeons, actors, musicians, each portrayed in his own setting, engaged on his own particular activity . . .

This busy and successful caterer is not the Vuillard who claims both our admiration and affection. What we think of first and last are all those magical interiors, those luncheon or tea tables, those lamplit comfortable women who are sewing or reading, all those rooms that seem to exist in some other order of time, ampler and cosier than ours. There are two secrets here. One of course belongs to the art of painting, to the untiring nuances of minor tones, the refusal to shout, swagger, glitter, the presentation of the persons concerned not as dramatic figures but as parts of the room they occupy. The second secret, without which, I believe, all those nuances of tone could never have been so often sustained, is love. We are being shown a portion of this world and our life in it that Edouard Vuillard loved. The Impressionists loved their world too, but their aim was to show us one instant of its history: they might be called super-colour snapshotters. Vuillard's time effect is very different; he slows it all up, almost stops it; the lunch, the sewing, the reading, might last for hours and hours, almost days; and nobody in these magic interiors, we feel, might make a single move for a whole afternoon or evening. The furnishings of these rooms, the very wallpaper, from which they are often hardly to be distinguished, holds them in a trance. And we share it.

Even so, the one Vuillard that I would choose first, without hesitation to possess, is different from those I have already praised. It is *Indoor Scene with Children*, in the Pushkin Museum, Moscow, an astounding collection. (What an eye those old Moscow merchants had!) It is far from being a complete shuttered interior. In the background we see the world outside, and indeed we feel the air is blowing through it. Various blues dominate it, together with some pale creamy yellows and some greys, and the only warm tint is a subdued maroon–cum–crimson in the rug on the

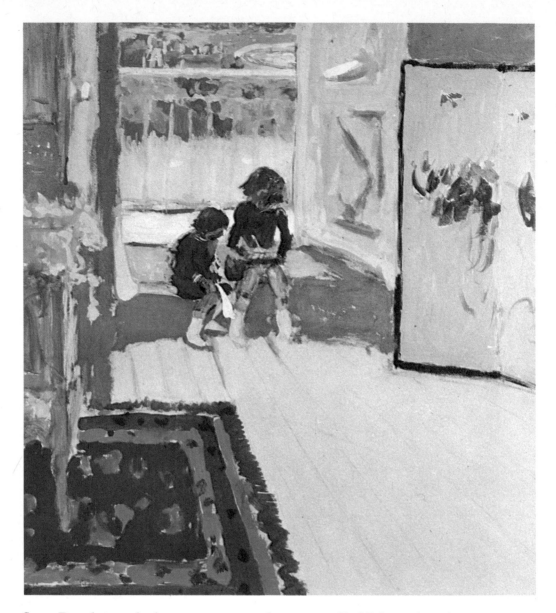

floor. But the eye is drawn at once to the two small children, deep in some ploy, sitting in front of the open door or window. Now these children have escaped the familiar trance; there is already a suggestion of movement about them, a pulsing life, and at any moment now, we feel, they will jump up and scamper away. And all this seems to me – and no art critic is going to move me an inch – a marvel and a joy, the art of our beloved Vuillard at its peak. It is both an interior and the beckoning world. It restores to us our childhood.

Nicholson: Begonias

We have been surrounded for many years now by painters who have taken up their brushes to send us an urgent message. It may be concerned with Marxism, Freudian analysis, a flight from the rational, an increasing death wish, a refusal to accept the outer world, a scientific theory of vision, some nightmare aspect of our existence – so on, so forth. It is then an agreeable change to meet an artist who simply

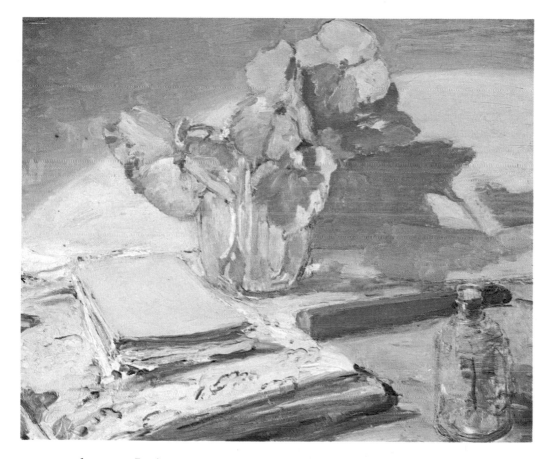

wants to please us. I take William Nicholson to have been such an artist. He asks us to share his delight in the visible world. An extrovert has arrived in the art gallery. He also asks us to enjoy what paint can do with canvas, and might be said to be a master of paintability. He is not a grand master, one of the giants. But we don't have to be giants all the time: it is pleasant to take a rest from them. A great many years ago I was sitting to Epstein, who told me a story quite indignantly, without a glimpse of humour. He was talking to Henry Lamb, who had plenty of humour, and he had mentioned Michelangelo. 'I don't like Michelangelo', said Lamb. Epstein was astounded: 'Not like Michelangelo! But he's *a giant*.' This didn't worry Lamb, who replied at once, 'I don't like giants'. I never heard Lamb on the subject but I

imagine he must have greatly enjoyed Nicholson, who in his art and his life made no claims to gianthood.

William Nicholson was a slight, dapper, fastidious man, who amused himself and his friends by dressing as if he had just arrived from the dandy years of the Nineties. He could be gregarious and full of fun but worked hard, succeeding with various media, throughout a long life. But in all his major work – in still life, portraits, landscape – he never suggests effort and severe application. If we have an eye at all, he delights us at once by making us feel that nothing could be easier and pleasanter than painting in his manner. We want to rush off and be painters ourselves, ignoring all the technical problems he has solved with such skill – all his sense of pattern, his use of shadows, his harmonious tone and subdued richness of colour, his artful placing of objects, his personal style that never makes loud claims for itself. He may be no giant, no visual prophet, no profound originator, no lonely explorer of the *Zeitgeist*, but he brings us immediate delight, which can return down the years, because he is one hell of a good painter, all that he ever wanted to be. Now I am not forgetting a portrait like that of Diana Low, radiant with youth. I am certainly not forgetting that superb *Harbour in Snow, La Rochelle*, for it belonged to my agent, A. D. Peters, and I often lost myself in it when I ought to have been considering 'percentages of the gross'. But if I take the whole wide range of his work, far more formidable than most people assume it to be, I find myself most impressed by his mastery of still life, surely unique in the England of his time. But which example of it ought to be included here? After some hesitation I plumped for his *Begonias*, if only because it was painted in the light of an oil lamp by a man in his seventies. And if any readers think it looks all too easy, let them buy some paints (no oil lamp) and see what they can do.

Gore: The Garden, Rowlandson House

Girtin and Bonington died in their twenties; and perhaps the nearest we can come in this century to that tragedy and loss is with the early death of Spencer Gore, born May 1878, died March 1914. We suffered a double loss with Gore. There are all the pictures he might have painted – and he was a hard-working and fertile painter. There was also the loss of his leadership, so strong that he came to share it, on the friendliest terms, with the older and more prestigious Sickert. He appears to have been one of those rare men who can continually take the lead and yet remain an engaging comic character, the best of company. He was a tall untidy man – a notable athlete in his youth – who was for ever twiddling a lock of hair as he attempted to solve aesthetic or any other problems that came along. When popular entertainments were being organized, Gore had to do his turn as a comic police-man. But he might almost be described as a serious policeman when it came to new developments in British art, largely inspired by the recent French masters, and to the marshalling of British painters who were all more or less moving in the same direction. His own range of interests was wide and so were his subjects and con-tinually modified treatment, with brilliant music-hall and ballet sketches at one extreme and his subdued and very characteristic 'London landscapes' at the other. I had owned an impressive large Gore interior for many years, but this didn't make my choice of just one tasting sample of his talent any easier. There was so much to choose from – and all of it so good and so various.

After much dithering I have selected for reproduction here one of his London pictures: *The Garden, Rowlandson House*, painted in 1911. Sickert was running a school there, but he closed it during the height of summer, when Gore was able to paint in this garden in Hampstead Road, probably in late July or August. It seems to me a painting that doesn't seem remarkable at first sight but then gradually pro-ceeds to capture the eye and delight the mind. Proof of this lies in a curious little incident. I had been staring for some time at a decent colour reproduction of this painting, noticing its avoidance of monotonous greens, its cunning distribution of yellow, the blues that crept in everywhere, and the touches here and there of a pale violet, all probably done with the dry paint that Gore favoured. Then I happened to glance out of one of my study windows, which shows me a corner of the garden and a field beyond with big trees – a scene I must have glanced at thousands of times. But now in a flash it looked different. There were tints and tones, with some blue invading the greens, some suggestions of lightest purple or palest spectrum violet, that I had never seen there before. Painting on an afternoon sixty-three years ago Spencer Gore had changed my eyes in the June of 1974. Certainly he did many more important things than that – and God knows what he might have accom-plished if he had reached a normal span of years – but in a personal record it is pleasant to add this testimony to his originality and great talent.

Illustration overleaf

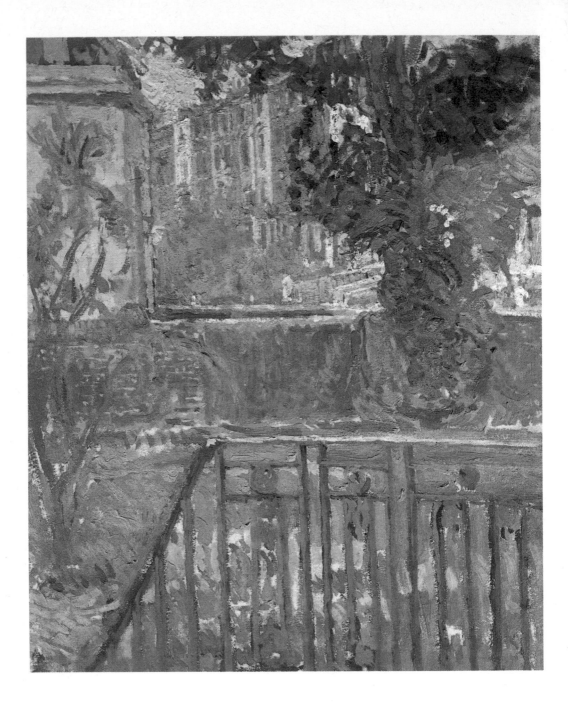

48

Paul Nash: Totes Meer

I have a maddeningly vague memory of meeting Paul Nash a great many years ago, long before his work had come to have any special meaning for me. His appearance and manner, so far as I remember them, never suggested painting of that order. I seem to recall a very handsome man, sharply dressed, brisk and decisive, who might have been a fashionable portrait painter, whereas I feel he ought to have looked more like a younger version of his friend Gordon Bottomley, the poet, generously bearded, large but loose and a bit dim, somewhat invalidish. But though I have nothing against Bottomley, I realize now that Paul Nash brought a better mind and a more accomplished technique to his work. Moreover – and this is always a lasting triumph for an artist in any field – Nash created a world of his own.

It is a world of significant and sometimes disturbing objects, a world in which persons are not to be discovered. Some of his pictures make me feel that persons have just left the scene, not ordinary people but Druid oracles, mysterious sooth-

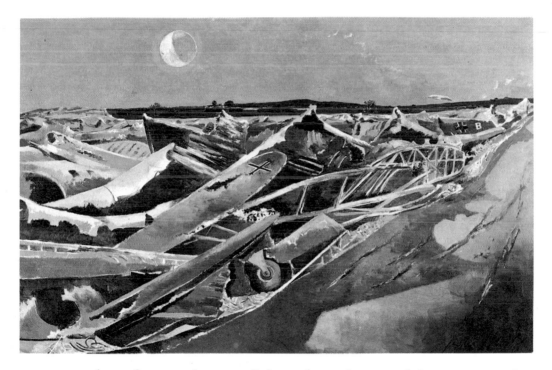

sayers, prophets of some unknown religion, who are just round the corner, turning their faces up to one of his strange moons. In other paintings it is as if Man had not yet arrived or had vanished long ago. There are severely ordered landscapes suggesting dreams that might soon turn into nightmares. We can feel at times that something like this might have happened if William Blake and John Sell Cotman had collaborated during a tour of southern England. Yet this won't do: Nash in his later years is triumphantly himself, and his comparatively early death (he was born in

49

1889 and died in 1946) must have robbed us of some superbly original work.

He was an official war artist in both giant wars. In the Second World War he was claimed first – and perhaps not very wisely – by the Air Ministry. This was hardly the man to be happy showing Spitfires and Messerschmidts in combat. Even so, compelled to choose one painting for reproduction here, I have ignored so much that delights and haunts me and have settled on one of his air-war pictures – *Totes Meer*. It was suggested to him by a dump of wrecked German aircraft near Oxford, where he was living at the time. But in spite of its being an official war artist's subject, a 'contribution to the war effort', there is to my mind a lot to be found here that comes from the artist's intensely personal vision of this life. The wreckage of aircraft brought down from the sky has been transformed with great skill into a sea – a sea of death. It is now so far from movement and life that the very waves will never rise or fall again. An instantaneous ice age might have occurred. The eye is rushed towards frozen peaks, beyond which are a normal landscape, where sane men might live a sensible life, and a horned moon. There is here no Battle of Britain celebration. What were marvels of twentieth-century technology are now so much twisted rubbish, contorted into a frozen sea of death. We are looking at – and then beyond – the end of an insane epoch. I see this as the testament of Paul Nash, painter and visionary.

De Staël: Soccer Players

Though I know the obvious facts about his life and career, he remains a mystery to me, never having set eyes on him, never having been able to question any of his close friends. His photograph suggests a tallish rather slack type, with a long nose and sharp eyes – but all this may be wrong. He belonged to an aristocratic St Petersburg family, arriving early in 1914, just in time for the world all round him to go out of its mind. While still a small child, he faced the death of both his parents, and was then taken from Poland to Brussels, where the family had friends and where he finally studied at the Royal Academy of Fine Arts, which gave him a first prize in a painting competition. He travelled widely during the 1930s, joined the Foreign Legion in September 1939 but was demobilized in 1940, when he settled down with another painter, Jeanine Tetzler, who presented him with a daughter in 1942. They worked hard but were desperately poor, and just when he began to be noticed and to sell some pictures Jeanine died, early in 1946. With some help from Braque, both a neighbour and friend, de Staël attracted more and more attention, worked closer to absolute abstraction and thereby aroused American interest. By 1951 he may be said to have arrived, with exhibitions in New York and London. In 1954 he settled himself and a wife and three children in Antibes. On 14 March 1955 he set to work on an ambitious new painting. Two days later he killed himself. But why? We are told he was suffering from nervous depression and insomnia, that he feared the loss of creative power, that he could not face some intensely personal problems. Not knowing the man I for one can't decide what to believe. He seems like a master mariner who brought his boat into harbour through the stormiest seas and then blew it up. Perhaps he carried all the way from the orphaned childhood in Poland a seed of self-destruction.

However, his art remains with us. I can't pretend to any close understanding of him as a painter. His *Notes on Painting*, extracted from letters he wrote towards the end of 1949, mean little or nothing to me, possibly because I am old and stupid. But the pictures themselves are a very different matter, to be welcomed with joy. After working in pure abstraction, always liable to become either mere decoration or messages in an unknown private language, he moved into what seems to me an altogether more fruitful area, an orchard instead of a stony formal garden. Here routine representation has vanished but we have not lost all contact with the visible world we know. We are offered traces, clues, suggestions, so that even in the boldest treatment we are not left to puzzle out an enigmatic private language. We are in a halfway house – sometimes delivered to us by way of painting knives several inches wide – that is filled with joyful discoveries: an exciting place. I will admit at once that the picture I have chosen, *Soccer Players*, was followed by far more subtle examples of his art; but this is a game I played for many years and it is a pleasure to discover it in this lofty company. Finding the game being played at night under arc lamps, he illuminated it all over again himself. *Illustration overleaf*

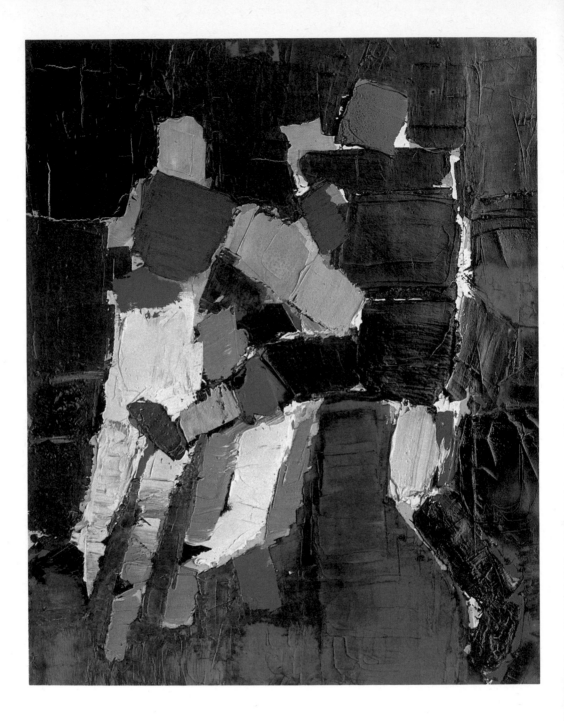

52

Delvaux: Hands

After some hesitation I have chosen this painter, Belgian and born in 1897, to represent Surrealism in this little gallery. He spent nearly forty years, working in the Post-Impressionist and Expressionist styles, before he joined, a comparatively latecomer, the Surrealists, chiefly influenced, we are told, by the earlier de'Chirico and Magritte. I have chosen Delvaux because he seems to me one of the few Surrealists who, at his best, really haunts the imagination. Does this mean that I reject on this level – a large amount of Surrealist work? It does. I feel strongly that too

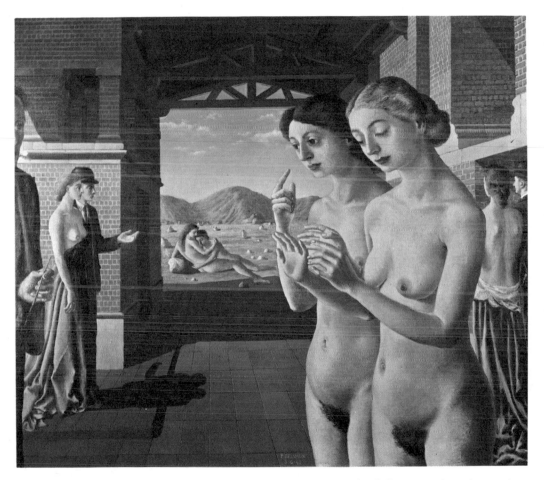

much of this painting is merely fanciful, the product of a fully conscious intention and not arriving, like a dream or an inexplicable imaginative drive, from the unconscious. (*How about having a giraffe on fire and some more limp watches?* – that kind of thing, quite consciously aimed at, for shock effect.) When Delvaux is successful – and this always involves one or more of his nude women – he creates to my mind a genuine haunting dream effect. We may remember many of our dreams, as I do, and they may not show us a single nude woman, as mine never do, but the dream

effect is there, as if Delvaux's memory or imagination has taken possession of us. And this seems to me a notable achievement.

It is not surprising that a lot of Delvaux's painting never reaches this level. For example, his pictures of skeletons – a favourite subject – seem to me to belong to the fanciful macabre rather than to true imaginative creation. (But then the skeleton as a symbol has lost most of its force long ago, if only because it has been overworked.) Even when the nudes arrive, they don't always work the magic, and I would say this is true when there appear to be processions or flocks of them. (But then Woman resists any multiplication of her, I think on all levels.) It is only fair to add, though, that now and again, without the aid of Woman, merely showing us a night train or a dark little station, Delvaux can suggest a dream atmosphere. But he reaches the full effect through his nudes. Though we find them in astonishing situations, with or near fully clothed men, wandering in midnight streets, or at rest in strange dream interiors, they are never at any time displaying themselves. They are calm and innocent, with never a hint of the lascivious. A man would have to be half-mad with lechery to see himself possessing one of them. (But then isn't it the partly clothed woman, sexually aware and artfully suggesting her charms, who arouses our desire?) These are Eve, newly arrived, an innocent symbol of potential fertility, naked because she is here as herself without any disguise. Then there is something else, perhaps a final appeal from the painter's personal life to our imagination, for in many of these pictures *we are looking at the same woman*.

To stress this final effect I have chosen for reproduction here a painting, *Hands* (1941), which for some odd reason was left out of the well-illustrated Flemish catalogue of his work. In the right foreground, holding up their hands, are two nudes, one fair, one dark, who seem to me to be the same woman. They are standing in a tiled hall with an open arch in the background. In the left foreground, only half-seen, is a fully clothed man who might be Delvaux himself. Beyond him are a woman wearing a long dress but displaying her right breast and a bowler-hatted businessman type, and there is a similar couple behind the two large nudes. Through the arch in the background we can see a naked pair embracing in a mysterious desert landscape closed in by barren mountains, all under a blue sky with some fleecy clouds. From a personal point of view (my own dreams never seem to offer great distances), the dream effect is weakened by what the arch reveals to us and I would be happier if that tiled hall were closed. Enough has been shown us to make us believe we are staring into dreamland, all symbolical no doubt, but certainly with the real outer world left far behind. And this is true memorable Surrealism.

Edna Clarke Hall: Family Group

Sheridan once told an author, who had sent him a book, that the work in question contained a great deal that was new and true. Unfortunately, Sheridan added, what was new was not true and what was true was not new. Much the same could be said of Women's Lib arguments. When they demand a reasonable equality of opportunity for women, they are only repeating what many of us, ready to call ourselves feminists, have been saying for years. So this is true but not new. What is new but wildly untrue is the Women's Lib notion that the apparent difference between men and women is due to the fact that men have imposed upon women a certain role that makes them seem different – and inferior. This is nonsense. The sexes are not inferior or superior but simply different, and they have been different for thousands and thousands of generations, lost in the mist of prehistoric ages. (Of course each sex may have its biological 'sports', exceptions proving the rule.) So a woman may uphold the sensible feminist argument by deciding to become a fully trained professional painter. But unless such women are the odd exceptions, they will disprove the further argument – celebrating their independence – by being very feminine in their painting. So you have not only a Berthe Morisot but also an unmarried Mary Cassatt, offering us tender studies of mothers and children. I considered including one of these two here, but then remembered a feminine artist much nearer home, some of whose work I have actually had in my own home for many years.

This artist is Lady Clarke Hall, who is still with us as I write this, although she was born as long ago as 1879. I realize that, for various reasons, her name will be unfamiliar to most readers, though in fact work of hers is represented in the Tate, the Victoria and Albert, the Fitzwilliam Museum, Cambridge, and some provincial galleries. She went with a scholarship to the Slade School in the great days of 1894. (Great days not because I was born that year but because the Slade was then flourishing mightily.) Four years later she married William Clarke Hall, a barrister and then a magistrate, finally knighted for his work with children. (Edna's father was the founder of the National Society for the Prevention of Cruelty to Children. As we shall see, children come into this story everywhere.) One reason why she did not become better known is that while she might keep on working, she was very much a private family person, not driven to make a fuss to catch the public eye. A further reason is that she was not an oil painter but worked more modestly in watercolours, drawings, etchings, lithographs.

If I had to find a phrase for the work of hers that I know best, I would say that it was full of an impatient tenderness. The tenderness is there because it is largely concerned with children – larking on the shore, brooding in the garden, staring at us rather defiantly out of handsome heads. Biologists tell us that females hear much better than we males do but don't see or judge space as well as we do. However, it may be that a special deep feeling for children sharpens feminine sight, enabling a

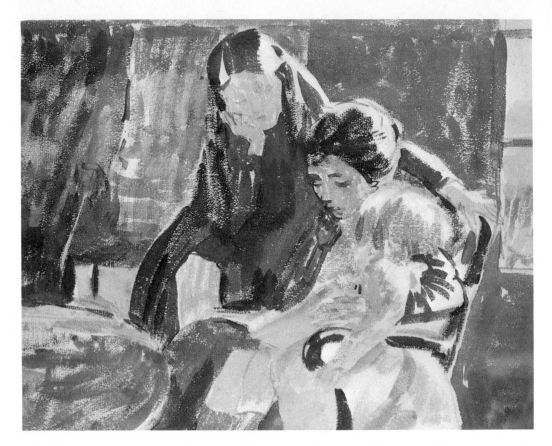

gifted woman artist to catch young children in their most characteristic and appealing postures. But such an artist has to work very quickly indeed. That is why I refer to Edna Clarke Hall's 'impatient tenderness'. When children are her theme, she is not trying to produce a leisurely highly finished work of art. By way of a drawing or a colour sketch she is trying to capture for ever a moment of tenderness in a woman's life, a glimpse of children when all unconsciously, in play or wondering and brooding, they reach and melt the heart. To prove this point I would have to offer more examples than one, and this I cannot do here. But I have lived with this work, all so deeply feminine, and I know. As it is I offer this quick but satisfying study of a mother reading to her small child, with another older child looking on. It is among other things an answer to those Women's Lib theorists who don't seem to understand that feminine means as much as masculine, that a woman, artist or no artist, has a wonderful realm of her own.

MUSIC

In a far better world than this, just as we have reproductions of paintings to illustrate the last section, we would include nice recordings to grace this Music section. Failing that – with the world getting worse, not better – what could I do? I did wonder about using simple musical notation for important themes – with the help of the American *Dictionary of Musical Themes*, which I have often made use of for my own satisfaction – but decided against it, because what I call (in a later text) 'amiable and unpedantic music lovers' often cannot read music. So I have done my best without these aids. Once again all is personal choice, indulgence of whims, with no purely vocal music selected for consideration. Great eighteenth-century masters, together with a few nineteenth-century giants, have been left out, while some smaller men have been brought in, almost petted. After all, it is that kind of book, almost an old man's hobby horse. But what follows may refresh some readers' memories or introduce others to an unfamiliar delight.

Rossini: Overtures

In that aquarium of odd fish, the lives of the composers, surely one of the oddest is Gioacchino Antonio Rossini, born in 1792, dying in 1868, after having had a fine fat slice of life. How did he contrive to write so many operas during his earlier years? How did he contrive not to write any more operas during the latter half of his life? Why non-stop and then full stop? How could he produce a lot of sorry stuff, forgotten now, but also dash off a comic masterpiece in a couple of weeks? Why did he, still in his thirties, suddenly lose all his high spirits, the *joie de vivre* that bubbles

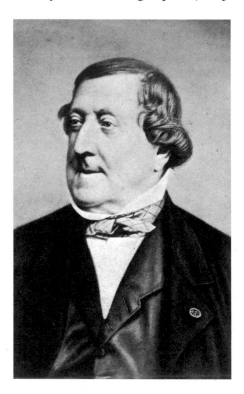

in his music, droop into neurasthenia and stage a long-running nervous breakdown? And why again, after his devoted Olympe insisted on his returning to Paris, did he recover those spirits and become the city's most entertaining host? Moreover, if we imagine that all the bubble and sparkle had long vanished from his music, then we have to explain how, as late as 1857, he was able to write those delicious trifles, intended for his Saturday musical parties, that we can hear now in Respighi's ballet, *La Boutique Fantasque* – so much vintage Rossini. Yes indeed, one of the oddest of the odd fishes!

During his worst years of depression, he ought to have had his old overtures played to him. (He had the money.) I have in mind of course the comic-opera overtures. How well they last! No matter what nervous disorders were to come, there is in these overtures a confident high-spirited young man at work and at play. They

were highly original then and still seem original now. They give me the impression of being filled with cheek and impudence. The heavy brass and the percussion section will come in with enormous pomp and ceremony, then suddenly stop, and after a moment's silence a flute or a few strings will offer us, very softly at first, some saucy little tune. It may be rudely invaded by the trombones, which are followed by a demure and lightly scored air that finally changes its character and almost frightens us with a ruthless crescendo. Oddly enough, when we consider the character of Rossini and his original audiences from Venice to Naples, there is about many of these overtures, so lavish with urgent brass and side drums, more than a hint of a military style, as if war were about to be declared. But even stronger than that is their atmosphere of bustle and hurry, as if Rossini couldn't wait, and we couldn't wait, to get at the opera itself – a further irony when so many of these operas have vanished. Finally, and above all, there sparkles and then blazes in these overtures a wonderful zest for ordinary sensual living, what the rich day brings and the night promises. It is a hell of a good time turned into music.

However, the overture to *William Tell*, with which Rossini took such care, must be considered separately. It is a far more ambitious work, a kind of small symphonic tone poem. Even the orchestra itself, during the slow opening, doesn't sound like that of the earlier overtures. I think we are entitled to call this a masterwork. The test of such a composition is that it can outlive much repetition and scores of bad performances by all manner of instruments. It seems to me that Rossini's overture to *William Tell* does this. I must have been hearing it off and on for nearly seventy years. I have just been listening to a brilliant recording of it by the Chicago Symphony Orchestra; and I enjoyed every moment of the piece. So if Rossini worked hard for once, he didn't do it in vain.

Berlioz: Symphonie Fantastique, Op. 14

Even a literary dabbler in music knows that the height and depth of Berlioz's genius are to be found in work much later than his *Symphonie Fantastique*. It is a symphony of sorts patched together, using earlier work, by a young man in a hell of a hurry. He is being driven by his daemon, his ambition, his half-crazy passion for a third-rate actress (Harriet Smithson, already the victim of malicious gossip), and, not to be ignored, the drugs he kept taking for his toothache. Almost painfully youthful, over-ambitious, originally scored for too large an orchestra, whipped together in a kind of frenzy, it ought to have been a complete mess. And indeed it contains long passages that I could do without for the rest of my life. And yet – and yet – it worked (for Liszt and Heine among other first listeners), and has worked ever since, never absent from the concert hall very long. I remember among other per-

formances one in the United Nations main hall in New York, where Munch and the Boston Symphony (it was one of their showpieces) finally fired the enthusiasm of an official audience that looked as if it could never be enthusiastic about anything.

Other men, other reasons; but in my judgment there are two reasons why something that ought to have been a mess became something like a masterpiece. First, that frenzy, hastily putting patchwork together, finally brought fire and life from this young man's unconscious. Secondly, here is one of those works of art that offer us, with complete fidelity, an epoch. It transports us at once to the Paris of 1830 and the Romantic Movement. It is earlier Balzac and Hugo and de Musset in sound.

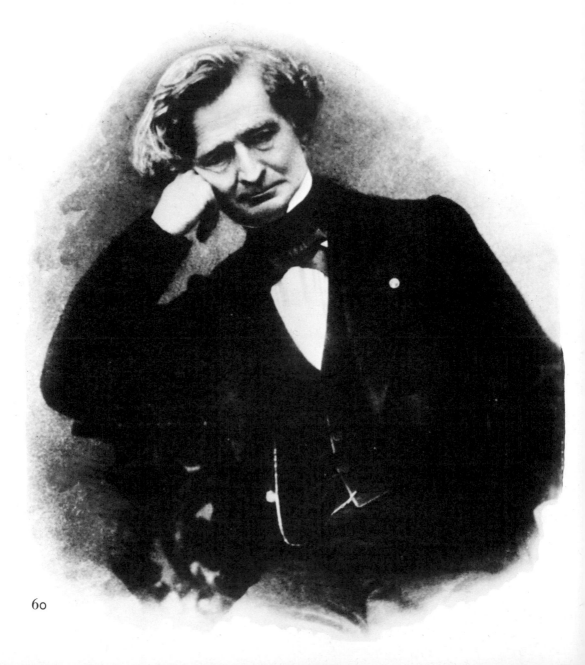

Listening to it we might be some French youngster of the 1830s sitting up late in a garret to finish a wild romance. If I am told that this is no way to listen to music, I shall retort that we are entitled to enjoy ourselves in our own fashion and, furthermore, Berlioz himself offered his first hearers more a scenario than a programme, too long to be set down here. There are many great musical works that defy the mind to wander, but this is not one of them, certainly not in its first three movements.

It is only fair to Berlioz to remember that what must have excited his early audiences – his acoustic boldness and his highly original handling of the orchestra – we now take for granted. The result is that his lapses into banality are more obvious than his originality. His first movement shows us 'the artist' seeing for the first time the woman who represents his ideal of beauty and charm, to which I for one bring two almost brutal objections. It seems to me too long for its content. Moreover, I find what we may call the Harriet *Leitmotiv* quite charming but not, as it ought to be, utterly bewitching. The ball in the second movement can be delicious in parts, but while there are some splendid woodwind passages in the rustic excursion of the third movement, it does not convince me that Berlioz is a pastoral man. And jumping now to the fifth movement, though not bored I can't accept him as a diabolical-orgy man. His frenzy came from haste, extreme youthful impatience, soaring ambition, but there is no real wild madness in him: he remains at heart a fairly conservative Frenchman, no Russian half in Asia like Musorgsky.

No, what really fascinates me – and I have heard it often enough – is by far the shortest movement of all, the fourth, the *March to the Gallows*, which he injected into his symphony from an unpublished opera. In its metallic heartlessness, its brazen feet on steps and roadways of iron, its ferocious drummings, I feel it has nothing to do with the Paris of the 1820s, when it was first composed. It is prophetic sound. It is the dreadful music, removed from all compassion, of the modern totalitarian state, marching the whole human spirit to the place of execution. And this was genius at work, warning us in time.

Schumann: Symphony No. 4 in D minor, Op. 120

In 1840 Schumann wrote to his Clara: 'In eight years twenty-two compositions are about enough; now I will write twice as much again, and then die. Sometimes I feel as if I were finding out quite new ways in music.' The following year, on her birthday the 13th of September (mine too, as it happens), he gave her a new symphony, his second. It was performed at Leipzig and was not well received. He set it on one side for years but by the spring of 1853, though his creative power was already enfeebled, he had at least revised and improved his orchestration of the work. He

called it, significantly I think, *Symphonistische Phantasie*, but it was quickly known as his Symphony No. 4 in D minor, Op. 120. Schumann could never be completely at home with any big orchestral work, yet he had not been boasting when he told Clara he was 'finding out quite new ways in music'. In this D minor he introduces us at once to what we can call two 'motto themes' that dominate, though in various guises, the whole work. It is as if he asked us to watch him planting two trees that grew and changed with magical speed. Whatever Schumann's faults may have been, this device, used both economically and forcefully, can be seen as a break-through in nineteenth-century music: a new way indeed!

For my part I am sorry that Schumann did not keep his first name for the revised work, 'Symphonic Fantasia', closer to its character than the formal title, which invites formal criticism. (His young friend Brahms was to write some *real* symphonies.) So, for instance, its continuous flow, without the usual breaks between movements, does not suggest a symphony. It is in all respects a highly original work with a character all its own. And though I have listened to it many times, I never fail to be fascinated by it – excited, charmed, moved in turn, and in places half-

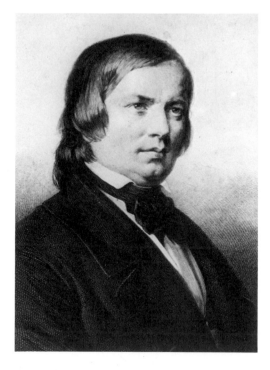

frightened by it. Here we have an essentially German Romantic revealing the strange depths of his soul – and even the close use of thematic material heightens this effect – and not simply striking a familiar attitude, making the most of a role. (Compare this work with Berlioz's *Fantastique*.) Everything down in those depths is here. There is sudden anger, almost ferocity, notably in the first and last movements. There is mystery – listen to the oboe's opening of the second movement, the

Romanze and, above all, to that marvellous introduction to the finale, in which one section after another of the orchestra suggests a stirring and awakening of the mysterious depths. And then, still a surprise, the sudden lyrical sweetness of the solo violin's arabesques in the second movement and the modified form of them in the trio of the *Scherzo*. I must admit that the *Scherzo* itself, bashing away outside the trio, is to me the least attractive part of the work, for here I feel that Schumann has forced himself out of character, pretending to enjoy a beer evening with the boys. But where in all this does the work become half-frightening, as if a friendly face had been covered by a mask?

I find this – and always have done – in the final moments of the work, when the *Presto* takes over. There is something about this movement's false endings and shattering chords that brings with it a suggestion of madness. These, with the presto upon presto, make a highly dramatic ending – and I have seen it lift an audience to a standing ovation – but I cannot escape a feeling of disquiet and growing compassion. Was all this written, more or less as it stands, as long before as 1841? When the depths had been stirred, when there might have been precognition, could there have been some foreshadowing of that madness which, after much suffering, was to destroy poor Schumann? It may be that I never listen to anything of his without having at the back of my mind some sense of his early doom, a man so gifted, so gentle and affectionate, so selflessly devoted to music in every form. However, in the D minor, he lived long enough to leave behind him a triumph of the German deeply romantic temperament.

Liszt: First Movement of the Faust Symphony

Liszt might be described as the whole of the Romantic Movement sitting at the keyboard. He reached both of its extremes. At one end, where it was half-bogus, histrionic and overheated, borrowing showmen's tricks, playing to whatever gallery was occupied by the ladies, he was there, as in his earlier international tours, when if he had not been a great pianist he would have been the king of travelling charlatans. He reached the other extreme of romanticism when he settled at Weimar where, year after year, he displayed a selfless enthusiasm for all that was beautiful and true in other men's music. (I doubt if any one man did more for nineteenth-century music, in all its variations, than Franz Liszt.) But I suspect that the musical Establishment, when considering and then dismissing him as a composer, were thinking more about those virtuoso tours, with their sale of his bathwater and those torchlight processions, than they were about his devoted years in Weimar, where he settled down to serious composition.

There is another thing. Academic musical criticism often falls into the same trap

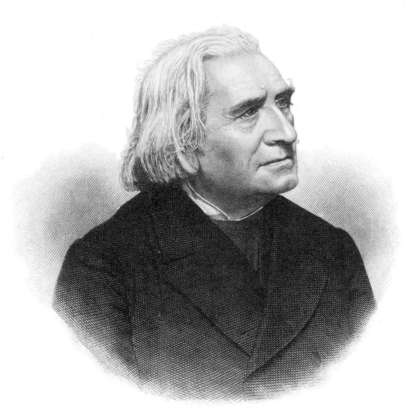

as academic literary criticism. (It comes from the examination syndrome.) It forgets that an artist must be judged by his best work. No marks should be deducted for inferior work. It can safely be ignored. (Even Shakespeare lent a hand to some shockingly bad plays, and about three-fifths of Wordsworth is mere stodge.) Now we know there are compositions of Liszt that are just about right for military bands on warm afternoons. Or in a simplified form are perfect for girls playing the piano in the gloaming. But there is another Liszt, a serious composer who is entitled to be taken seriously. So, for example, his *Faust* may not be one of the great symphonies, but it is a good symphony, an original and splendid example of its romantic kind, and well deserves our attention.

The Faust legend, especially in Goethe's version of it, haunted Romantics. It was inevitable that Liszt, like Berlioz, would not be able to resist it. And indeed there were elements in Liszt's character and music that brought him close to the Faust legend. He may not have had the same breadth and depth of scholarship and science but he had a Faustian restless questioning mind. As we know, he was susceptible to Gretchens of every shape, size, social stature. And both in her person and his work there was at least a touch of Mephistopheles, many brilliant hints of diablerie. Why not then a *Faust Symphony*? It would be programme music on a higher level, not descriptive of events but telling its tale – in a movement each for Faust, Gretchen, Mephistopheles – by the character development and clash of its themes. This he

contrived with great skill. The devil has no themes of his own but enjoys himself twisting and mocking those of his two victims. Gretchen has her own tender subjects but is also involved with Faust's characteristic themes. It is Faust's own movement, the first, that has remained my favourite.

Here Liszt set out to write a satisfying symphonic movement that would also be a portrait of Faust as we first discover him. There are themes, admirable in themselves, that suggest his restless melancholy searching, his courage in refusing to ignore his problems, his flashes of tenderness, and there is only one of them, though probably necessary to the musical development, that hardly seems to form part of the scholar's portrait – a theme that leaves the all-purpose key of E flat for a sturdily defiant bright E major, almost trumpeting some spectacular military victory. But though I cannot believe in this theme as part of the character analysis, I listen to it and enjoy it readily enough. The truth is, we have here – Faust or no Faust – a zestful, richly romantic symphonic movement that any good orchestra can bring to life. And now it is time we heard it more often in our concert halls and were not almost completely dependent upon our recordings. I could do with shouting a bravo for brave old Liszt!

Verdi: Falstaff

I can pay no greater personal tribute to Verdi's music than to declare, as I do now, that I delight in his *Falstaff*. I make this point because its libretto is based, though rather loosely, on what is to my mind one of Shakespeare's most detestable plays. Even if he set out to please the Court, he should never have written *The Merry Wives of Windsor*. To begin with, it is a wretched scamped lazy piece of playwriting, yawning in our face as it refuses to do some decent plotting. I am no Shakespeare but I swear I would never have put my name to such a botched job. But there is worse to come. The Falstaff of *Henry IV* is one of Shakespeare's greatest creations, on the same immortal level as Hamlet or Cleopatra. What would we feel if he had written a play in which Hamlet were a half-witted sot or Cleopatra an embittered prude? Yet the Falstaff of *Merry Wives*, the dupe of small-town housewives and their husbands, doomed to be mocked and pinched by all the local urchins, is just as shocking a caricature of the great original, who would have seen through everybody and everything at Windsor in half a minute. I cannot imagine why Shakespeare was content to play traitor to his own magical creative power. For my part I would rather he had been caught stealing from the box office of the Globe Theatre.

But there it is. In *Falstaff*, Verdi's opera, we are back to the same old nonsense. It ought to be intolerable, and yet it isn't, being altogether delightful. From some

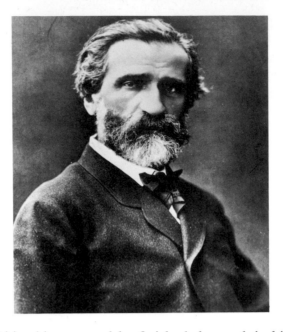

hidden orchard of his old age – and he finished the work in his eightieth year – Verdi plucked the most delicious fruit of all. And if I love this music, it is for a variety of good reasons. I must admit at once that I am not an opera man. A great deal of it seems to me too silly to be endured, let alone applauded. Suffering heroines capable of prolonged vocal gymnastics leave me unsympathetic. I regard with suspicion heroic tenors who keep telling us for more than ten minutes how they must cope with a crisis at once. I can leave for ever those rollicking choruses quaffing nothing out of pasteboard tankards. And so on and so on, with boring recitatives and favourite numbers flogged to death.

Anything like this has vanished from *Falstaff*. True, not for the first time. It cannot be found in Wagner's *Meistersinger*, a kind of comic opera and a favourite of mine. Even so, compared with *Falstaff* Wagner's opus seems to last for hours and hours and weigh a thousand tons. In Verdi's, by an old man's miracle, everything moves swiftly and deliciously. Yet we don't seem to be listening to so much light music, the stuff of operetta. Voices or orchestra, which is beautifully handled, leap to do justice to every humorous or dramatic moment. Themes that would have been repeated to exhaustion in earlier operas of Verdi's now come and go like golden leaves in the wind, tantalizing the memory. Falstaff may be a fat imbecile here in Windsor, but what a varied wealth of music is allotted to him, from his bellowings to his entrancing reminiscences of his life as a slender young page! What a duet that is between him and the disguised Ford and how it soars above the thin unbelievable plot! How the merely excited chatter of the women is lifted into some high silvery realm of sound! And how the sheer charity of the music softens and so reconciles us to the gross barbarities of the final scene in the Park. What an astounding work – and what a man!

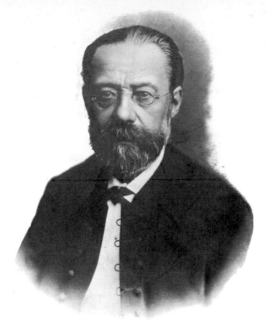

Smetana: Piano Trio in G minor, Op. 15

This is not one of the great trios for piano, violin, 'cello, no *Archduke*, yet I have a special affection for it, as I shall explain later. It is a comparatively early work, as the Opus number suggests, written in 1855 when Bedrich Smetana was still teaching in Prague, and eleven years before he produced his famous comic opera, *The Bartered Bride*. The trio is a lament over the early death of his small daughter, and is dedicated to her memory. Though Smetana had visited Liszt in Weimar and was considerably influenced by him, this work has no obvious programme and we are left to guess at the experiences that shaped and coloured its music. From the very opening of the first movement, filled with chromatic descents (largely favouring the 'cello), it has always seemed to me sharply poignant. Both the second and third movements, though quite different, are haunted by the lost child, now still scampering around, now cold and lifeless; and each movement has its own tune, tenderly playful in the second, impassioned in the third. In the very last moments of the piece, when life is hurrying on again it is interrupted by an exclamation. No *Archduke*, I repeat – but then would a little girl want one? – but a work of great tenderness and some depth.

So far so good. But now I must confess that I have an attitude towards this trio – indeed, a relationship with it – I fail to understand. I first heard it just after the Second World War when I was visiting Prague and was engaged to dine at the British Embassy – up there, on top of the hill. One of the Embassy staff was musical, knew I was fond of music, and so brought in a fine trio, which included one of the country's best 'cellists. So they played the Smetana. The setting was unusual and rather romantic, certainly; but I can see no reason why I should remain half-

bewitched by it. Then for ten years I ran an annual three-night chamber-music festival at my house in the Isle of Wight. With the musicians staying in the house, I was able to enjoy several performances of the Smetana. (But I must have had score parts – and if I had, then what has become of them? But then what has become of all manner of things?) And for some years now I have had it on a record.

But why the special and rather intimate attitude towards or relationship with this particular trio? Did I ever lose a little daughter? No – thank God! – I didn't. So we can ignore any deeply personal appeal of the subject. Then was there some performance of the trio, in Prague or elsewhere, closely associated with some crisis, major or minor, in my personal life? There was not. Very well then, what is the matter with me? Why should there be something strangely significant, haunting the memory, about this particular piece of music, tuneful and moving but no blazing masterpiece? I don't know. There is a great deal about myself and about life in general that I don't know. Am I linked up to somebody who knew Smetana in 1855? Will its significance belong to the future, not the past, so that the fatal heart attack will arrive in the middle of the third movement? Am I? Will it? But why go on? I don't know and neither do you.

However, as I write this, a close and generous friend has just asked me what I want to hear at the musical evening party she is arranging for me. I told her that if she had no objection, then I wanted the Schubert Trio in B flat and the Smetana Trio in G minor.

Bruckner: Scherzo of Symphony No. 7 in E

I had a slight amiable acquaintance with Bruno Walter, and one night, talking after one of his New York concerts, I asked him why he never tried some Elgar. I wasn't accusing him; it was just a mild enquiry. Not without a touch of embarrassment he murmured something about Elgar's music not being sufficiently concentrated. I stared at him – not rudely, I trust, for this was a delightful old man; but I am never quite sure about my stares – and said with an upward inflection, 'Bruckner?' But then somebody joined us, and that was that. Well, many of us have found ourselves up on the mountain or into the church with Bruckner, and have also been lured by him into featureless and boring meadows below. However, we are entitled to consider the Seventh Symphony a very special work. It has some odd features. It is half in this world and half in some other world, not easily named – except by the devout Bruckner.

To be this-worldly for a moment, it is worth mentioning that this Seventh brought Bruckner his first success as a symphonic composer. It rang a bell that has been ringing ever since 1883. But now for the oddities. It was the *Scherzo* that he

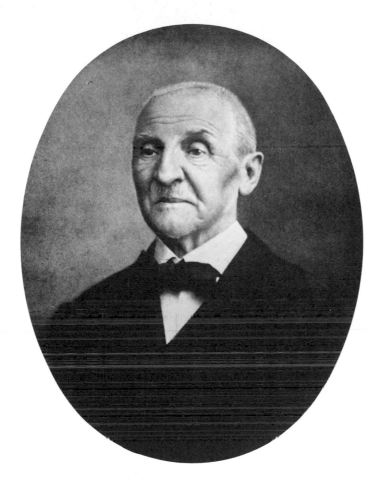

sketched first, presumably before he knew what the other three movements would proclaim. Now we have to remember that against all reasonable odds this pious and naïve little organist, Anton Bruckner, who trembled before a woman, had a passion for the music of that super-erotic blazing cad of genius, Wagner, going to the length of borrowing for the score of this symphony Wagner's peculiar tubas. (But I don't mean of course that he had to be lent the actual instruments.) When he came to the first movement, he declared that the theme that began it was bestowed upon him by a dream. If this is odd what happened while he was writing the formidable and searching *Adagio* was odder still. When he began this movement he had a premonition of Wagner's death and news of it arrived before he had finished the movement. Another smaller oddity is that at the climax he called to his aid, against all symphonic tradition, a clash of cymbals and the shrilling of the triangle, and, I believe, to this day it is left to the discretion of the conductor whether or no he makes use of this extra and perhaps rather vulgar percussion. When the score of this powerful work was completed, with the fourth movement joining hands with the first, it did not find its way to Vienna – and Bruckner was nothing if not an Austrian composer – but was pounced upon by Nikisch, wildly enthusiastic, who gave it its

first performance in Leipzig at the end of 1883. A small personal point – I find it equally odd that I should remember seeing and hearing Nikisch conduct in my own youth.

I am not trying to take anything away from this deeply felt symphony if I say that I play the *Scherzo* far more often than I do the other three movements. It is one of those favourite bits put on to fill a few minutes or to give a tasting sample of the record-player. It never seems to me typical Bruckner at all. It is too vivid, ingenious, dramatic. Sometimes it seems a dramatization in sound of the crisis of belief and unbelief that haunted these years. The soft drumming and the sinister rhythmical muttering of the strings represent the unbelievers, with their discontent, their sneers and gibes, while the trumpets break in to rise and proclaim their faith, the positive denying the negative. (The trio, a thematic reversal, shows us the converted unbelievers, calm at last, enjoying a quiet song.) And if all this is too fanciful, then let us assume that while he was engaged on the preliminary sketch of this *Scherzo* he had a few drinks and then, staring out of the window, saw a very pretty peasant girl stop, look up, and smile. Whatever happened, while I am the enemy of all those forced jolly scherzos, I remain an admiring and affectionate friend of this one, lighting up, even with its sinister undertones, the grave length of the Seventh Symphony.

Brahms: Clarinet Quintet in B minor, Op. 115

If this work is not a masterpiece, then I have been in need of a deaf aid for the last fifty-five years. And let us admit our debt to Richard Mühlfeld, who, though one of the Saxe-Meiningen violinists, decided to teach himself to play the clarinet. (It is more than likely that his self-instruction brought an increased range and power to the instrument.) In 1891, Brahms, as one of the guests of the Duke of Saxe-Meiningen, fell under the spell of Mühlfeld's clarinet, and had several private sessions with him, to learn all he could about the instrument. The result was the Clarinet Trio and then the glorious Quintet, which he described, in his familiar grumpy and debunking style, as 'a far greater folly' even than the Trio.

The remark is typical of Brahms in his lifelong role as the oafish provincial, ready to be rude in all companies, refusing to adopt the other role of the smiling smooth celebrity. It is that of a man who while pretending to be too old is somewhere deep inside still too young. This is the Brahms who could not walk in step with a woman, either putting them on pedestals or regarding them with contempt as available sexual objects, so many goddesses or easy-going chambermaids. But this Johannes Brahms, the too-German German, was always performing a charade. His real life went into his music.

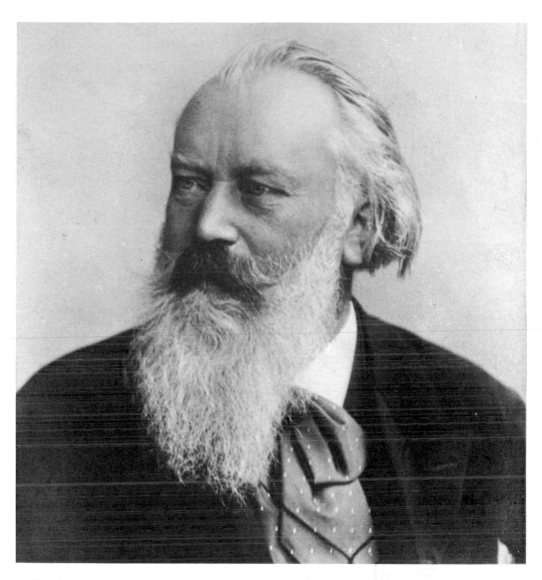

He was only fifty-eight when he wrote the Clarinet Quintet. But he had no more than half a dozen years to live. It is a work that comes out of the sunset of his music. Behind its noble melancholy there is something close to heartbreak. It ends as it began except that darkness is deepening round the sunset. All its themes, from the opening *Allegro* through the wonderful *Adagio* to the variations of the finale seem to me entrancing, with the autumnal beauty that belongs to so much of Brahms. If so minded we can read for hours and hours about the bridge that he built between the classic and the romantic and his architectural complexities, all without a word being said about this beauty, this entrancing quality of his subjects, the lovely song that he is singing. Yet it is not hard to imagine some intellectual Victorian organist who might have solved most of Brahms' technical problems and yet remained obscure because nothing he wrote enraptured the ear.

Again, the relation between the instruments in this quintet is exquisite. After hearing it a great many times, both live and in recordings, I sometimes fancy I am listening to a duet between the masculine and feminine sides of Brahms's nature, the strings being male and the bubbling wilful clarinet, moving from playfulness to anguish, being altogether female – perhaps expressing, in Jungian terms, the relation between his consciousness and his *anima*. And I make no apology for these fancies or thoughts: after all we are considering here one of the masterpieces of chamber music.

For live performances I go back to when Charles Draper was playing the clarinet with the London String Quartet. But I am able to remember – with I think justifiable pride – that the finest performance of this noble work I ever heard was under my own roof. When I lived in the Isle of Wight, I had a rather large entrance hall, which with its stairs and gallery would seat about 150 people, so that I was able to organize my chamber-music festival that ran for three nights every September, with the musicians as house guests. It went on for ten years, but it was in its first year that the Griller played the Quintet with Frederick (Jack) Thurston, already a sick man – I think he died the following year – but still producing the most exquisite sound from his clarinet. That was the best performance of the work I ever heard or ever will hear this side of Paradise.

One tiny ghost of a link with Brahms may interest a few readers. I am not remembering now the many times I stared at the broad back of his friend, Hans Richter, conducting the old Hallé. It is a pianist I am recalling. One of Brahms's daft prejudices was a detestation of England and the English – which his close friend Joachim could do nothing to modify – but all the same he was able to praise enthusiastically one of Clara Schumann's best pupils, the English Leonard Borwick. And it must have been in 1920 or 1921, when I was up at Cambridge, that I heard Borwick play for a couple of hours in a private house, giving what amounted to an intimate recital. And I think Brahms would have been pleased – even while pretending hard not to be.

Bizet: Symphony in C

I have long felt a certain tenderness for Bizet. This is not unreasonable. First, he had the most damnable bad luck. Dying at thirty-six, when better medical attention might easily have saved him, his masterpiece *Carmen* was still being regarded as a partial failure when in fact it soon became a triumphant success and has remained one ever since, being performed over and over again throughout the world. Secondly, there is something appealing about his odd temperament, his confusion about himself, his naïveté illuminated by odd flashes of insight. Thirdly, although

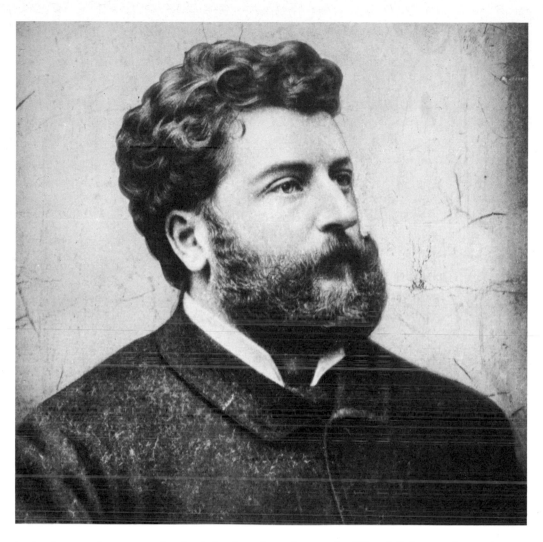

he had more than a touch of original genius, the musical Establishment have always been rather stuffy about him, as if the superb music of his last years was a kind of confidence trick. Moreover, I can listen with pleasure and genuine admiration to this teenage symphony of his, though by some mischance I have never heard it in a concert hall and have to depend upon the recording made by Beecham with the French radio orchestra, a recording I recommend to all amiable and unpedantic lovers of music.

It was composed while Bizet was still a student. He wrote it in a month, just after arriving at his seventeenth birthday. This was late in 1855. It reappeared, after having been completely forgotten, as late as 1933, when the French composer, Reynaldo Hahn, gave a lot of Bizet manuscript scores to the Paris Conservatoire. It was performed for the first time by Weingartner at Basle in 1935. Noel Goodwin tells us that 'It was introduced in London later the same year, and quickly became a favourite with listeners in many parts of the world.' That's as may be but I never

seemed to be around when it was on the programme. However, I could afford to wait until Weingartner was supplanted by Beecham. (I remember meeting Weingartner at a musical party in London, but this must have been a few years before the Bizet symphony came his way.) This lively teenage venture was Tommy Beecham's meat, done by him to a turn.

Nobody is going to pretend that with this opus by a seventeen-year-old we are in the company of Beethoven and Brahms, Bruckner and Mahler. But it is good listening, and I venture to suggest it provides us with a better half hour than most of the more ambitious and ponderous works of his much-esteemed French elders, not excluding his mentor, Gounod. After all, there can be light symphonic listening as well as heavy symphonic listening. And if this teenager can pull it off, then why not? If Beecham thought he did, then he is good enough for me.

The first and fourth movements, *Allegro vivo* and *Allegro vivace*, even though no examples of symphonic development, are good to hear, being as neat as a pin and crisp as a biscuit. I care less about the third movement, another *Allegro vivace*, because its hunting-chorus subject is one of those forced scherzo themes that older and better composers have found among their failures. But the second movement, the *Adagio*, is a little triumph, with its unexpected semi-oriental theme for the oboe. And this theme, together with some flashes here and there in the finale, makes me wonder if some critics have not been all wrong about Bizet. With *L'Arlésienne* and *Carmen* chiefly in mind, they suggest a Bizet who laboured to work up 'local colour', almost as if he had been deep in research in Provence and Spain. But as we listen to this teenage symphony we can catch a glimpse of a Bizet who as he matured and gained confidence discovered in himself a deep vein of the brilliantly exotic, a natural sympathy with what was at once impassioned and alien, well away from the main stream of mid-century French composition. I am not saying he was alone in this, because something like it can be found in all the arts at that time in France. But it was poor Bizet, dying too early, who captured most listeners – and still does.

Tchaikovsky: Symphony No. 4 in F minor, Op. 36

We probably owe Tchaikovsky's Fourth Symphony to a character hardly to be encountered outside nineteenth-century Russia. She was Nadezhda Filaretovna von Meck, a rich widow with eleven children who lived in the country and devoted herself to reading and music. Her private violinist knew Tchaikovsky, and told her about the composer's struggles, privations, nerves and genius, with the Russian result that she offered Tchaikovsky an annual pension of 6,000 roubles, so that he could travel, compose, and not suffer so much. They never set eyes on each other

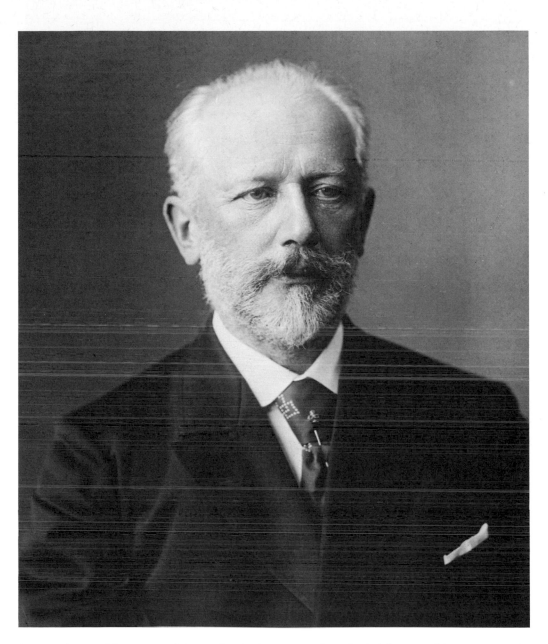

but exchanged innumerable perfervid letters. (The whole history of Russian music during its great age consisted of events that could have happened nowhere else.) With his 6,000 roubles Tchaikovsky set off happily on his travels, and composed his Fourth Symphony, which he dedicated, as well he might, to Madame von Meck. As severer critics have suggested, it may be closer to a melodious hotchpotch than to a true symphony, but no matter, it is a highly enjoyable work and I for one prefer it to the Fifth and Sixth – and, God knows, I have heard all three often enough, often too when I had gone to hear something else. Even so, I have always been ready for the Fourth, which seems to me to provide splendid musical entertain-

ment, we might almost say fun and games, in spite of that large helping of fate and suffering in the first movement. (I suspect he was enjoying it, as he wasn't later.) I agree that as examples of Tchaikovsky's melodic genius, we would be better off with *Eugene Onegin, The Nutcracker Suite* or the ballets, but then I am determined to register my enjoyment of one of his symphonies, if only to annoy the more pedantic musicologists.

Certainly the first movement is too long, but then he was probably showing Madame von Meck from what dark fate and suffering she had rescued him, so justifying her 6,000 roubles and his trip to Switzerland. He doesn't quite convince me that his bleeding heart was bared in this movement. There are some moments in the finale of the Sixth Symphony that really do drip with misery, so many tears splashing from the reddened nose of an orphaned girl, but here in the Fourth's first movement we are having a fairly good time with the orchestra so busy, the brass with fate, strings and woodwind suffering away. The second movement is just nice tuneful Tchaikovsky, which might have turned up anywhere with cheerfulness breaking in. The third, *Scherzo*, is very ingenious and a great little pet of mine, with the pizzicato of the strings, then the woodwind being folksy, then the brass with a kind of midgets' night march, and then finally – glory be! – all of them artfully and triumphantly combining.

But the last movement, with its tremendous opening bash, is really my favourite. Asked years ago by BBC radio to suggest a present they could offer me – on radio of course, no wine or cigars – I said they might allow me to conduct their Symphony Orchestra in this finale of the Fourth Symphony. (But Lord knows what chaos would have arrived if they had been silly enough to agree!) There was one occasion when I had more than enough of this splendid movement. I was seated close to an enormous orchestra in Moscow – I will swear it had at least twelve double basses – and the applause was so long and loud that we had the whole movement over again, with that opening bash more tremendous than ever and merry hell knocked out of what had once been a modest folk song, *In the field there stands a birch tree*, so that it was as if a forest of birch trees was joining in the assault on the Winter Palace. But I still enjoy that last movement, and indeed can still listen with pleasure to the whole symphony that probably isn't a symphony. So here I stand – to be counted.

Dvořák: Symphony No. 7 in D minor, Op. 70

To avoid obvious confusion I ought to add that the above symphony was often known as No. 2 and that the numbering of Dvořák's symphonies can be turned into quite a large and bewildering subject, best left alone. Let us consider in its place the subject of Dvořák's reputation. I don't know what other people feel – and I imagine there must be plenty of us – but I am tired of music critics and musicologists being

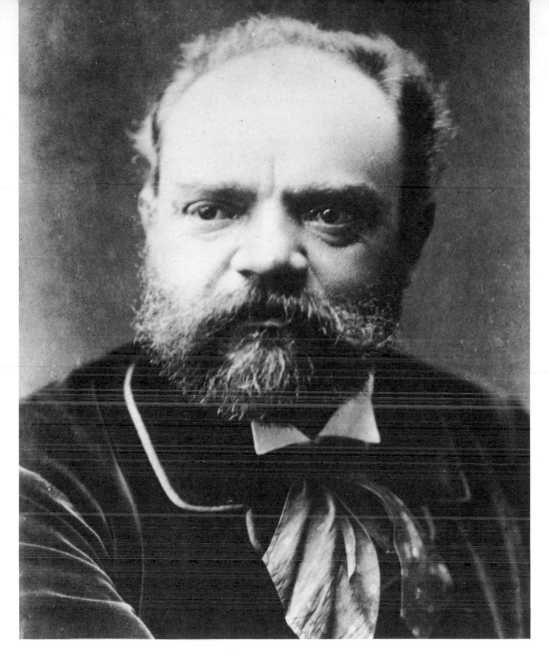

condescending about Dvořák, for whose work and personality I for one combine admiration with warm affection. We read too much about his being a peasant, as if we were dipping into the *Almanach de Gotha* or the *Social Register*. Dvořák was born a peasant, and in many respects he remained a peasant till the day he died. (Take a look at the photograph – the blunt width of the bearded face and the spread of nose, every feature, except the capacious forehead, to be found in every Central European market square.) But this happened to be a peasant of genius. Then there is this insistence on his use of folk tunes. Certainly he spent much of his life in his native Bohemia, which appears to have hummed with folk tunes day and night, and Dvořák made use of them when he felt like doing so, usually making no secret of the

fact. But neither at home nor in America was he going around copying every popular tune that caught his fancy. He had no need to go in search of melodic material: that broad head of his was a storehouse of it. Like Schubert, whenever he needed a splendid tune at short notice, he had one. He was like a peasant in a fairy tale.

I know and delight in much of Dvořák's chamber music – it may be carelessly contrived at times but it has a freshness missing from the work of more thoughtful masters – and I have always taken a particular pleasure in his 'cello concerto, a beauty. But then I can easily imagine Dvořák, a smile on his broad face, arriving with Bohemian beer, roast goose and dumplings, and with them another feast – of melody. However, I have deliberately chosen his D minor symphony because some readers may not know this magnificent work and may thank me one day for calling their attention to it. Let me add at once that in my mind it far outshines the all-too-familiar New World symphony. It is altogether – and the alliteration is accidental – bigger, bolder and more beautiful. The faintest hint of condescension must go now. The critics can't give Dvořák any little pats on the back for this work, if only because in it he is soaring high above them. Here is a major contribution to nineteenth-century symphonic music. It puts the Bohemian peasant, who spent half his adult life making ends meet, up among the masters.

The size and force of this work never fail to surprise me. There are giants moving around in its first and fourth movements. In more than one place, with the brass going deeper and deeper, the earth opens to reveal startling abysses. We expect to hear – and we get them in full measure – those exquisite little melodies (ending so often with flutes trailing away into the remote blue) so characteristic of Dvořák. The slow movement is filled with them; it is a little world of melting song. The main theme of the scherzo makes no great appeal to me, but the Arcadian trio is magical. Even so, it is the weight and challenge of the first movement and the tremendous finale that I listen to still with astonishment: this is a Dvořák eight feet tall.

A postscript. I have heard the London Symphony Orchestra play this symphony on both sides of the world, and when I listen to it now I am using the L.S.O. recording of it with the late and much-lamented Istvan Kertesz. (He died, still young, in a drowning accident.) I may be biased here but it does seem to me that this noble and infinitely varied work has found the right orchestra, delicate at one moment, impassioned and stormy at the next.

Fauré: Piano Quartet No. 1 in C minor

Gabriel Fauré was born in 1845 and died in 1924. These dates suggest a good long life, but when I read about Fauré I can't help feeling he lived even longer than that. This is because he grew up in one musical world and survived to remain, immensely

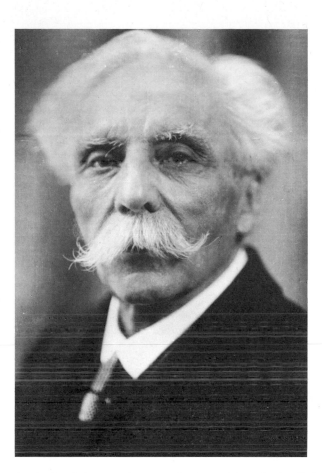

distinguished and admired, in another musical world entirely different: at one end are Berlioz and Liszt and at the other Stravinsky and Schoenberg. French artists rarely revere their elders; there is nearly always a great deal of shrugging and face-pulling; but Fauré was an exception, very much the revered elder. Some of this was due to his fine personality and the quality of his music. But there was also the feeling that he was essentially French, an exquisite product of Gallic culture, a château-bottled artist of rare vintage, defying the demands of the export trade. He is one of those composers, like Bruckner in Austria or Elgar in England, who seem magical to their fellow countrymen and boring to foreigners.

I can't pretend to have any acquaintance with Fauré's later work, said to offer the very essence of his rare quality. I gather that it is severely bare, making little or no appeal to the emotions, avoiding any hint of the voluptuous, no nonsense anywhere, fastidiously and indeed purely classical. Such music was never intended for me. The truth is, I have a coarse palate. I enjoy all the things that Fauré left out. I don't want my music stripped bare but all dressed up, preferably going somewhere very pleasant. If it turns emotional, very well it turns emotional, though it hasn't to become neurotic for me. If a man is convinced that life is disagreeable, ugly, cruel, not worth living, then I don't think he should compose music. Again, if a composer

is so aristocratic and fastidious that only a tiny group of people are fit to listen to him, then it is all right with me if he shows me the door out. While he is carving thin slices of cold chicken breast, I am on my way outside to a juicy meat and rich sauces. One advantage of not having a fastidious palate is that a world of varied flavours is open to you. If the emotional and the voluptuous don't make you wince, then the enticing programme can be very long and wide indeed. You can cry 'Open Sesame' to the nearest good orchestra or chamber ensemble.

Moreover, you can do this to Fauré himself if you ignore his very late works. My choice here is the earlier of the two piano quartets, No. 1 in C minor, written in 1879 when Fauré was already thirty-four. It is a great favourite of mine, enjoyed both on records and on actual performances in my own house. (But then so is No. 2.) How the first movement sweeps on, its two themes like great birds swooping and rising! With what delicacy the second movement picks its way above the pizzicato! How solemn, noble and tender the *Adagio* third movement is! And surely the fourth movement, with its three compelling subjects, is best of all! This work is nearly a hundred years old and yet sounds quite fresh, newly made, to my ear. Whatever may be said about Fauré's feeling for a classical style, this is a romantic piece. But it belongs to a romanticism without brandy, cloaks and daggers, midnight assignations, love potions. This is a romantic who will keep his appointments and be on time for dinner. Even so, there is in this Piano Quartet one glimpse after another of a wild beauty, never allowed to stay and clot everything but always moving and turning, escaping our grasp. But now and then, we might say, her hair blows across our faces.

Elgar: Symphony No. 1 in A flat, Op. 55

I began to admire Elgar as soon as I started to listen to serious music – say about sixty-five years ago. It was not long before I came to love this man's work. If I were discussing it with musical Americans they would explain how this happened: Elgar's music is very English and as I am probably very English myself – well then, some such love affair must have been inevitable. But there may be some confusion here. Elgar is not superficially English, unlike some younger men who were fascinated by folk tunes and a 'hey-nonny-nonny' atmosphere. (Pompous marches? Similar compositions have come from all over Europe.) No, Elgar was never in his work superficially English, but both as a composer and as a man he was *deeply* English, something not easily understood in New York, Chicago, Los Angeles. He gave himself time to write out of this deep Englishness. (Here I recommend without reserve Neville Cardus's chapter on Elgar in his *Ten Composers*.) He had time because he is one of the few major composers who had to educate himself musically,

attending no Royal College or Academy. This explains why he was already middle-aged before he began creating masterpieces in unusually rapid succession. His feeling for and sense of music were a natural gift, but effective and indeed brilliant orchestration has to be learned, in Elgar's case slowly but surely. But once he had the technical resources, as he declared in public, he put the whole of himself into his music, keeping nothing back.

What is this deep Englishness that enchants fellow countrymen like myself? It is easy for us to recognize and enjoy but hard to explain. We are at heart an imaginative people – it is our dramatist-poets and actors who have conquered the world, not our shopkeepers – and we applaud bold dramatic statements that challenge the imagination, like those of Churchill in 1940; but behind them we welcome a brooding tenderness, and behind or below that still a dreamy melancholy. (Foreign visitors in the seventeenth and eighteenth centuries noted this, before the Industrial Revolution and the Empire buried it a little deeper.) All Elgar's more important music reflects and expresses, boldly or exquisitely, these characteristics. Here I must add that too much has been made of him as a complacent Edwardian Imperialist. This belongs to his persona, not to the personality discovered in his serious music. He may be, as some sniffers have told us, a bourgeois composer, but

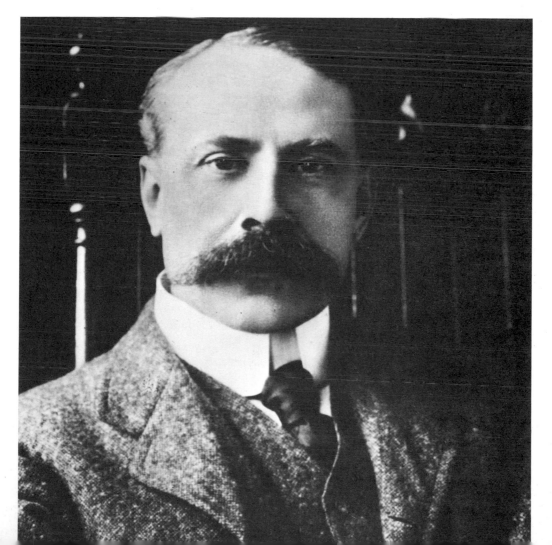

that is all right with me because I am a bourgeois listener, who happens to believe that most European art of any size has come from its middle class. Try a revolution and destroy the middle class, the arts vanish behind the red flags and the gunfire.

If I had been asked down the years to offer a single test sample of Elgar's music, my choice would never have been the same. At one time it might have been the *Enigma*, probably without its blatant finale. Again, it could have been one of the two concertos. Again, the Second Symphony. More likely still, *Falstaff*, which Elgar once told me was his own favourite work; but though I can still enjoy it there is too much Hal and not enough genuine Falstaff in it to win my vote. The Introduction and Allegro for Strings is a gem still sparkling away, but it is not a big enough work and we miss Elgar's dazzling orchestration. So now, compelling myself reluctantly to choose one piece, I settle for the First Symphony, which had its first performance, in Manchester under Richter, at the end of 1908. (Elgar had probably spent about ten years brooding over it.) To begin with, after a grandly spacious opening it offers us immense and delectable variety, with the grand first subject always somewhere round the corner until at last it takes command again. Moreover, its third movement seems to me one of the great adagios of all time. I don't know how often I have listened to it, either in a concert hall or through recordings, but its dying fall – with those muted trombones a stroke of genius – still clutches at my heart. My American friends can like it or lump it, but I find in this work the bold dramatic statements, the brooding tenderness, the underlying dreamy melancholy, of deep Englishness in all its varying moods. Out of this music, to me who know them well, the Malvern Hills rise in sunlight, in mist and dusk, in starry silence, in full sunlight again, in the vanishing days and nights of a lost summertime. And from blaring brass down to muted strings, this is what the inspired Elgar is telling me.

Mahler: Das Lied von der Erde, 'Der Abschied'

Asking forgiveness of my friend, Neville Cardus, who loved Mahler and wrote so superbly well about him, I could put it like this. There are times when I think about Mahler and I see a man with a forehead like a cliff and burning coals for eyes who arrives to talk about himself for hours and hours. This talk ranges far and wide, from banalities about his childhood and bands in the park to sudden mysterious utterances that seem to pierce the enigmas of human destiny. But he goes on too long about himself; there is too much of it; and too often when he raises me up he drops me with a bump. And although this is clearly a remarkable man, I wish he would go away and leave me alone. He is, as people used to say, 'a bit much'.

However, this is not for me the Mahler who wrote *Das Lied von der Erde*, that

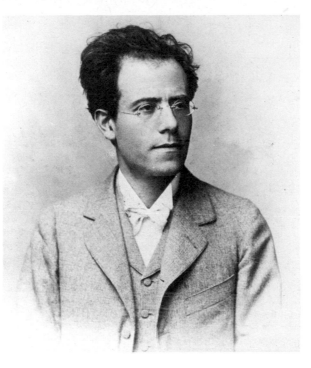

strange and compelling masterpiece. Apparently it is a setting of a German translation of some Chinese poems, but here my mind is blank. I know nothing about the
German poet or the Chinese poet or poets. I do happen to know that Gustav
Mahler was a Jew who became a Catholic convert. But in this work I find neither
the unconverted nor the converted Mahler – nor for that matter the man who
rushes in to talk about himself. He is, so to speak, somebody else who is now somewhere else. I don't say he is in Ancient China or anywhere near it, but he is neither
Jew nor Catholic but some kind of pagan – and, if we descend to a brutally frank
diagnosis, a pagan who is already facing the heart failure, with its occasional
moments of fading away, that all too soon will kill him. Nevertheless, the verbal
Leitmotif of the whole work, 'Dunkel ist das Leben, ist der Tod!' (Life is dark, and
so is Death), seems to be rather misleading, for until the final movement, though
melancholy may come creeping in, life in this world is not dark but sparkles and
gleams. After all it is with the fading of all this light and beauty that the final and far
longest movement, 'Der Abschied', is concerned.

'In conception and art,' Cardus writes, 'the "Abschied" is amongst the unique
things of music'; and upon this I would not cast the smallest shadow of doubt.
Over and above its highly original development and intricate orchestration, we can
discover in it various marks of genius. For example, take its length. It is a long
movement, demanding nearly half the entire work, yet if it captures us completely
it seems even longer than it really is. (Clearly I have banished boredom here.) Some
magical element in the design and the score seems to prolong, widen and deepen,
the fading of the light, the farewell, the resignation, the whispered acceptance: not

83

minutes but months, perhaps years, are passing. Another stroke of genius was to award this movement not only to a female voice – with Woman herself crying farewell to the feminine principle of Nature – but also to give it to a contralto's richness and depth, earthier than a soprano's birdlike lyricism. A final touch of genius is in Mahler's decision to avoid any traffic with pathos, in what would have seemed to most composers a most promising pathetic situation. (The danger here is that the creator, busy being expansive, seems to us to be enjoying himself, like Dickens with his poor little Paul Dombey.) Mahler is not enjoying himself; he is quietly, stealthily, dissolving the world of our senses; he is announcing in last whispers the final separation of the dying human spirit. You may not believe in this account of our end – I don't myself, for reasons I have given elsewhere – but while the music goes murmuring into silence, then awe and wonder and an unforced heartbreak remain with you. We live, you feel again, in a mystery.

When I want to listen yet again to this strange symphony of earth and spirit, I return to the old recording made by Bruno Walter and the Vienna Philharmonic with Kathleen Ferrier, whose face, raised in song, appears on the record's sleeve, still looking young and beautiful and ready to sing for a hundred years. The mystery in which we live seems bitter and dark with doom here. Mahler himself never lived long enough to hear this work being performed. Kathleen Ferrier had already been invaded by the disease that would carry her away. Good Bruno Walter has gone now. Only the Vienna Philharmonic remains with us. But no, not true, for the music – yes, all the music – is still here, so that we can place ourselves again under the spell of the *Song of the Earth* and its long farewell, 'Abschied'. As I did this very morning.

Debussy : Orchestral Suite, La Mer

Debussy, we are told, completed *La Mer* during the summer of 1905 at Eastbourne. If this seems vaguely comical, we have to remember that there have been terrible seas and death-dealing wrecks not too far from Eastbourne. At this time Debussy had probably reached the summit of his power as a composer. True, he was only in his earlier forties, but then he died at fifty-six and after a long wasting sickness too. How *La Mer* compares with his other major works, I am not competent to decide, and anyhow it is the kind of question that never seems to me very important. (We are now so competitive-minded that we make our artists compete against themselves.) We know there was a sailor element and great feeling for the sea in Debussy, though he never undertook long voyages, chiefly because, I imagine, he had to keep busy at home to earn any sort of a living. Here I was more fortunate than he was, for during the 1920s and 1930s I made several long voyages

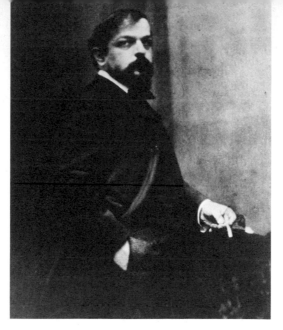

in cargo vessels. I mention this because in such circumstances there are times when you can feel almost alone with the sea, and so you come close to what Debussy was getting at in *La Mer*.

Most music that has brought in the sea has really also brought in sailors and almost, one might add, shipping lines and the captain's table. It gives us a humanized ocean, not the huge wild thing itself. Debussy's three 'symphonic sketches' are very different. In them the sea is on its own, not a background for a cruise. It is the ancient thing that will smile at us on Tuesday and then on Wednesday will smash everything and drown us. Anybody who associates Debussy's music with delicate wispy or toylike creations will be astonished by *La Mer*. There are passages in it that seem to weigh tons and tons and are about to overwhelm us. This work, like the ocean itself, can move from what is harmless and indeed beguiling to what is terrifying. Nobody else, to the best of my knowledge, has given us the fascinating or fearsome *otherness* of the sea as Debussy does in this extraordinary work.

The three movements, as I think we are at liberty to call them, paint different pictures for us. The first, *De l'aube à midi sur la mer*, clears the mists and brings us the sea alive and moving on a sunlit morning. And so far, so good. The second movement, *Jeux des vagues*, shows us the waves at play of course, foam catching and losing the light above the shifting glitter of water, a delightful surface; but we are at the same time made aware of a depth and formidable reserve of power below this surface. The third, *Dialogue du vent et de la mer*, at once heaves up tons and tons, enough to break a ship in two, but then we are a thousand miles from ships and men, there is only the wind howling above the waves. Yet we seem to hear mysterious challenges, daring us to venture into this elemental ancient world of maddened air and heaving water. What an imagination Debussy had, this eccentric and self-indulgent composer who had always gone his own way! What a work *La Mer* is, weaving into sound all the varying and dramatic patterns of the sea itself!

Richard Strauss: Tone Poem for Orchestra, Don Juan

Before coming to Strauss, perhaps I ought to repeat what I said in the Introduction to this section – that no purely vocal music of any form will be considered here. Our Strauss is the master of the orchestra. We might please many of our contemporaries, convinced of his essential vulgarity, if we called him the Boss of the Big Band. And certainly in with-it musical circles his huge orchestra is *out*; his tone poems are *out*; and he himself is *out* – a fact of which the film man, Ken Russell, in hotter pursuit of bad taste, took savage advantage. As in any capacity I don't have to keep an eye on fashionable taste, I am not prepared to exile poor Strauss into some arctic darkness. But I will add this: that if I am condemned to keep only one of his tone poems then my choice will be the first of them all, *Don Juan*, that astounding composition by a young man of twenty-four. It is one of the marvels of the 1880s.

To begin with – and to be negative – *Don Juan* is free from the main faults of later Strauss works. So, for example, it is not unimaginatively over-descriptive, with the orchestra turned into a gigantic box of tricks. No attempt is made to give us the rustle of petticoats and underclothes as the Don's victims undress themselves. Sex is suggested but we are spared its gasps and moans. We are not yet involved in the mimicry business. Moreover, we come off better at the other extreme, where there are heavily Germanic heroes, deathbeds and resurrections. In this region even domestic life weighs a ton. Strauss himself was about as metaphysical, transcendental, mystical, as the average restaurant proprietor or wholesale grocer. Success lured him into showing off and the pretentious. But I find nothing of this in *Don Juan*, which I have just been hearing for the umpteenth time – with von Karajan and the Vienna Philharmonic at my service in the study.

There is nothing young and untried about the complicated scoring of this work, from the demoniac huntsmen of the horns and the unleashed hounds of the strings to the solitary tender oboe. Yet for all its astonishing skill, there is to my mind a youthful freshness in it that acts as a preservative. Though it is a long way from any idyll of young love, being a tale, told very savagely too, of recurrent lust and idiot 'conquests', ending with a final shudder of disillusionment, I feel that youth is in it and stays with it, fading a little perhaps but never vanishing with the years. It is as if, even now, we have not lost all contact with its early audiences, who in their amazement or delight heard a young man bringing new and apparently defiant sound out of the orchestra.

We have all read, perhaps rather too often, those contemptuous references to the 'giantism' of the later nineteenth century, responsible, we are told, for the creation of huge orchestras, with whole sections doubled and redoubled, symbolic it appears of unchecked capitalism and the triumph of the brassy bourgeois. The thought of these monster ensembles brings me no joy – and anyhow we can no longer afford them, now that musicians have a union – but neither does much joy come from

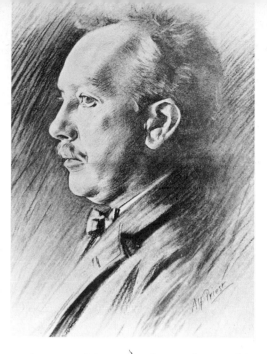

most of our new eccentric ensembles, scraping and scratching away or blasting us electronically. I hold the view that the orchestra Strauss uses for his *Don Juan*, able to play anything in reason, is one of Western man's finest creations, and I never see and hear it assembling and tuning up without a lift of the heart. And if it begins with *Don Juan*, as it does so often, then so much the better.

Glazunov: Ballet, The Seasons, Op. 67

I have passed the afternoon – the house empty, a dull day outside – listening to Glazunov, still a great composer in his native Russia, once esteemed and decorated outside it but now almost forgotten. He was born in St Petersburg in 1865 and died in Paris in 1936. And I will risk declaring at once that he is not a great composer but that he hardly deserves to be completely ignored. From the first he had every-thing, as people say, 'going for him'. He had devoted well-to-do parents; his mother was musical; his father controlled a prosperous firm of booksellers and publishers. He soon became the star pupil of Rimsky-Korsakov and was so far ahead in orchestration that he wrote his first symphony in his teens – and it was widely per-formed too. By the time he was into his thirties he had written about six sym-phonies, and then poured out a lot of other work, including some very successful ballets. He was also a conductor, an influential critic, an editor and publisher of Russian music, a professor at the St Petersburg Conservatoire and then for twenty-five years its Director. If there was ever a busier man in music, I can't think of him. He disliked the Revolution but manfully accepted the Soviet system for nine years

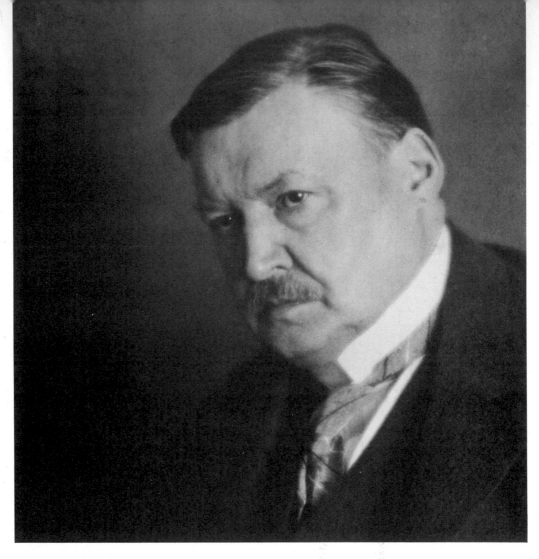

to organize its music, not going into exile in France until 1926. Both in and out of music, his tastes and attitude of mind were strongly conservative. He did most of his more ambitious composing during the earlier half of his life.

Technically he was well equipped. Though not adventurous, his orchestration is sensible and pleasing. It was not his technical resources nor even a lack of invention that prevented him from reaching greatness. It was his style of life, all too smooth, settled and busy. He didn't write out of deep or wild experience. No cry for help sounds in his music because he never needed any. His last movements may be bustling and jolly but they celebrate no real triumphs because no battles have been fought and won. The spirit of man, desperate or ecstatic, plays no part in his music. Where he is at home is not in the symphony but the ballet. But have I any right to make these assertions when I cannot have heard more than about a thirtieth part of what he composed? No, I have not. But even so I am ready to bet money that I am right.

I remember attending a Moscow performance of his ballet, *Raymonda* (his first)

and finding it tedious, but this afternoon I enjoyed most of his later and shorter ballet, *The Seasons*. It is true that a bacchanal keeps charging in, loud and rather vulgar with nothing really wild at the heart of it, making me feel sure that Glazunov, in or out of music, was never a man for a drunken orgy. But like his master in ballet, Tchaikovsky, he is a great hand at a waltz. (Earlier he had written two *Valses de Concert*, which I have known for many years.) There is something about these Russian waltzes, perhaps a hint of sadness somewhere, that makes them more appealing to my ear than the famous Viennese variety. But what appeals to me above all in Glazunov, encouraging me to declare he ought not to be completely ignored, is his fondness for certain charming, melodious and slightly melancholy themes, which have a family resemblance between them. There is one, I think, given to *Ice* in *The Seasons*, and they can be heard again in the first and third movements of his Fifth Symphony. When they are given, as they ought to be, to strings and woodwind these little tunes give me much pleasure, but they fail him and me when he tries to make them symphonic, blared out by the brass as if the fate of mankind might be in question. There is more than a touch of regret in these melodious little themes of his, to which he always seems to be returning. It is as if somewhere at the back of his mind, Alexander Konstantinovich Glazunov, St Petersburg's great master of music in every form, felt somehow he might be forgotten in all the capitals of Western Europe. But at least I for one have remembered him today.

Sibelius: Finale of Symphony No. 5 in E flat major, Op. 82

Writing the above title has suddenly whisked me back to an evening somewhere between 1929 and 1931 when Arnold Bax came to see me. (Why, I can't remember.) Proudly in my possession then was an EMG gramophone, the kind with an enormous horn, not there to make a hell of a noise but to do justice to what went into the soundbox from the soft fibre needle that had to be used. (And even today I still wonder if the electrical equipment we have gives us the same delicacy and purity of tone.) Learning that I had some Sibelius records, Bax insisted on hearing them, and memory even now shows me that crumpled face of his as he listened intently. The Sibelius boom was *on*. About eight years later, as Cardus reminds us in his fine sharp piece about Sibelius, Beecham conducted a Sibelius Festival: 'Audiences of the most distinguished pedigree attended Queen's Hall. The programme of the festival was of silk, with letters of gold: the "patrons" seemed to exhaust Debrett. . . .' And now it is all over. Just as he was overdone, now he is underdone. The icy winds of Sibelius still screech or bluster over his distant wastes, but hardly anybody listens.

With his serious music in mind – as distinct from his potboilers destined for military bands and hotel lounges – Sibelius declared that while other composers offered their listeners cocktails, his gift to them was clear cold water. (Not one he would have gladly accepted himself, if we have done with metaphors.) And my trouble here, listening as I do for pleasure and an occasional lift of the spirit, is that I don't want the cold-water treatment. I don't relish wandering around alone up there in Finland too often in foul weather. Even in music, I want to meet some other people, settle down in front of a fire, take a glass of wine or brandy. If I seem to be suggesting now that I can't enjoy any Sibelius, then I must correct myself. Some genuine pleasure, even some life-enhancing moments, lifts of the spirit, have also come that way, across the frozen lakes; but let us admit that too often it can be chillingly bleak, bare, altogether far removed from firelight or candlelight and the faces of our fellow creatures. It is then we hear the strings turning into whiplash gales, the woodwind moaning through leafless trees, and the trombones and the tuba blasting their way out of the frozen earth.

Yet what a brief but wonderful musical adventure the finale of the Sibelius Fifth Symphony brings us! We are looking for something, it might be a kind of magic pendulum belonging to some vast invisible clock of heroic human destiny. We have a vision of it that immediately fades. Hope vanishes, and we are left with nothing but a far-distant muttering of those voices that always tell us never to be hopeful. We dismiss them and console ourselves by enjoying our own melancholy. But is the quest all in vain then? No look! Here it is, the treasure of the quest, the shining

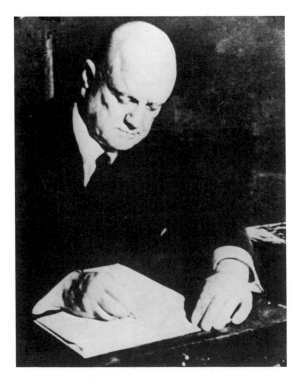

magic, the vast singing pendulum – but no, it's gone, probably for ever. We don't know what has happened, where we are, what we can do. But now – look, look! – it is here, almost above our heads, and if we shake it is with joy. Triumph fills the air. And now – *listen* – that vast invisible clock of heroic destiny is striking – six times, to leave us with a challenge. Well, all this may be both too fanciful and too personal; I don't ask for its acceptance. But a listener must be half-dead in the spirit if he can take this wonderful last movement without wonder and a surge of joy. Yes, indeed, wonder and joy – and what more can a man ask for in this world – bald old boozy Sibelius brings us out of his Northland, now for this little time enfabled and magical. Let us drink to his memory – and not in clear cold water.

Rachmaninov: Symphony No. 3 in A minor

A long time ago, while still in my teens, I saw and heard Rachmaninov play. His appearance was memorable. Instead of being massive or shaggy or both, like most of the virtuosi of those days, he was thin, sharp-faced, crop-haired, and gave no sign of enjoying himself or us. (But then he was doomed every other night to play his Prelude in C sharp minor, which I murdered fairly regularly myself at that time.) Much later I felt he was being systematically underrated as a composer, by all but the most sensible music critics, just because he was popular – a thoroughly bad reason. (Beethoven is even more popular.) Now if I were as intuitive as I often imagine myself to be, then all those years ago I might have concluded that there was about that slight unpretentious figure a tragic aura: here was a gifted man, I ought to have felt, doomed to be unhappy. But I felt nothing of the sort: so much for my intuition.

Already in his middle forties, Rachmaninov never returned to Russia after the Revolution, and in 1918 began a new career as a super-pianist in America, which of course rewarded him handsomely. There are two significant facts here: for a long time he offered the world no new composition; and when not on tour he lived, surrounded by fellow Russian émigrés, in Southern California. Knowing Southern California, I can't help feeling that this move, which he shared with so many exiles, was a bad one. If there is a place different from anybody's homeland, rich with real life and memories of childhood and youth, it is Southern California, with its plastic style of life and rather sinister countryside. It has a formidable gross product of deepening disillusionment and homesickness. It might have been specially designed to make Russians ache for Russia, which may be covered with snow all winter and dusty all summer but brings tears of longing, down to the last birch tree, from almost all Russian exiles. And my guess is that nobody felt more longing and ache than Sergei Rachmaninov, moving towards old age in an alien world.

Indeed, it can hardly be called a guess once you have listened to his Third Symphony, composed so many years after his Second. He was now well into his sixties. It was badly received by critics in general, who announced that it was thin old-fashioned stuff, not worth taking seriously. But being a literary listener, with no stake in the musical with-it game, I for one take it seriously. Music worthy of the name is not written by counterpointing and harmonic computers but by men and women, hopeful or hopeless, joyous or suffering human beings. And this Third Symphony is the best and most honest expression I know in music of a struggle, doomed at the outset, against the pain and despair of a widening and deepening homesickness. It is filled with the anguish of an ageing exile who knows he will never go home again. Except in the initial statement of the rather easy first subject, together perhaps with the faint echoes of themes from long ago, in the *Adagio*, it is free from sentimentality. (Tchaikovsky, I feel, would never have resisted a Russian folk song or two.) The war against depression, the benefits of American fame, are honestly declared – all that busyness, for example, which opens the *Allegro* finale – but the battle is already lost again when we hear the faint faraway woodwind passages, to say nothing of the doomful brass and timpani. Yet I don't think this was all conscious composition – as if Richard Strauss were composing *An Exile's Life*, for instance – and fancy that much of it, with its new spareness and bareness, came straight from Rachmaninov's unconscious. And while I could not pretend that this is one of the great symphonies, I know nothing else in music that brings us so close to the rising pain or the underlying despair of man suffering as so many men have suffered, from homesickness.

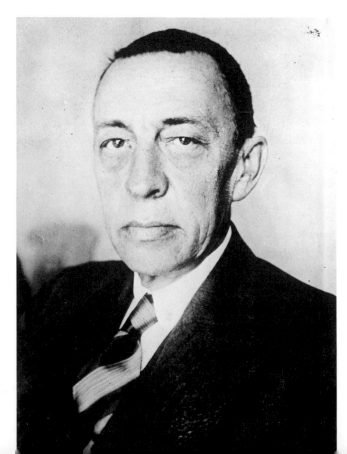

Holst: Orchestral Suite, The Planets, Op. 32

His name must not deceive us. He belonged to the fourth generation of the Swedish Holsts, all musicians, who had settled and worked in England. He was born and bred in Cheltenham, a town as essentially English as any I know, and he must be accounted an Englishman and his work as a highly original and solid contribution to English music. While I had the luck to know or at least run across many composers of his generation and a later one, I never even laid eyes on Holst. I regret this all the more because he seems to me to have been a very remarkable man, over and above his genius as a composer. With poor health, bad eyesight and a timid disposition, he had everything against him at first – feeling 'miserable and scared' in his boyhood and youth. Yet not only did he develop an uncommon power of will, defying all setbacks, but also the capacity to arouse enthusiasm, both in schools and among evening groups, for the kind of music he enjoyed best. And this music, like his own, was never the easy sensuous kind. Indeed, for all its very wide range, there are moments in his own work when we miss at least a hint of voluptuousness, a suggestion of rich sensuous pleasure.

The great popularity of *The Planets* surprised him, and probably rather annoyed him, because he must have felt it was being constantly performed when other later work of his, work he preferred, was being neglected. He ignored the fact that it represented a thundering good idea, which other composers of orchestral suites or tone poems had somehow overlooked. He began the work – oddly enough with *Mars* – in 1914, not long before the outbreak of the First World War, but didn't finish it until 1917, after which he set about his *Hymn of Jesus*, which I can recall astonishing me in the early 1920s. As so often happens, there has been a wide gap in my *Planets* listening, and because I have not a clear memory of my earlier impressions of the suite I shan't bother about them, confining myself to what I have felt fairly recently. The mere passage of time can make a difference. So, for example, *Mars*, which must have been so often imitated, is no longer startling, seems almost routine, even though its technical brilliance is still there.

Indeed, of the first four planets, *Mercury* now holds most interest. *Venus*, bringing calm and quiet has perhaps too much of both, and while avoiding the erotic, never in Holst's mind, might have suggested more femininity, the depth of peace that Woman can bring. And giant *Jupiter*, to my mind, won't do at all. There is nothing Falstaffian about its merry-making, nothing larger than life. It is as if a company (probably teetotal) of English folk musicians were sharing a country house for the weekend. The gigantic planet and its moons are missing. However, beyond *Jupiter* we reach the magic. Holst himself never arrived at old age, but I venture to suggest he must have been living in terror of it when he wrote *Saturn, the Bringer of Old Age*. The huge slow tread of its wasting years chills the spirit. (Even if I don't really feel it, Holst did and communicates his dread with a wonderful economy.) But the spirit here doesn't succumb without an underlying protest,

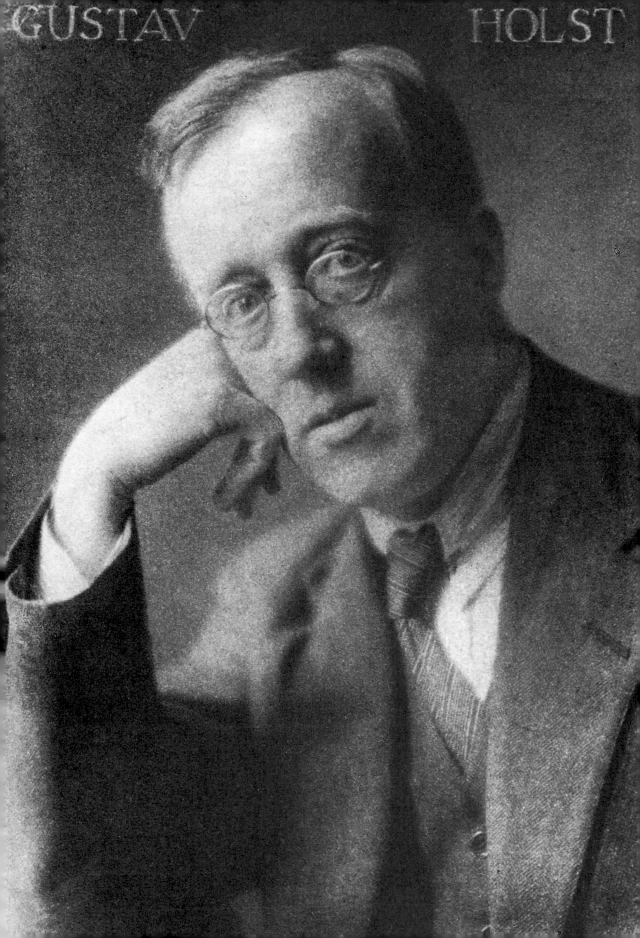

GUSTAV HOLST

more than a hint of baffled rage. There is genius here, I feel. About *Uranus, the Magician*, I am not so sure. It is an immensely clever piece of orchestration, but not that of a man, I suspect, who has ever really enjoyed tricks, sleights, illusions, hocus-pocus. But when we arrive faraway at *Neptune, the Mystic*, Holst's composition is truly magical. The persistent soft exchanges of those two minor chords and the harps are not being played at us; we are overhearing it all somewhere at the outer edge of our solar system, from some unimaginable strange planet. And the introduction of those distant high soprano voices, half-heard and then beginning to fade for ever, is a masterstroke, not of talent but genius.

But now for a sharp protest. One of the performances of *The Planets* I recently heard was by the Hallé on BBC television. Now of course on television the eye must be fed and flattered every moment, and at a concert we are shown close-ups of the conductor and a variety of his players. But not – surely not – when we have come at last to *Neptune*, when the imagination might be allowed to take over from the idiotically busy eye! If we must stare – and it isn't easy to close one's eyes against a brilliantly lighted television screen – then all we need is the floating image of some mysterious planet against a distant glitter of stars, and *not* – surely to Heaven *not* – more close-ups again of a viola, a harp, a conductor's baton or, a final outrage, glimpses of Manchester ladies busy producing those mystical voices! This is really *shooting Neptune*.

Ravel: La Valse, Poème Choréographique

Why this work for orchestra, comparatively slight, all over in twelve minutes? Certainly Ravel was no copious and fruitful composer – the last man to pour out music without stint – but he offers us a reasonably wide choice of compositions in varied forms: so, again, why *La Valse*? I propose to wander around the question rather than offer an immediate answer to it. We might note in passing that the piece was first performed early in January 1920, so we may assume that it belongs to 1919. In England Elgar had composed his 'cello concerto, an impassioned lament for an Edwardian Age that the war had blown to dust. Now of course Elgar and Ravel were two very different kettles of fish. Yet the large hearty and tweedy Englishman and the small dandified Frenchman had one thing in common, apart from their music-making. Both existed behind a mask. I met Elgar only once – some years further on than his 'cello concerto – and I perceived immediately that he was playing a character part, roughly that of a retired colonel off to the races. He needed such a role because, a wincingly sensitive artist, he believed not only that his England had gone but also – as he told a fellow composer who told me – that the taste for his music had gone too. (And how wrong Time proved him to be!) Now I never set eyes on Ravel, but the mask of this small quiet perfectionist was as

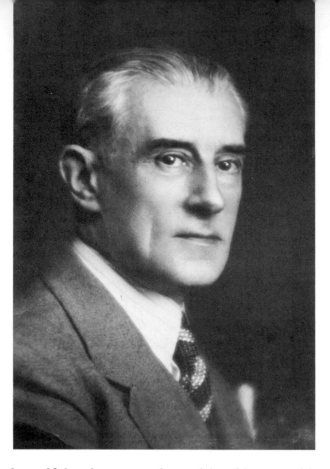

notorious as his beautiful waistcoats and exquisite shirts – and he took dozens of them and fifty-seven white ties for a short visit to America.

Am I now about to suggest that Ravel wrote *La Valse* in the same spirit in which Elgar wrote his 'cello concerto? No, I am not, even though, while so entirely different in form and style, there is a certain emotional overlapping between these works. But Ravel seems to me to compress a bewildering variety of feeling into his twelve-minute tone poem. Here he is a complicated man writing a complicated little work, held together by its unceasing waltz rhythm. We are taken into a ballroom that exists in some unknown and terrible dimension. One critic writes, 'There is something faintly sinister in this music', an astonishing understatement, I would say, for I find much of it very sinister indeed. It is as if Time had been speeded up to mock and defeat all sensuous enjoyment. Within a few seconds a delicious waltz tune has either turned sour or been whisked away. We might be dancing with a fair partner who within a few turns suddenly ages sixty years. Or again, the whole ball-room shrivels into a tiny ghost of a merry evening, retreating towards oblivion. But then a big drum will be thumped and we are off again, zest and sweetness returning – but only for a moment or two before our ears and feet are mocked and baffled again. And in the end we might be trying to waltz in Hell, to an orchestra in a frenzy, piling up fragments of waltz tunes that sound like a scream of brutal derision.

It is no use telling me, as I have been told, that Ravel is simply mourning the disappearance of an elegant but lively Viennese style of life shattered by the First World War. There is that, but it seems to me there is a great deal more than that. There is also, I feel, a distrust, deepening to hatred, of a whole idly sensuous way of life, perhaps with envy sharpening the contempt and derision, the result of a withdrawn fastidious personality. Moreover – and here I defy commonsense – it may be that the future as well as the past plays some part here, casting a shadow before it arrives. That same year, 1919, while Elgar was lamenting so poignantly the passing of an era, he might also have been dimly aware of the approaching end of his own creativity. So too, Ravel, who was to die in 1937 after years of silence and sad bewilderment (the result of a car accident) might have felt obscurely that years were on their way that could never be waltzed through – hence the final scream of derision. And if I seem to be making too much of a tangle and jangle of waltz tunes, then I am sorry. But I have now answered the question: why this comparatively brief work, *La Valse*?

Bartók: Music for Strings, Percussion and Celesta

When we are young we think genius or great talent is everything. When we are older we begin to realize that character, as distinct from natural ability, is very important too. Without some strength of character, the support of the will, great talent, or even genius, can be seen to suffer and start to fail a man. This is the view, I suggest, of middle age. But when we are much older still – really old, as I am now – and we are considering the life of any artist, let us say, we ought to introduce a third factor, namely luck. There can be good or bad luck quite apart from any influence of character, so many results of pure chance, beneficent or evil gifts of fortune. All this seems to me to be well illustrated by the career of Béla Bartók, certainly a great talent, perhaps an original genius, with only minor defects of character, but dogged and brought to despair by sheer bad luck. So, for example, he was fascinated by the folksongs and music of southeastern Europe and not at all by politics, but Hungarian political conflicts blundered in and out of his life and nearly wrecked it. Again, in his last years, an exile in America and agonizingly homesick, after a long interval of desperation, just trying to keep himself going, recognition and commissions came at last – for a violin sonata, a viola concerto, a string quartet, and so on – but then down he went, and died from leukaemia. Without doubt this was an unlucky man.

However, in the mid-1930s the luck changed for the time being and Bartók was able to produce some of his finest works. Among these – and my own favourite – was his Music for Strings, Percussion and Celesta. And now, as elsewhere in these

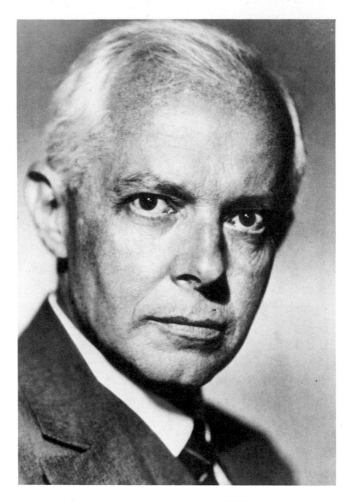

informal notes, I must indulge in some guessing. (If I substituted proper research I would be dead and gone long before this book could be ready for the printer.) There are times when most of us decide we must face something that is menacing or at least worrying in our life or work. This could have been one of those times for Bartók, when he recognized there were certain elements, aggressive, dry and harsh, in his work. But why then should he plan an intricate composition in four movements, using only strings, percussion and celesta, so refusing all aid from mellifluous woodwind and sonorous brass? Is he not in danger of being drier and harsher than ever? Possibly; but then he may be accepting a challenge, may be ready to work through those dubious elements to reach a strange beauty on the other side. And if nothing like this passed through his mind, then it ought to have done.

I have in front of me here a highly technical analysis of the first movement so daunting I could hardly dare to quote any of it. But after all isn't it the final effect that matters most? Isn't that the essence of the composer's communication, just what he is trying to get across to us listeners? Now I find in that first movement not only the intended originality of tone and a determinedly narrow range but also an

effect that suggests a curious mixture of pleasure and pain, perhaps bringing me closer to the personality of Bartók. The second and fourth movements are richer and more varied, but although quite different are alike in this respect – that they describe a man who is trying to enjoy himself and is not succeeding, not really being an enjoyer. The third movement is easily my favourite. There is the celesta moving us to some silvery distance. There are the violins passionately divided. There is some menacing hammering by piano and strings. And all the while enchanting passages come and go, swell and fade, like so many fascinating strangers, beautiful girls and charming men, encountered briefly and tantalizingly in a foreign hotel.

Bliss: A Cantata and a Prayer

These two are the final items in a Lyrita stereo recording presented on his eightieth birthday to Sir Arthur Bliss, Master of the Queen's Musick. Other items date back to the earlier 1920s, but these two belong to the end of his seventies – old man's work without any trace of the enfeeblement of age. *A Prayer to the Infant Jesus* is for unaccompanied women's voices, and captures, though tenderly, clear-eyed simple female piety. The Cantata, called after its opening line, *The World Is Charged with the Grandeur of God*, is altogether more elaborate and ambitious. It is scored for a mixed chorus, two flutes, three trumpets, four trombones, and is an heroic enterprise, if only because the words come from various poems by Gerard Manley Hopkins, as awkward a customer to set to music as the higher reaches of English poetry can offer. Though, alas, deficient in fervent Christian feeling, I can – and do – listen with admiration and great pleasure to these works coming from the composer's glowing old age, as indeed I have listened with equal admiration and renewable pleasure to almost everything he wrote down the long years.

Acute readers will have already noticed something vague, timidly generalizing, in what I have said above. I am not quite myself here, am I? There is a good reason for this. Bliss and I were old friends, and for many years met constantly, usually with Bliss, an ebullient and determinedly loquacious character, taking the lead in talk, leaving me to follow as best I could. Now he had one steel-in-concrete rule: I was not to say anything about music, not even to complain about or compliment an orchestra. 'A plumber can only talk to another plumber', he would declare, in what never seemed to me a happy analogy. Why did I put up with this, when I am not easily dominated and would even listen patiently when he would explain literature and the drama to me? Partly because he was my friend but also because I have always felt gravely respectful towards music and musicians. The very sight of a full score – even though a lot of rubbish may come out of it – makes me feel humble.

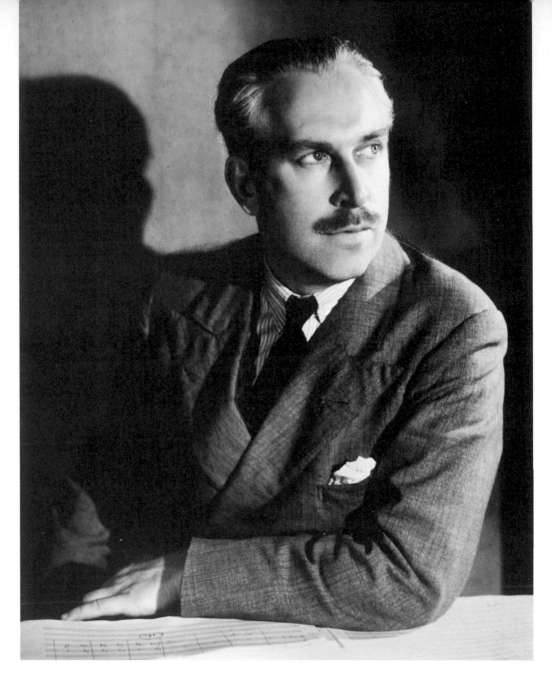

This is, I feel, the noblest of the arts – and let us forget about plumbers talking to plumbers.

So even less acute readers will now understand why I couldn't produce anything worth reading about Bliss's music. He would have torn out the page and stamped on the book, accused me of treachery, and perhaps have blazed away on the telephone like another King Lear – and on a bad trunk line too. I couldn't risk it, not even while I remembered our opera, *The Olympians*, which has a magnificent score I happen to know fairly well, plumbing or no plumbing. I am here bound and gagged and can only mutter that my friend was a splendid composer and a wonderful old character.

Walton: Orchestral Suite, Façade

Sir William is a quiet man but might be at a pinch a formidable one, so once this book is published I had better keep well out of his way. I say this because here is a composer with so many big solid works to his credit, the fruits of his maturity, and yet, bringing him in here, I insist upon choosing and discussing something he knocked off in his earlier twenties, at first for fun. (He must have taken it rather more seriously a few years later when he decided to select and then rescore some of its movements. We are told he is a man who works slowly and carefully.) In terms of musical solidity and achievement I am not about to put *Façade* on the same level as *Belshazzar's Feast*, his symphony or three concertos, to name no other works. Yet I have not singled out *Façade* idly and frivolously. There is a sense in which it is unique not only among his compositions but also those of most composers highly esteemed. It does something that has hardly ever been done. It represents – and immediately restores to our memory – the epoch in which it was written, the lost

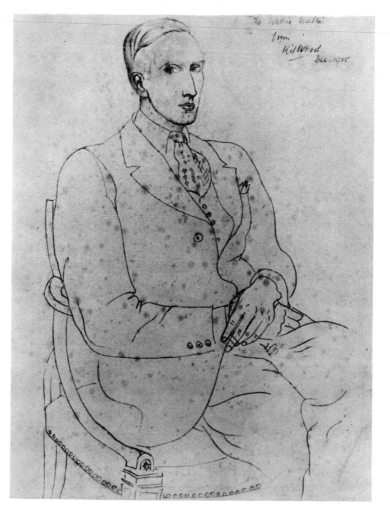

early years of the 1920s. And how many other works have done this so completely? No doubt Poulenc was doing something of the kind at the very same time, but Walton did it better. And this is why *Façade* ought to be remembered.

Certainly it is a witty burlesque, ranging from light parody to sardonic comment. It is a very clever young man, trying himself out and also having fun. It is music being cheeky and thumbing its nose. But all this was very typical of those years: the epoch was frankly expressing itself here; *Façade* was what we came to call later *in*. The war was over and done with, especially for the young, rising up and pressing on, and probably there would never be another. What about having a high old time, rattling round from party to party, persuading the girls, newly accessible, to get out of those awful clothes? Mayfair and Chelsea might be said to be awaiting the arrival of Evelyn Waugh. As the reader has already guessed, I was never quite in the mood myself to enjoy the manner and style of this heady epoch; too many friends, too many years, had been lost; I had to do a lot of work to meet new and grave responsibilities; so I have no jazzy 1920s bias. However, this only sets my enjoyment and appreciation of *Façade* into high relief, clearly seen again after five decades.

Listening to the suite again after many years, as I have just been doing now, the sheer orchestral wit of the thing is astonishing. It is as if a number of brilliant imps had taken over the woodwind, brass and percussion sections. What ought to have been sickeningly sweet is turned slightly sour. Or trumpets boldly proclaim what is going to be an anti-climax. Or when all seems to be going well, a bassoon will inject a low rude comment. The very neatness of the endings are a form of wit. If a *tutti fortissimo* precedes them, it is obviously a lot of fuss about nothing. Never has so much bad music been transformed into what, if its intention has been understood, is really good music. Now we all recognize that what we have here is an expression of youthful high spirits and immensely clever impudence. But let us suppose that Sir William had returned to something like this mood with all the experience and weight of his maturity. What a wonderful comic opera – a full glorious evening of it – he could have written!

ACTING

I am not properly equipped to write this section. I have never been a drama critic, attending almost everything and with all my notices pasted up and carefully indexed. Moreover, I must have missed a number of really important productions just because I was out of the country. Without a single note, I must depend upon my memory and a few issues of *Who's Who in the Theatre*. Thanks to colour reproduction and recordings we can return to the paintings and music, see or hear them again, but most stage performances (apart from a few records) have gone for ever. (But not if what I believe turns out to be true, for then they would still exist in the fifth dimension and we might be able to enjoy them again. Odd, by the way, that no player friend of mine has ever thanked me for outlining in print this belief.) Finally, as in the two preceding sections, no order of merit will be established among these players, who will be so many personal choices, possibly at times entirely whimsical. But then so is the theatre.

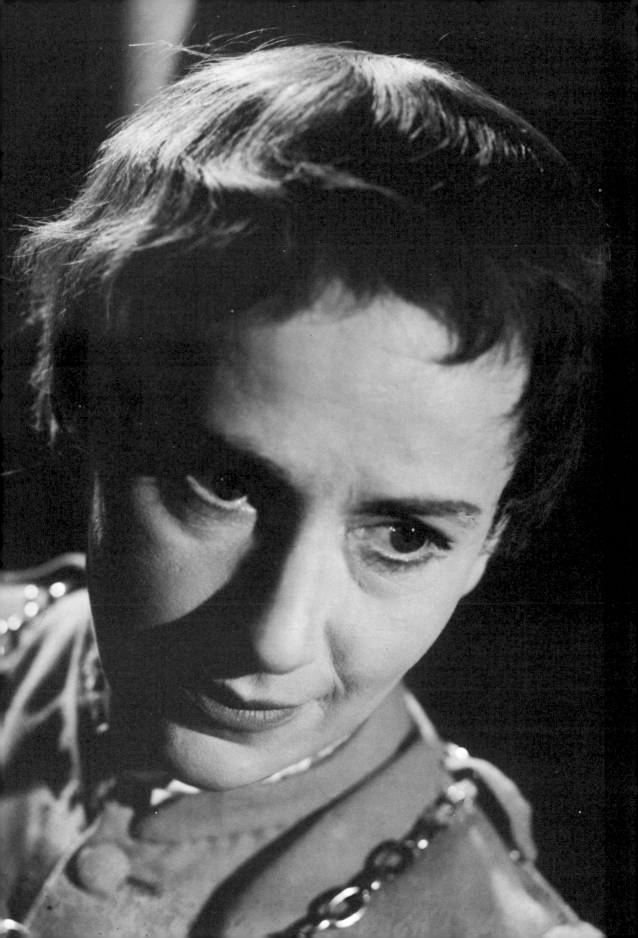

Peggy Ashcroft

As I write this I have known Peggy Ashcroft for nearly forty-five years. During these years she has climbed steadily, quietly but firmly, to the top of her profession, to being recognized, by people whose opinion is worth having, as the best all-round actress on the English-speaking stage. (All this too without the bamboozling publicity that films bring.) She has made far less fuss on her way up than many a small-part actress regularly makes. Of all leading actresses, she might be said to be the least 'actressy'. I have enjoyed innumerable hours of talk with her without the theatre being dragged in every few minutes. She can think about other things, support various causes, both political and generally cultural, attend meetings and help to organize special performances, and keep alive a circle of friends from many different walks of life. This means she can break out into the open from the hot-house of the theatre. God knows she can work when it has to be done, but she also knows when to rest, to have a change, to follow her other interests. If I stress all this, when I am thinking about her here as an actress, it is because I feel that her comparatively free and broadly based style of life has made an important contribution to her work. If her career has been dazzling, it is partly because she has refused to waste time, energy and money dazzling away in private, moving from de-luxe to super-de-luxe, acquiring larger and larger cars, more exotic fur coats, invading five-star hotels with an entourage. She rises inside the theatre like an evening planet, but on the other side of the stage door she prefers to live the life of a sensible, middle-class, professional woman. On the stage, however, she is anybody she chooses to be.

It would not be true to say I have seen every major performance of Dame Peggy's, chiefly because during the 1930s, the later 1940s and the 1950s, I was often out of this country for considerable periods. However, I have seen most of them, whether they were roles inside or outside Shakespeare. And now I must make an important point very carefully. If I declare that Dame Peggy is a little great actress, I shall be angrily accused of contradicting myself or attempting to insult her. But the 'little' here is not pejorative. I am about to praise her. Unlike many famous leading ladies, so expansive that they have begun to blur movements, gestures, tones, Dame Peggy tends towards contraction, a smaller scale of performance, in order to convey, with every appropriate detail, the central truth of the character she is playing. She is not trying to dominate the production by a continual larger-than-life effect. (This may be dangerous with a few parts, notably Cleopatra, but the great slapdash Cleopatras didn't work either.) An artist may look at a drawing through a magnifying glass or a diminishing glass. The latter will not hide any real faults and will bring into sharp relief the character, truth or falsity, of the drawing. So we might say that Dame Peggy is the leading actress who knows how to make use of a diminishing glass. What we see through it, in turn, on the night, is usually extraordinary and memorable, a character brought to life.

Since she played those exquisite girls in the early 1930s, she has of course acquired a tremendous technique, partly by taking thought, partly by experience enlarging instinct. I said above that on the stage she is anybody she chooses to be. This is true, but it is also true that she tends to pick her way delicately among potential parts. For some recent roles she would rightly consider herself quite un-suitable. But age doesn't worry her at all. She played a Viola (illustrated on page 104) deliciously youthful still when she was into her forties. She appeared as an entirely convincing Katharina, the petulant young Shrew who has to be tamed, when she was actually into her fifties. And as we all should know, for there has been nothing like it in the theatre of our time, there was her performance, from youth to age, as Margaret of Anjou in *The Wars of the Roses*, finally – an astounding tour de force – playing the whole trilogy in one day.

But then she has an asset beyond price – that incomparable voice. An American colleague, hard to please in the theatre, declared 'She has the most beautiful voice I shall ever be allowed to hear.' She can make it coo and trill or lash out in the fiercest denunciation: she can do anything with it except speak badly. That well-esteemed trainer of voices, Elsie Fogerty, may have helped, but I suspect that most of that voice was a gift of nature. Young Peggy began by winning the Diploma in Dramatic Art awarded by London University. Dame Peggy, Doctor Peggy – and how typical of her not to have slyly changed to Margaret on her way up! – has by this time a diploma awarded by half the world. Even her oldest friends (and we know what they can be – carping old brutes!) are proud of her.

Humphrey Bogart

Raymond Chandler wrote to his English publisher in 1946:

> When and if you see the film of *The Big Sleep* (the first half of it anyhow) you will realize what can be done with this sort of story by a director with the gift of atmosphere and the requisite touch of hidden sadism. Bogart, of course, is also so much better than any other tough-guy actor. As we say here, Bogart can be tough without a gun. Also he has a sense of humour that contains that grating undertone of contempt. Ladd is hard, bitter and occasionally charming, but he is after all a small boy's idea of a tough guy. Bogart is the genuine article. Like Edward G. Robinson, all he has to do to dominate a scene is to enter it.

This is well said but it does not take us as far as we ought to go.

Bogart died in 1957, aged fifty-seven, after wrestling bravely with cancer. He was an actor who went from the theatre to Hollywood. The point is important because he must not be mistaken for one of those film personalities put together and then blown up for the camera. During his earlier Hollywood career he was fully

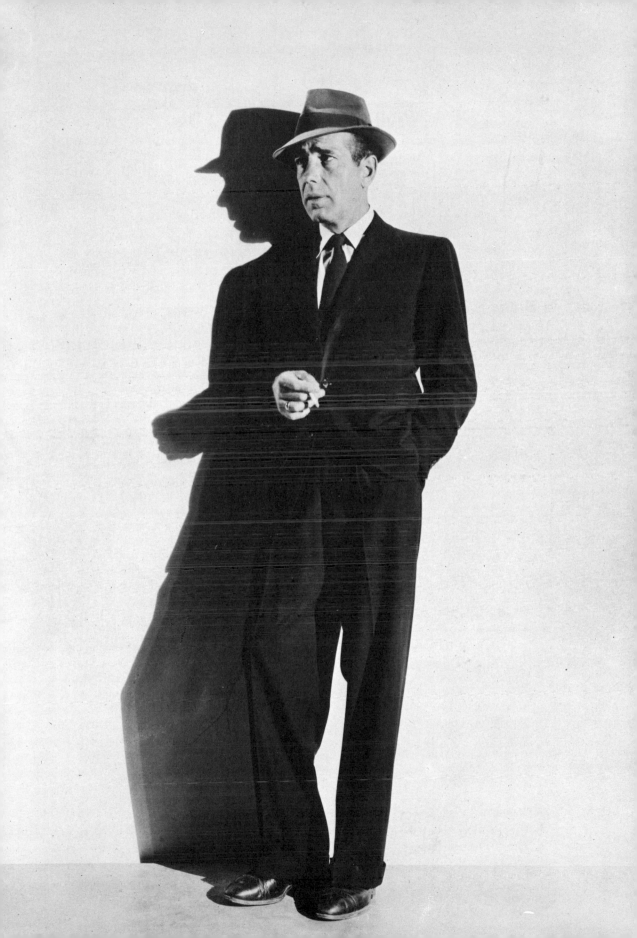

employed playing 'baddies', parts in which he was adequate but did not reveal himself completely as he did when he came to play leading parts – not as an obvious 'goody' but as an ambivalent character. He died before his time but during recent years his films have been continually revived in many different countries, in which he has become a kind of cult figure. This is why he deserves a place in our gallery here or in any other of the same sort. It is as if in a world becoming more dubious and menacing he justly demanded more attention and admiration.

His film personality was so strong that people may be forgiven for overlooking the fact that he was by choice, profession, accomplishment, an actor. Compared with an Alec Guinness, let us say, his range was very narrow indeed. Undoubtedly he was one of those actors who take parts into themselves. As a star he was always playing *the same kind of man* but not just the same man. (Compare, for example the Bogart of *Casablanca* with the Bogart of *The Big Sleep*.) Within his limited range he moved from role to role. Moreover, the people who worked with him have told us he was both a conscientious and considerate actor. Being a drinking man and private 'hell raiser', he might be 'hungover' and late arriving on the set, but once there he did his level best both for his director and fellow players. He drew big money but he earned it – and since his death has earned it over and over again.

However, when he came to play leading parts he seems to have put more of his private self into them. He brought out his sardonic humour, his dislike of affectation, self-importance and humbug, with which Hollywood is crammed, and 'that grating undertone of contempt' which Chandler so neatly pinpoints. There were genuine small differences between his later roles, as I have suggested, but we are entitled to claim for him a general overall effect. It was that of an unusually independent, laconic though capable of piercing repartee, *dangerous man* who had an instinctive feeling for what was decent, honest, and open to love. And ever since his last parts and his death we have been living in a world, bureaucratic, over-organized, fearful, that has made this sort of man harder and harder to find. We come upon any presentation of him, especially in cities where there are plenty of cinemas, with relief that can turn to joy. Here at least is Bogart, not caring a damn, to dominate a scene that is largely depersonalized. So while other stars have been fading, he has been burning brighter and brighter. Hence all the revivals and the international cult of a man who never even pretended to be a great actor. And good luck to them, I say!

Gerald du Maurier

He was a superb actor. He could direct other actors with impressive skill and tact. Because he was so successful, his influence was enormous, bringing into fashion a

new naturalistic under-emphasized style of acting – even perhaps of writing. He triumphantly presented the Edwardian upper middle class to itself. (But it is only fair to add that he succeeded in a much wider range of parts than he is generally credited with playing. This is especially true of him during the First World War.) Knighted comparatively early, he was for many years the acknowledged head of his profession. As an actor-manager he made a lot of money at a time when money went a long way. He had a charming wife who adored him, three delightful daughters, and a host of friends. He spent his later years in a fine old house in Hampstead, Cannon Hall. Apparently, as people like to say now, 'he had it made'. But in fact he hadn't. And now, particularly for those of us who have good memories of him and his art, we have to understand why.

A book I have always recommended with enthusiasm is his daughter Daphne's intimate portrait of him, *Gerald, a Portrait* ('Daughters are the thing!' – and Chekhov, after talking to Tolstoy's, declared this before Barrie did). Like a good daughter, Daphne du Maurier is at once deeply loving but clear eyed: no man writing about a famous father would come near her. Long before the end her bright pages begin to darken and are invaded by melancholy, and, if we have any sympathy

at all with her subject, move us greatly. Du Maurier died at sixty-one, after a serious operation that he might possibly have survived if his despair had not made him struggle out of bed when it was dangerous for him to move at all. But then he had been existing for some years with a kind of death in his inner world. When he might have been making great plans to play great parts, he was beginning to yawn over his career, to regard acting itself with distaste, to accept parts in films (which he disliked) to pay the bills, to take refuge, away from all major challenges, in buying toys and tricks and playing practical jokes on his fellow actors. So what went wrong? I will risk a few guesses. First, he could not accept and feel at ease in the world that emerged after the First World War. Though only in his fifties he could not help feeling he had outlived his own epoch. His thoughts avoided the present and wandered more than ever into the magical past. Again, for a man of great talent and sensitivity he had few inner resources, far from enough opportunities to use his mind. Lacking these, he soon drifted into boredom, not to be conquered by toys and tricks. Finally, he was an artist who had somehow lost the hopeful courage of art. He shrank from stretching himself and risking some derisive remarks at the Garrick Club. He played safe and then found himself shrugging and yawning.

Here I am not guessing. I discovered his timidity from personal experience. I had sent him a copy of my first play, *Dangerous Corner*. After a couple of weeks or so, he came to see me one Sunday morning – no problem from Hampstead to Highgate Village, where I was living. He was uneasy, moving around the room, touching things. He said his wife and daughters had read the play, adored it, and begged him to do it. 'But, y'know, Priestley, everybody isn't as clever as you are.' (Actually, as events proved, this play didn't need a clever audience, just an audience – anywhere.) In short, in spite of the enthusiasm at home, he wasn't going to do the play. (Back to Sapper and Edgar Wallace.) But this refusal seemed to me to come from an uneasy and indeed an unhappy man. Never mind about my play – but this was a superbly gifted man who had ceased to live with the whole of his nature and personality. Though without such dogmatic statements, it is all there – and poignant too – in the lights and shadows of Daphne du Maurier's intimate portrait of her father.

Edith Evans

'I don't think I'm a great actress,' she tells an interviewer. This is nonsense. If she is not a great actress, then she is a fraud. (What about those honorary degrees from the universities of Oxford, Cambridge, London?) And she is certainly not a fraud. I believe she was halfway to being a great actress when she walked out of that milliner's shop for the last time. Of course she went on tour and played all manner

of parts, but I suspect that many a manager wondered what had happened to that small part he had given her – had he misread the play? I don't mean to suggest she was a determined upstager or hogger of the spotlights: the point is that she not only filled a part but naturally enlarged it and overflowed in it. Take for example the Nurse in *Romeo and Juliet*: in most productions a nice little character part, but cast Edith Evans and it seems to be half the play. And she can't help it. Either she is – and has long been – a great actress or she's a monster.

Consider her stage size. In ordinary life she is not a large woman, and I ought to know because our acquaintance goes back more than half a century. (She was in fact a friend of my parents.) I have no doubt that if a good dwarf part had come along she would have convinced us at once that she was pitiably diminutive, creeping around the stage. But given a reasonable number of inches she seemed to turn them into ells, whatever they are. She can do it off the stage if she feels like it, though not to old acquaintances, only to unwelcome intruders. As soon as we ran-

sack our memories of the theatre, it is ten to one we catch her towering above everybody, a tremendous woman. It is all an illusion, but then so is the theatre. When the buzzbombs were coming over, late in the Second World War, Albany was almost empty; but she was there and so was I; and some nights we shared a fire-fighting watch. To see Dame Edith in her new role as a fire fighter was to feel that the war could not last much longer.

Again consider her appearance. She was not uncomely but she was no beauty. Yet over and over again she was cast triumphantly as a lovely enslaver of men, all bewitchment, seduction, tender mockery. Her Millamant would have enraptured Congreve himself, making him forget Mrs Bracegirdle. She made you feel you were in the presence of a raving beauty: it might have been hypnotism. And she worked the wonderful trick, along the years, whenever a part called for it. (The exception was Cleopatra, but then Shakespeare's eloquence defeats every actress who attempts the role.) Moreover, we must remember she did not succeed in these bewitching parts by specializing in them, helping to seduce us by an association of ideas, for she would turn up as Juliet's Nurse or a simple Welsh maidservant or as anybody else she fancied. And there she would be, a shade or two larger than life, for ever holding the eye and catching the ear, certainly the dominant great actress but always offering some satisfying core of truth.

Her voice has always been an astonishing and highly personal instrument. I don't know if Ellen Terry or the Vanbrughs or William Poel or one of those milliners had anything to do with it, but I do know there has been no voice like it on the English Stage during my long years. Unless it is confined to some character-part accent, it rises and falls in its own delectable fashion, rather as if the woodwind section of a symphony orchestra had been lifted into the blue upper air. Nor is it something kept for the theatre for it goes trailing away, delicately bubbling with laughter, even in her private conversation. Yet its owner has presented us over and over again with a Lady Bracknell that would have terrified even Oscar Wilde, a veritable monster, an ultra-fashionable elderly female of the Nineties turning into a dinosaur. (Look at the photograph on page 111.) And yet this same woman, now in her old age, can fill an empty stage with poetry, delicious mockery, and a gallery of characters. What a woman! What an actress! Larger than life perhaps, but, fortunately for us, much better than most of the life that comes our way.

John Gielgud

He seems to me a very difficult subject for one of these sketch portraits. This will come as a surprise to many readers, especially if they are oldish occasional playgoers, for they will tell me at once that he is a romantic Shakespearean actor,

memorable for a fine presence and a magnificent voice. And indeed if they are really old, they will add that he is the representative in our era of a splendid tradition. Now while this is not completely true, for reasons I will put forward below, there is some truth in it. For example, not long ago when BBC Television asked Sir John to give a series of short talks on the theatre and its players, they made a wise choice. No other leading actor would have been so effective, and not simply because Gielgud enjoys an excellent memory, a sense of character, and a dry but friendly humour, but also because theatrical tradition is alive in him. It is there in his blood (Poland is somewhere there too, it is worth remembering). But while his may have been the most memorable Hamlet of our time, it will not do to recall him only as a romantic Shakespearean actor. It does not begin to do justice to his temperament and his career, which incidentally demands, even as a summary, about seven columns of close print.

This formidable record brings some surprises – at least it does to me. For example, he has spent far more time directing plays than I thought he had. Again, until we come to his Shakespeare recitals – and his wide-ranging tours of these should be esteemed as a national service – he has not played Shakespeare as often as most of us would imagine. On the other hand, he has appeared in a fairly large number of contemporary plays, but these I propose to ignore because I can't discover any pattern in his choice of them. But now I must face the difficulty with which I began. I like to divide leading players into two different types. There are those who put themselves into their parts, and there are those who take their parts into themselves. I don't feel that Gielgud fits easily into either category. Certainly, as his career amply proves, he can play widely different parts with equal success, yet an apparent Gielgudish quality survives them. But if we decide he is one of those who take parts into themselves, then we must grant him an unusual breadth of personality – on the stage if not away from it.

If we consider only his peak performances, then we shall find three quite different Gielguds. The first might be called the Young Elizabethan, the Shakespearean actor, whose fine presence and wonderful voice brought him fame. If I say 'Young' it is not because I feel he has failed in the older parts – he is too good an actor to do that – but that he has been less impressive in them, not his unique, keen-edged but musical self. (*Bulky* Shakespearean roles – thick dominating fellows like Othello, for instance – are not for him.) The second Gielgud belongs to artificial high comedy, from the Restoration dramatists to Wilde, as if born to play it. Here his style and manner, his incisive delivery, his beaky and arrogant profile, his dry but very effective sense of humour, are all completely at home. From Valentine in *Love for Love* to John Worthing in *The Importance of Being Earnest* (illustrated on page 113) he has etched characters of high comedy with beautiful precision. But now we jump to the opposite extreme, to Russian tragi-comedy from Chekhov and others, to what cannot be etched but can only be suggested, to characters lost in vague hopes and dreams and doomed to failure. He has been superbly at home too, over and over again, in this faraway, half-daft, half-magical, land of snow and birch trees. The first time I ever set eyes on him, he was playing the seedy but hopeful student Trofimov, in that early production by Fagan (bless him!) of *The Cherry Orchard*. Perhaps it was then that the sorcery of Chekhov began to work on him. Though he had to wait some years before opening it, his gallery of Chekhov characters was entrancing.

Readers who wish to test Gielgud's remarkable versatility can do it by attending re-runs of two films. In the first, the Hollywood version of *Julius Caesar*, he plays the embittered and relentless Cassius with such force that he dominates every scene in which he appears. And by far the best thing in the second film, *The Charge of the Light Brigade*, is his performance as the gently muddled amiable Lord Raglan, who might have wandered into the Crimean War from *Through the Looking-Glass*. Well, as the actors sometimes say – 'Top that!'

Alec Guinness

A friend of mine lives not far from Alec Guinness in the country, and he told me that Alec could wander around or attend local functions and yet never be recognized. I suppose I ought not to have been surprised (though I was), in spite of the fact that Alec has now been one of our leading stage-and-film actors for many years. I remember some of his early appearances when he seemed to be stiff and, though not unappealing, awkward, but I can't recall the exact time when he left all this behind him and became an actor of quite remarkable finesse. Indeed, I find in him three qualities that give him distinction. In the first place, he is essentially a quiet thoughtful man, no show-off, no noisy bluffer, who considers his work in some depth. Secondly, he is one of our few leading men who does not take parts into himself but puts himself without reservation into his parts, and with astonishing versatility. But though he may change his appearance, voice, manner and style, with every different role, he does this as a conscientious actor and not as a mere super-mimic like another Peter Sellers. He is bent on creating a character down to the last detail. Thirdly, there is this quite remarkable finesse, which all students of acting should observe closely and admire, preferably returning to more than one performance.

Only the other night I caught him in a late scene of a TV play about which I knew nothing. But clearly he was playing an oldish man who was ready for death out of

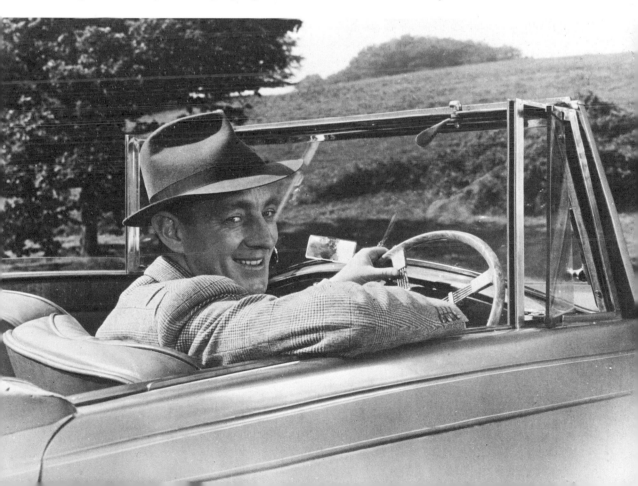

his disgust with life – incidentally that of an author. Being a creature of fixed social habit, he was ending the evening with a cigar and a glass or two of port. But even in the way he smoked and drank, with one tiny detail after another, Alec suggested the man's bone-deep weariness and fastidious disgust – and all this in a TV play that would have a single performance. It returned me down the years to the Old Vic production of *An Inspector Calls*, in which I marvelled at his playing of foolish young Birley, in which he had only to walk upstage, his back to us, to give us a further display of the character of this thoughtless youth. Finesse again!

I watched him continually only in one film that I wrote for him and co-produced. This was *Last Holiday*, a film that had various depths of irony that London critics seemed to miss as they shrugged it away. (It was more successful on the Continent and in New York and Hollywood, where Pauline Kael described it as 'the perfect little film.') Now Alec Guinness had to play an ordinary young man whose life begins to change dramatically. (There is a still from this film on page 115.) The scenes were not shot in chronological order, which meant that Alec had to be ready every morning to present his young man at some different stage of his development, jumping forward or backward in time. And this he did so beautifully that I have been applauding his skill and tact ever since. More of that finesse!

Though he appeared in the Honours List some time ago, and of course he has been praised often enough, I for one cannot escape the feeling that his distinctive quality – not only his versatility but the depth and subtlety of his playing – has long been undervalued by both critics and public. They tend to respond to publicity, fuss, showmanship, and these are not what this modest but dedicated man is offering them. He brings to them more than most of them have the keen observation and insight to understand. By this time he ought to be an actors' actor. But is he? I doubt it. I am no actor, but guided by experience and temperament, I have some notion of what acting is all about, and this quiet deeply thoughtful player stands high in my respect and esteem and grateful affection.

Edmund Gwenn

'Teddy' to his innumerable friends, Gwenn had a very long and distinguished career, being born in 1875 and dying at eighty-three in 1959. Almost always in work from his earliest years, he had his share of light stuff but gradually took on better and better parts in really good plays, with Shaw, Barrie, Galsworthy his authors. (He created Straker, Shaw's 'new man' in *Man and Superman*.) Shortish but stocky, with a broad but flexible face and an engaging grin, he was no romantic leading man but could always succeed in a fairly wide range of character parts. He was an attractive man as well as being – and this is something I never say lightly – a

very good actor, never worrying too much about a prestigious career but always devoting himself wholeheartedly to whatever part he accepted.

At this point I must explain that after I had taken over *Dangerous Corner* I had formed, with the valuable help of my agent and friend, A. D. Peters, a producing company called *English Plays*. Our first task was to put on a new comedy of mine, with our friend Cedric Hardwicke directing it. This was *Laburnum Grove*, set in a cosy middle-class London suburb, with a cosy suburban type, always pottering about in the greenhouse, George Redfern, as its chief character. He is rather despised by other characters until he cheerfully announces, at the Sunday supper table, that he is a crook. Teddy Gwenn in this part, which he accepted at once, was a gift from Heaven. He accepted a salary of £50 a week (but in 1933) without any percentage of the gross, never presented any problems, and was all smiling ease and bubbling enthusiasm. Incidentally, once the play was running he used to order (at

his own expense) a real supper to be sent in every night, and ate and enjoyed it, in place of the sliced banana stage meal, while playing one of his trickiest scenes. This comedy was a great success and ran and ran. We decided to send exactly the same company to New York, where it opened in 1935. Gwenn was then lured to Hollywood, and though he returned to London for a few years Hollywood claimed him again and kept him, though still somehow breathing English air. I remember dining with him there, on a very warm night, when we had roast beef and Yorkshire pud and some kind of plum duff. And possibly if we had not originally sent him to New York in *Laburnum Grove* he might never have gone near Hollywood.

Many actors took to the stage, to pretend to be other people, because they were – and often still are – dissatisfied with themselves. (Actors, I repeat, but not actresses.) I never felt this about Teddy Gwenn, who went into a play like a born sailor returning to a happy ship. (One of his declared hobbies was 'The study of ships and the men who sail in them.') He played every part with enormous if controlled zest. Not long before he joined us in *Laburnum Grove*, I saw him in a very different part, that of a fiery and ragingly bad-tempered old gent in a musical. His face a dangerous scarlet – he must have held his breath – he not only attacked a chair but utterly destroyed it, as I had never before seen a piece of furniture so thoroughly demolished. Yet behind this ferocity was a depth of good humour and tolerance, belonging to an essentially sweet nature, very hard to find elsewhere in the theatre. Brave happy Teddy Gwenn, who spent so long in Hollywood and yet somehow contrived to be living still in England, no more than a magic stone's throw from the Green Room and Garrick Clubs!

Cedric Hardwicke

We were friends for more than half his lifetime. He was designed to be a happy man, and that is what he was for many years. He reached the stage early, among great performers, before the First World War; he survived that war intact; he was already successful in the 1920s and at the beginning of the 1930s, years before there was such a flood of theatrical honours, he was given a knighthood. For an actor he had an equable temperament; he was a clubbable man, who enjoyed good talk; he moved steadily forward in his career without being consumed by ambition; his whole life was in the theatre and yet somehow he was able to escape it, never being one of those actors who could talk about nothing else. He was fond of saying that barristers and doctors, for example, did more acting every working day than any actors did at night; and, oddly enough, I often felt that he might have been equally successful as a barrister or doctor, though this may have been some trick of style and manner. He seemed a solid personality, rare in the theatre, and yet at the same

time there seemed something curiously elusive about him; though this never prevented my regarding him with some affection.

Broadly speaking, his reputation grew with two very different kinds of parts. They might be said to have demanded a lot of make-up or hardly any at all. The first were very fruity and ripe character parts, mostly – although he was a Midlander – belonging to the West Country. The second, and more important, were straight authoritative parts, usually given to him by Shaw. Now Shaw was not always as perceptive about players as he imagined himself to be, though I have chiefly in mind his later years; but he was dead right about Cedric. Though Cedric in fact never shared Shaw's philosophy, opinions, outlook, he was a born Shaw actor. He never seemed to have simply learned the lines, often very demanding, but always gave you the impression he had thought them. Possibly he picked up a certain high style from his earliest days, 'walking on' for Tree, George Alexander, Bourchier and the rest, and this would have pleased Shaw, the enemy of naturalistic mumbles. For these parts Cedric had a special voice quite unlike his ordinary speaking voice: it was resonant but with a curious hollow-echo *timbre* in it. And if anybody has played Shaw leading parts better than he did, then I have never been around when it was happening.

Both his career and his private life, I feel, went wrong during his later years. The man designed to be happy was no longer happy. No doubt for a variety of reasons, he found himself spending more and more time in America, dividing it between

New York and Hollywood, and less and less in London, where he felt at home and at ease. He was never that in America, though until his very last years he kept up a fairly bold front. He didn't really *like* America – even though it had made such a fuss of him – and his remarks about it became drier and drier and more sardonic. (At no time though, in my experience, had he ever been an enthusiastic gusher of an actor, the type that goes on falling in love with the theatre or celebrating a honeymoon with it.) The Hollywood parts began to seem sketchier figures of authority, and if he had ever felt any affection for New York, where he returned to the stage from time to time, there was little sign of it during our later meetings there.

Finally, an urgent telephone call from Alec Guinness in New York told me that Cedric was in hospital there, ill, lonely, deeply depressed. Before I could make any plan to see him, there came the news of his death. Now I prefer to forget Cedric as one of New York's star performers. I return him in affectionate memory to the London of the 1930s when and where he was enjoying his performances and audiences, a cosy domestic life, his various clubs, his many friends. He was a very good actor but never a great actor, except at certain moments in his Shaw plays. Perhaps the wonderful luck started too early and then began to run out. Perhaps behind his apparent solidity and calm assured manner, there was a passive and sub-missive quality, touched with cynicism, useless to any leading actor and not helpful to a man determined to enjoy his life. I suspect the American career tired him out: he became older than his years. But I doubt if I would ever have found so good a friend and engaging companion in a harder and more ambitious man.

Katharine Hepburn

She has had a long stage career, which has included many Shakespearean parts, but it happens I have seen her only once in a playhouse. This was when she appeared in London playing the lead in Shaw's *The Millionairess*, not one of the master's major creations. I liked *her* though, but then I always do. Unlike some other actresses who move from stage to screen, she seemed just the same in the theatre. But again, having seen and admired her in many films, I liked her being just the same. How-ever, this is not the beginning of an attempt to undermine her reputation as an actress, which is well deserved. What I want to do here is to set her apart from other Hollywood female stars and explain why I find her uniquely appealing.

That sardonic comedian, Fred Allen, described these stars as 'chambermaids with caps on their teeth'. This is unfair of course, but we can truthfully declare that many of them have been products of the front office and its publicity department. They function then as wonder girls for the readers of fan magazines and as clever directors' dolls or puppets on the studio floor. They take their beautiful masks,

tearful or smiling, all the way through extraordinary adventures. (I am not of course thinking now of a Garbo, who needs no praise from me.) And clearly K. Hepburn is not one of these bovine beauties. Indeed, from the first she refused to go through the Hollywood tarting-up mill. On the other hand, well outside the above category we can find a few stars – like Bette Davis, for example – together with a number of well-known supporting players, who are real actresses, eager to identify with any good role even if they have to spend hours being made up as madwomen, hags, witches. Now while Katie Hepburn is very much a real actress she is not one of these eager identifiers, delighted to look like somebody else. She prefers to look like herself. In other words, she turns her roles into various aspects of herself, into queenly Katharine, young-actress Katie, haughty Miss Hepburn, managing K.H., that athletic Hepburn woman, and so forth, down the long gallery.

She may be comic, she may be tragic, she may be somewhere between the two. But while some responsible acting will be brought to each varied role, all the parts will have to share a rich amount of essential Katie Hepburn. (And why not, if we enjoy her?) There will be the same magnificent profile, probably an heirloom of good bone structure. In full face she is never pretty but either beautiful or ugly – it depends upon what she is up to. If it is softened by love and tenderness, her face

can be suddenly heartbreaking. If she is furious with somebody – as she often is in her films – not only do her eyes harden but her mouth might be part of a letter box. To be frank – and this always means something unpleasant is about to come out – her voice brings no particular pleasure to my British ear; it has too many ha-aa-rd vowels not musically differentiated; but even so it has provided her with an effective acting instrument. Finally, I seem to recall accounts of her aristocratic background, style, presence, but I can say nothing about these, if only because I am never sure about aristocracy even in British terms, let alone American.

What I am sure about is that she is the kind of woman I delight in, even if she is only an image on a screen. She suggests a real person with an unusual amount of fierce integrity. Compared with the ultra-female creatures that belong to picture postcards and the lids of chocolate boxes, she may seem – especially to the *machismo* types who are always wrong – too mannish and hard, but this, to my mind, is where to discover deep rich femininity. She has been, and still is, I hope, what we might call a darling firework.

Charles Laughton

His career must be regarded with respect. Its details should be considered before any judgment is passed on him and his work. During his swift rise in his twenties he was appearing in plays of great distinction and rarely descended to the nonsense that attracts so many leading men. This was largely true of his film career in Holly-wood, where the pressure to inject adrenalin into debilitated scripts must have been much greater. Later he left both screen and stage to undertake far-ranging and demanding tours in America to give public readings of classical texts. He organized and directed Shaw's *Don Juan in Hell* as a platform piece – and very good it was too – with Charles Boyer, Agnes Morehead and Cedric Hardwicke. When he came back to England he went to Stratford-upon-Avon and played both Bully Bottom (seen in the photograph opposite) and King Lear, about as wide apart as two Shakespeare characters could be. The last time I saw him on the screen – and I think it must have been his final appearance – he was in a film adaptation of a popular novel about politics and Washington, and as an artful old Southern Senator he dominated all the proceedings. Even after leaving out a great deal to his credit and sound taste, I offer this as an exceptionally fine record for an actor 'of star quality', who must have refused innumerable invitations to triviality. This hotel keeper's son from Scarborough who shot up like a rocket took with him to those perilous heights a feeling for artistic integrity.

However, the Devil – whom Laughton played superbly in his *Don Juan in Hell* – demands to have an advocate. Not in Laughton's aspirations and choices but in his actual performances there could be what we might call, after the scientists, 'an

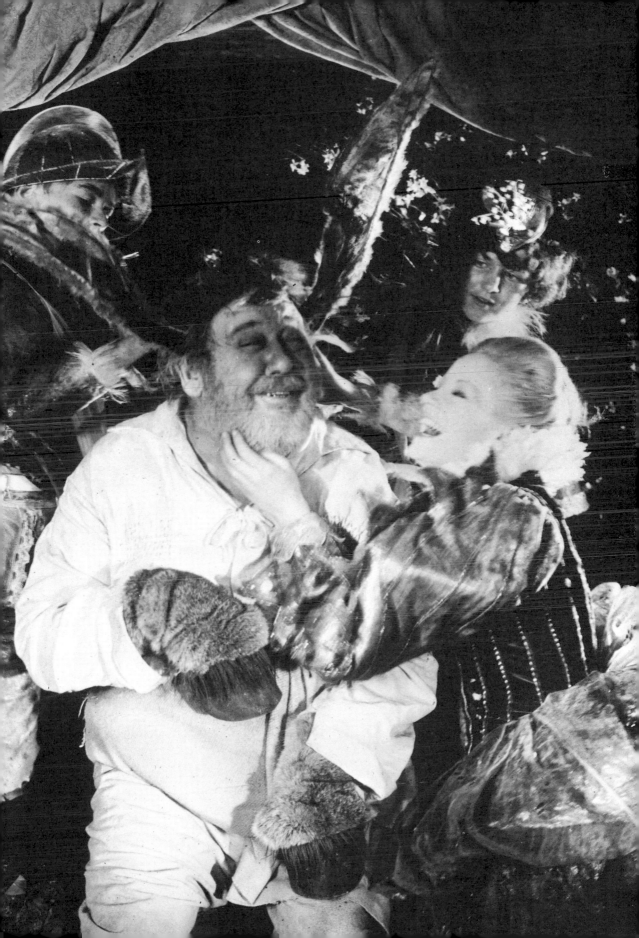

uncertainty principle'. They might work, and they might not. Compared to a brilliant hard professional – Olivier, let us say – there was in him something that suggested an amateur, wonderful of course but somehow still an amateur. Often he was unable to 'fix' his stage performances. He could vary wildly as I am told he did with his Lear at Stratford. One reason why he was not uneasy filming, though he never told me this himself, was that once he was in the mood and ready to tackle a big scene, then that was that and he didn't have to do it all over again the next night on a stage. (But it often took time, I believe, for him to find and hold the right mood.) His voice was intensely personal, easily recognized – and I always welcomed the Yorkshire traces in his vowels; but offhand, without having heard him on these occasions, I incline to think that for a man who went off on reading tours he hardly had the necessary wide range of tone – but of course I could be wrong. Unlike many of my acquaintances, in and out of print, I am often wrong.

For one reason or another I spent some time alone with Laughton both here and in America, but I would not say we were friends though the time might pass amiably enough. There were two sides to his nature and I didn't fit in with either of them. On one side was a large enthusiastic innocence, which found me too cool – as he said himself. On the other side, entirely different, was a certain element that always seemed to me sly and rather sinister. He made good use of both sides in his acting, as most people must well remember, and if on occasion his performance slipped and lost conviction it was because one side began to show when it was necessary to hold on to the other. Even so I recall, with a warmth he would not have credited me with, so many memorable performances, and behind them an unusual leading man's career, starry at its height, depending upon a feeling for artistic integrity. He spent years in a vast factory of cynical nonsense, one of its pet players, but went his own way – often into the open air.

Gertrude Lawrence and Noël Coward

At a first glance it may seem unreasonable to lump these two together in this fashion. Their careers brought them on to the same stage neither very often nor for long. Gertie's later and more spectacular years were passed over three thousand miles away from Noël. Probably they were not even friends any more by that time. So why make a pair out of them? Well, I have my reasons – and they are not mere excuses. To begin with, I feel they belonged to the same world, running their races out of the same stable. When not engaged in mimicry and mockery, playing straight in fact, they both hoisted themselves high above their lower-middle-class origins and always suggested an upper class. But it was not the English upper class we associate with the peerage and the counties but some mysterious upper class,

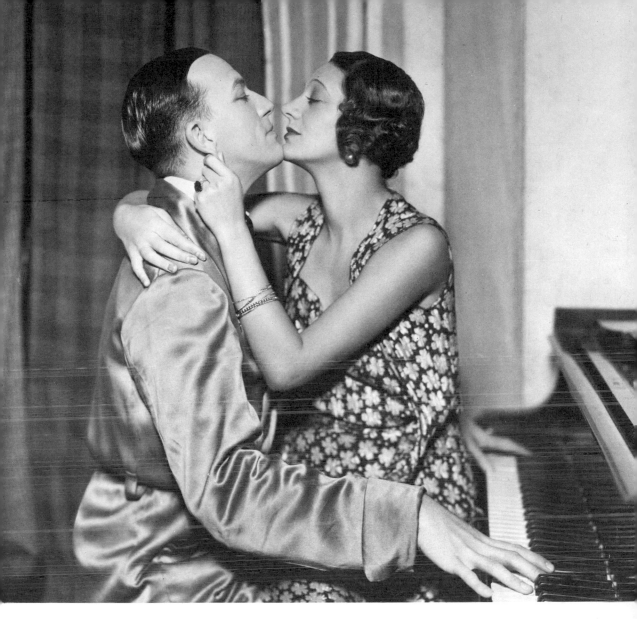

probably first established in Ruritania and then arriving in Shaftesbury Avenue.
Again, by combining talent with a steely determination, they swept aside various
disadvantages. Consider, if you remember her, Miss Lawrence: she wasn't
beautiful, not even really pretty; her figure was only so-so; her singing and dancing
were rather sketchy; but somehow, perhaps by sheer mimicry, she made us feel she
was a delicious woman and a starry creature. Coward had of course a variety of
talents but was never designed by Heaven to be a very successful actor, certainly
not in straight leading parts. His plummy voice – at least to my ear – was against
him, even though he could time a line, especially one he had written himself, with
any man; and though he knew when and where to move, he always seemed to me
rather wooden.

Yet I have a better reason for joining them together. Though they rarely shared

the same stage, when they did, I feel strongly, they brought out the best in each other. It was Noël with Gertie, Gertie plus Noël (as her writer too), which offered us the great treat. And it was Coward's series of playlets, *Tonight at 8.30*, that challenged and triumphantly confirmed their astonishing versatility. If Gertie ever did anything better, I never saw it. If Coward, either as writer or actor, was ever more impressive, then I missed something. Now in the complete edition of these playlets, well worth reading today, nearly forty years later, the second and third of the nine are *The Astonished Heart* and *Red Peppers*. To my mind Coward never wrote anything better than these two. They are poised at extremes of dramatic writing, both equally good in their construction and dialogue. *The Astonished Heart* shows us a busy and dedicated psychiatrist who almost snubs his wife's beautiful schoolfriend but then becomes her lover and drives her to despair and himself to suicide by his half-mad neurotic demands. (Jung would have said that he was the victim of two activated archetypes, the Anima and the Shadow.) At the opposite extreme from this strong and deeply felt piece, *Red Peppers* gives us an hour of George and Lily Pepper, two third-rate music-hall performers, all of it broad and brawling low comedy. And Coward's acting, both as the tormented and tormenting psychiatrist and the poor defiant George Pepper, was as good as his writing. Moreover, as the mistress driven to despair and as hot-tempered vulgar Lily Pepper, Gertrude Lawrence was his perfect feminine partner, with never a gesture nor an intonation wrong. (She had learned a lot earlier by playing revue sketches, a training hard to find now.) She went on to become a great and perhaps rather self-indulgent star in New York, but I feel she reached her peak, both for force and sheer versatility, playing opposite Noël Coward in his *Tonight at 8.30*. Yes, these two brought out the best in each other, and this is why I have taken them together here.

Wilfrid Lawson

In 1937, when I was helping to cast a new play of mine called *I have Been Here Before*, I talked to one Wilfrid Lawson who had been sent along by his agent to be considered for the part of the German in this play. Though he was known in the West End as a character actor, I decided on a hunch that Lewis Casson should play the German and asked Lawson to take on the straight lead, Ormund, the North Country businessman. (Lawson was in fact a fellow Bradfordian, like many others in the theatre, then and since.) This was his meat and he pounced upon it with a roar. The play was successful, and even more successful still was Lawson as its leading man. I had two so-called Time plays running together throughout this season of 1937–8, and each of them could boast of a remarkable performance. There was Jean Forbes-Robertson in *Time and the Conways*, and there was this strange

Wilfrid Lawson in *I have Been Here Before*. He always gave one the impression – he was a teasing type – that he might do something daft during the next performance, but during these years he was in fact superbly professional. I remember, in *I have Been Here Before*, he had to cross very close to a table, apparently hit a knee or a shin, and mutter a curse on the thing. It looked and sounded like a tiny accident but if you had seen the play three months later the bump and the mutter would have been just the same.

Lawson never became a star. There was too much going against him. Off the stage he was often capricious, boorish, and, after he had been drinking, was capable of ringing up a manager at two in the morning. Even on the stage he had serious limitations. He was nothing to look at. At moments of high emotion his voice would rise from a droning baritone to a strangulated tenor, and in his later years he was often barely audible. Intelligent fellow actors told me he was difficult to work with, pulling himself away from the usual cooperation, asking a question that never fed

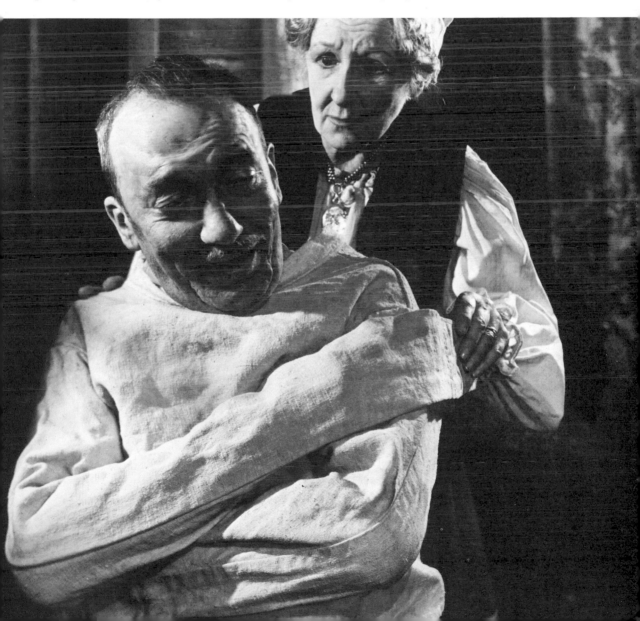

the actor answering it because he would give it such an odd vocal shape or leave it dangling in the air, so puzzling the audience. He tended to create a space round himself. Nevertheless, the people who really cared about acting (never a crowd) and ambitious young actors themselves would follow him from production to production, even when he might be playing comparatively small parts and when he was becoming increasingly hard to hear. Unnoticed by most of the press and all the great public, there was a Wilfrid Lawson legend.

Why was this, with so much against him? No doubt his peculiar self-regarding method helped him. But there had to be something special there to help, just as an unusually selfish man must at least have a fairly impressive self. Lawson brought to a part a quite fearless quality together with an exceptional density of personality. He was the exact opposite of the nervous uncertain actor shakily anxious to please. He gave the impression that he had first discovered what the part meant and then didn't give a damn. If you didn't like it, you could lump it. This gave him a magnetism that broke through and scattered all his defects. I have mentioned small parts but really with Lawson there were no small parts. He enlarged them simply by playing them in his own fashion. He could have carried on a letter in the third act and yet suggest he might be about to play King Lear. I don't mean by this that he had to be noisy. He could be very quiet and yet be magnetic, as I know from experience. Again, when I saw him in Strindberg's *The Father*, I doubt if I caught a third of what he said and he might have been half drunk, yet when he allowed the old nurse to put him into a straitjacket (a scene shown in the photograph on page 127), it was heartbreaking and you felt you had at least caught a glimpse of great acting. He could be a hell of a nuisance, especially if you were part of his management, but Wilfrid Lawson was indeed a remarkable actor, a kind of diminished and later version of an Edmund Kean, with beer instead of brandy.

The Lunts

In the summer of 1929 I was 'taken' to the St James's Theatre to see a play called *Caprice*, newly arrived from America. I went sullenly. The fact is, then and since then, I like to go to the theatre when I want to go to the theatre, and don't at all mind going alone. I go in the same spirit in which I go to a concert or an exhibition of paintings. I have always resented London's social playgoing, turning the play into part of a night out, because Basil is on leave and Uncle George and Aunt Maud are up from Cheltenham. So I glowered at the St James's curtain that night, taking no comfort from the fact that *Caprice* was a comedy freely adapted from the Hungarian. But by the time the curtain had fallen on the first act my resentment had vanished and I was sitting in an enchantment. This was not because *Caprice*

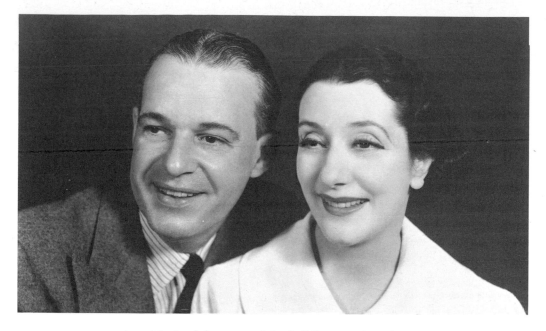

was any masterpiece. It was because I had fallen under the spell of its leading players, Alfred Lunt and his wife, Lynn Fontanne – the fabulous Lunts.

Why the enchantment? Because there is both an aesthetic and intellectual delight, and one very rarely discovered, in being offered direction and acting raised to an unusual high pitch, brought close to perfection. In the ordinary way, with a run-of-the-mill director slogging away during his three-week rehearsals, what we get is little more than a rough sketch of a play, a charcoal cartoon not a portrait of it. We need something much more, both from the director and his leading players. Now unless they were miscast, perhaps not working together, the Lunts gave us that *something much more*. Over and above their exceptional individual talent or his reserve of strength or her bewitching femininity, their secret was that they took over where the director left off. They were capable of rehearsing and rehearsing, making another tiny cut or adding a nuance, when they were already playing to crowded houses bursting with applause. (I never saw them rehearsing themselves of course, but I imagine that Alfred had the ideas and the drive and Lynn the flexibility and the quick sensitivity, with both of them sharing the notion of the portrait of a play in full colour, a dream of perfection.) The result to an intelligent member of the audience would reach beyond mere satisfaction to sheer exhilaration. And they could even make fairly stupid audiences feel that something splendid was happening. When Robert Sherwood, no genius but inventive and a tidy craftsman, was asked how he contrived to write such successful plays, he replied, 'I get the Lunts.'

Nevertheless, now that the bouquets are out of my hands, I must make a sharp point. There is a weakness most great glittering stars have in common, a temptation they find it hard to resist. They cannot help choosing plays that are smaller and not

greater than they are, slight pieces that would hardly exist without them. (A three-weekly rep production of *Caprice*, say, would be a disaster.) And it cannot be denied that the Lunts, for all their devotion to the theatre, tended to shy away from masterpieces, works that would test them right to the bone. What they brought close to perfection were too often dramatic toys, light-comedy playthings. Yet their great talent, their enthusiasm, their untiring capacity to rehearse and rehearse, might have taken them securely among masterpieces. And I am not being ungrateful for the hours of delight they have given me if I say I wish they could have been employed, year after year, by some magnificent American National Theatre, under some formidable director who could have taken their splendid gifts and then wrung the last drop of sweat and blood out of them. And remember, after all, these two were no butterflies: they were high up among the hardest-working pros in the world.

Marilyn Monroe

If they should ever catch sight of this page, film producers, directors, actors, writers, who had to work with Monroe, will begin howling in protest. Names of fine actresses 'worth a dozen Monroes' will be hurled at me. I may be accused of being bewitched by the memory of the blonde to end all blondes.

But in fact I don't like 'living dolls' and even if I did, they would not resemble Marilyn Monroe. She is simply not my type, would never have been at any time of my life. I can never remember giving her image a single glance heated by desire. And here let me add that not only did I never meet her but that I was never near a film studio where she was working – or trying to work while driving her associates half out of their minds. Furthermore, I haven't read Mailer's book on her and don't intend to do. It is one thing to offer an insight and some guesses in a few hundred words, and quite another thing to buy them in a whacking big expensive book.

I may be all wrong about this, but I suspect she was difficult – keeping everybody waiting, not turning up at all – not because of drugs, booze, too much sex, and so on, but because, with a limited technique, no great experience, she wanted to project a certain image. It was not her public image as a sexpot-de-luxe. Indeed, it was very far removed from that image familiar to everybody. And this meant that what came easy to most film stars was very difficult for her, which probably explains all the delays and vague excuses for not being on the set, ready to work. What was almost routine to the other players could be a dreaded nerve-racking challenge to her. But I have not brought her into this gallery, probably surprising many readers, to provide her with excuses. I am here to praise her.

To do this I will set aside various films of hers that I have seen but will con-

centrate on what is probably the best known of all and one that I have seen several times. This is that broad fast comedy, *Some Like It Hot*. Here she had to play with, or if you like, *against* some brilliant comedians of great experience. And what she did, while projecting her own particular reverse image, was to create a character that existed in another dimension. She was in the comedians' world, but not of it. Her eager wondering innocence, never suggesting promiscuous sexual experience or the cynicism that begins to darken it, came from somewhere else. She was caught into the story of course but at the same time was somehow visiting it, almost as a child might be. This effect was so strong that I am certain that if she had not been in the film it would have dropped at once into a lower order of entertainment. This seems to me the best example, yet much the same could be said of other films, even if she had not been given a leading part. Whether consciously or unconsciously – and the stronger impulse would have come from the unconscious – she reversed the image of the notorious public sexpot, going from bed to bed, often squalid enough at first. She brushed aside the calendar or *Playboy*-style tantalizer, stepping out of the dark carapace of her actual experience, to present us with an image, at once charming and convincing, of half-bewildered but eager innocence. To have done this more than once, with almost everything against her, transforms her from 'a dish' into a remarkable serious actress. I care nothing for her wanton legend, it is her work, coming out of both hope and desperation, that I praise; and I lament her wretched end and miss her.

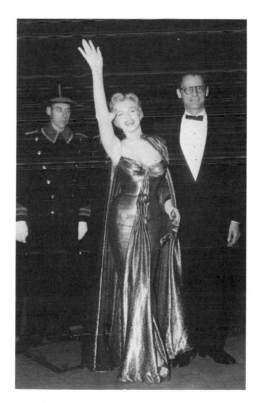

Laurence Olivier

He describes himself as 'actor, director, manager', as well he might for he has been all these on the highest possible level. Thanks to films and extended stage tours, he is world famous. Awards, foreign decorations, honorary degrees, have been showered upon him. No English actor, living or dead, can begin to compete with or challenge him. A Garrick, a Kean, a Henry Irving, merely enjoyed a small local reputation when compared with his. His career has been fantastic, as if a young actor had been visited by a wild dream. He has not been just another success but a phenomenon, the theatre exploding into legend. Now I happen to have known him for a very long time, ever since I used to go next door to Gladys Cooper's, to play tennis with him, then a very shy modest youth. While I am sure he has remained exactly the same man at heart, he has since given me glimpses of various masks or personas. For example, after he first returned from Hollywood there was a 'tough-guy' phase, and this was followed, largely through frantic overwork, by an irritable 'tetchy' phase, making friendly relations difficult (but I was no treat myself), but then at last, after much mellowing, he emerged, in Yeats's phrase, 'a smiling public man', bearing his load of honours lightly.

These various personas are important because they help us to understand his approach to his art. Here, before we approach it too, I must suggest certain limitations, even if they are only shadows that throw into high relief his triumphs. Neither by temperament nor vocal range is he a poetical actor, even though he has succeeded, by the sheer force of great talent and determination, in some of the major parts of poetic drama. But the fact remains that he hasn't Gielgud's music nor Richardson's extraordinary range of tone. But this may make him seem more limited vocally than he really is, because it is also a fact that in his complete surrender of himself to a character he can offer us scores of different and entirely convincing voices. Incidentally – though he goes deeper than this on the stage – he can entertain his friends by superb mimicry.

In the phrase above about surrender we can find the key to his method and his art. He is the ruling prince of those leading actors, a minority, who don't take parts into themselves but put themselves into parts. He is essentially a complete identi-fier. Unless we happen to be one of his friends, we think of Olivier as the character we last saw him play. He does not show us Olivier but Coriolanus or Chekhov's Astrov or Osborne's Archie Rice, the third-rate entertainer – seen in the photograph opposite. (His range of course is astounding.) But will this do? I may seem to to be describing any really good character actor, not the great glittering figure I began with, the world-famous leading man. But here for once I am ready to agree with the materialist philosophers: that if enough is added, there can be a change of quality, not merely of quantity. And this is what has happened to Olivier. He has added so much.

Though I have never been anywhere near him when he has been studying a part

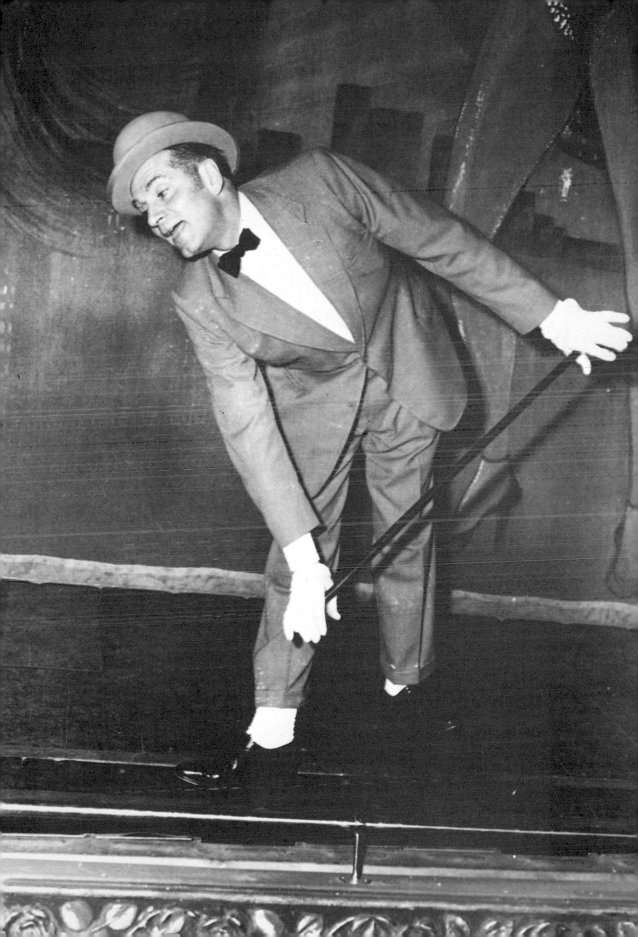

and when rehearsing, I feel I can allow myself a few guesses. It all begins with his constant deep desire to surrender himself to the chosen part. Though he will inevitably bring with him a certain magnetism, he would not be considering his role in terms of that magnetism. So far as performance and playgoers are concerned, he is going to change his identity. There will be no Laurence Olivier on the stage. He will bring to the task of obliterating himself and becoming somebody else certain qualities that are rarely combined. They are an iron determination (no 'smiling public man' now), a natural force of personality, and, what is so often missing from that force, an immense capacity to take the most careful pains, deciding on every last detail. Add these together, throw in the magnetism of his tremendous reputation, and you have a performer a light year removed from any good character actor. Add too, for good measure, his brave confidence in his versatility, the way in which he will tackle almost anything, from Oedipus to some suburban nitwit. His very courage may occasionally send him the wrong way, as I believe it did in his Othello for the National Theatre, but nineteen times out of twenty it will bring him, as younger playgoers say, 'spot on'. And there is no luck involved in this. He has earned his gigantic reputation.

He brings the same qualities to his direction of plays, as I hope a tiny personal anecdote will testify. He was directing for the National an old play of mine, *Eden End*. One day he tracked me down by telephone to a remote pub in the Yorkshire Dales – an urgent message. Would a woman in 1912 be already using lipstick or would she simply put extra rouge on her lips? I didn't know and didn't care. But he did. He used the force of his personality to get hold of me somehow on the distant telephone while at the same time he was taking immense pains, down to the last detail. So the director, so for many years the actor. And if we care about the theatre, there is not a single award, honour, medal, ribbon, we should begrudge him.

Jules Raimu

Not only did I never know this great French actor but I never set eyes on him in the flesh. All that I was acquainted with were images of him on the cinema screen. But what images, what richness were there! In my memory he both haunts and enriches those superb films of the 1930s, surely the great French decade of the cinema. He didn't die until 1946, but then – and this is strange – he was only sixty-three. I call this strange because during the 1930s he must have been fairly continually playing characters older than himself. (Am I wrong in thinking that this rarely happens in films and must always suggest the presence of a remarkable character actor – a Richardson, a Laughton, a Raimu? And I remember that both Richardson and Laughton shared my admiration for Raimu.) Now one of my fancies – and I don't

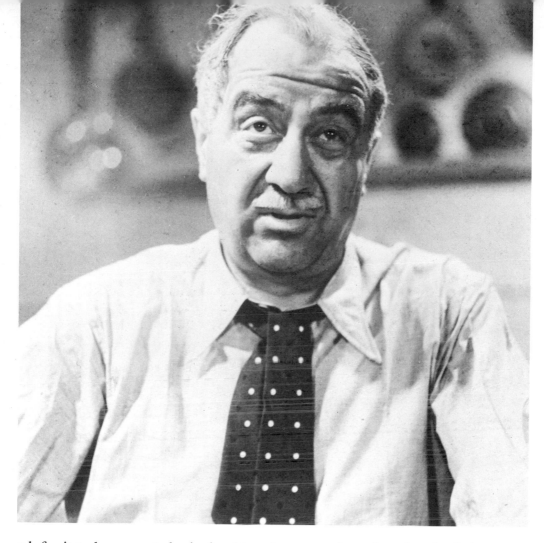

ask for it to be respected – is that Frenchmen can be rather sharply divided into *thicks* and *thins*, as different in personality as they are in physique. When I feel myself coming to dislike the French, I believe I always concentrate on the *thins*, especially their tight-lipped narrow conceited intellectuals. When France is in favour, it is populated by *thicks*, robust and zestful men, getting thick on a good bourgeois cuisine with plenty of wine.

Addressing myself now to readers of more than one generation, I must announce that Raimu was nothing if not a bourgeois *thick*. He was indeed a kind of king of bourgeois *thicks*, containing within himself a rich essence of their quality. There are of course various social levels here, even within French society, far more socially democratic than ours. So Raimu might be – as indeed he was, to my delight – this village baker, unable to turn out a decent loaf because his young wife had run away with a picturesque shepherd. He might rise to be an anxious *maire* or a half-defiant, half-sycophantic bureaucrat, again perhaps worried because his attractive wife has vanished in the direction of more distinguished company. Raimu characters were rarely settled and at ease. They had their little triumphs, lighting up that large and

very expressive face of his, but sooner rather than later there would be doubts, worries, deepening anxieties, to cloud and wrinkle his features. He could look over his shoulder almost as if overhearing an order for his execution. He could enter a room, not designed to comfort him, filled with his own importance and then be gradually deflated. He could throw you one glance that created a haunted man. If any of this suggests over-acting, then I am doing this remarkable performer an injustice. No matter what the scenario, the plot, which might be absurd, was doing to him, his performance always existed within an atmosphere – or rested on a secure foundation – of entirely convincing reality. The others were never shadows – French film acting was too good for that – but he was always more solidly there. Bourgeois *thicks* may now be a vanishing tribe, and indeed French filmdom seems mostly populated by sexy or murderous *thins*. But I doubt if I ever see a film imported from Paris without missing Raimu, without wishing some magic would bring him into the next, and best, sequence: a great actor.

Claude Rains

I can imagine an American filmgoer, seeing Claude Rains in one of his later Holly-wood roles, as an autocrat or smooth villain, feeling certain that here was a man who must have left an aristocratic landed family, somewhere in England, to amuse him-self making films. Rains had that air, however sketchy the scenario or wooden the dialogue. But his early life is surprising. After a solitary appearance at the age of ten, for many years he was not in the scenes but behind them. He was a call boy at His Majesty's, then a prompter, finally an assistant stage manager. After deciding to cross the road to the Haymarket Theatre, he was again an assistant stage manager, but gradually began to do some acting both in Australia and America, where he went as general manager for Granville Barker. All very theatrical of course, but even so an odd beginning for a man who became a leading actor. Here I can ask two questions but I can't answer them: I never knew Rains. There he was, in the years before the First World War, behind the scenes at these two splendid theatres, and still an impressionable youngster; so was he deeply influenced then by a certain grand style and a forceful precise articulation? The second question is quite different. Did he enjoy America so much, during his Granville Barker tour, that he made up his mind to return there, once he had established himself in London after the war? That is certainly what he did, first appearing on the New York stage and then afterwards going to Hollywood, so that we lost him, greatly to my regret.

A smallish man, sharp-featured and not handsome, not mellifluous but with a voice of his own, always suggesting at his best an explosive force that might at any moment be dangerous, he was – or undoubtedly could be – a remarkably fine actor,

who might have reached some memorable heights if he had returned to London instead of going on to Hollywood. My sharpest memory of him dates from the middle 1920s when he played Faulkland in *The Rivals* at the Lyric, Hammersmith. As a rule this neurotically jealous character is played as if he were rather a bore, clearly part of a sub-plot, but in this particular production, with Rains playing him, he dominated the piece. The two Absolutes, Bob Acres and the rest, faded away, and you waited with impatience for the return of this half-mad Faulkland. I am not saying that if I had been directing this revival I would have welcomed such an astonishing performance, hammering as it did the play out of shape, but as a member of the audience, already familiar with *The Rivals*, I was fascinated by Rains' Faulkland and well remember it after nearly half a century. So I still regret all those years he devoted to Hollywood films when he might have returned to London and startled new audiences all over again. He might have brought back something of the grand manner, with its controlled force and precise diction, that he observed and listened to so long ago as a call boy, prompter, assistant stage manager.

Ralph Richardson

Unless my memory is altogether treacherous, James Agate, who could often be very perceptive about actors, never understood Ralph Richardson. He saw him as a large eloquent version of a very ordinary man. He could put it another way and tell us that Richardon was 'of the earth earthy'. Now I will accept that, if only because I think better of the earth than Agate did. It is not simply so much muck, salt water and molten iron. It is a planet going round and round a star. It is our Great Mother of marvels. Out of its dust and mud came all our myths and legends and William Shakespeare and Rembrandt and Beethoven. And it is to this earth that the earthiness of Richardson's acting really belongs. His Bottom the Weaver is the one of his troupe who 'had a dream past the wit of man to say what dream it was'. His Falstaff (the best I ever saw) was not simply a fat rogue who ate and drank too much, he was the man who praised sherris-sack because it ascended into the brain, making it 'apprehensive, quick, forgetive, full of nimble fiery and delectable shapes . . .' When he ventured into Ibsen's Norway, it was not to play another pastor or doctor but Peer Gynt, bewildered in a sad fairy tale of illusion and disillusion. When I wrote *Johnson Over Jordan* for him, I had this breadth and depth of his acting in mind, Johnson being an apparently ordinary man to whom extraordinary things would happen. At every age he has been the actor who can go bumbling along and then suddenly take you into another dimension.

Here I must return to my division of leading actors into two kinds, namely, those who put themselves into parts and those who take parts into themselves. Surprising as it may seem at first to many people, I feel strongly that Ralph Richardson belongs to the second group. He doesn't surrender to roles, completely identify with them; he gives them life by bringing them into himself adding Richardsonism to them. True, the arguments on the other side are not without weight. He has played with success all manner of parts, with no restrictions as to nationality, social class, occupation, outlook, and has wandered from Shakespeare to our newest playwrights. (I have myself provided him with widely different roles.) Can this then be an actor who doesn't lose his identity in parts but takes them into himself? The answer is that it can, as we shall discover shortly. But first there is another argument from the other side to be answered. I shall be told that an actor who simply plays himself – and we can all think of several examples – will be inclined not to spend much time and trouble on a new part, whereas Richardson broods over an important new part and analyses and annotates its text. Why work so hard if in the end you will rely on the breadth and weight of your personality? But there is no question here of an actor 'who simply plays himself'. It is more complicated than that. Consciously Richardson is a highly technical actor. Taking the parts into himself, finally depending upon his personality, is largely an unconscious process. (And this explains the presence almost always of certain mannerisms.)

This personality, however, makes that of most actors look small and threadbare.

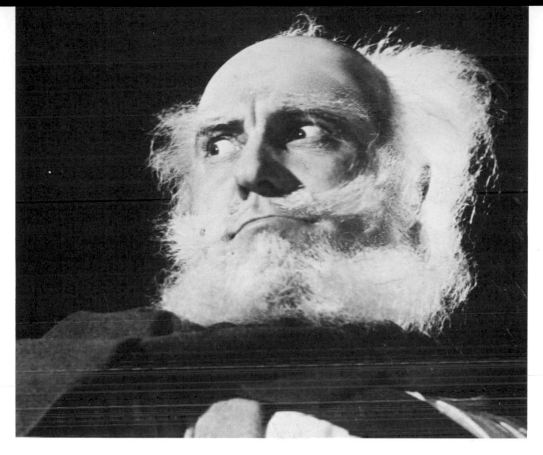

It is broad, deep and rich, quite different from the rather eccentric persona he offers to acquaintances. He has a cultivated taste in the arts and he has read widely. He has always been a very sensitive – and often very sharp and witty – critic of his fellow players and of the theatre generally. More than once down the years he has flashed out a critical remark about my own behaviour or public manner that has left me enlightened and rather chastened. Superficially, he can be self-indulgent, extravagant, not entirely dependable, a bit daft about machines or some ploy or other. But my guess is that behind – or really well below – this façade there has always been a dark bewilderment, with questions that brought no easy answers. And here we may find a reason for that extra dimension which may suddenly open out and enlarge his acting.

What is certain is that whether he is performing consciously or unconsciously he has had at his disposal a voice of extraordinary range and tone colour. Together with his understanding of the character, this voice, which could rise from a grunt to a squeak, was the secret of his wonderful Falstaff (illustrated above). He could have been, and indeed has been at times, a superb comedian. But while he is essentially not a tragic actor, no Macbeth for example, he is more complicated and deeper in his appeal than any comedian. Perhaps he could be described – while saluting him as a great actor – as a moon-faced *wondering* tragi-comedian, earthy possibly but never really at home in the sad bad world we have inflicted upon this earth.

Jean Forbes-Robertson

I never saw Sir Johnston Forbes-Robertson on the stage, but once, in his old age, we were fellow guests at a City banquet, to which he contributed a noble presence. He also spoke and it was as if a 'cello had been brought in to replace banjos and bassoons. It was with this noble presence, this voice, that Jean, born in 1905, spent her childhood. Her mother, Gertrude Elliott, actress and manager, was more than twenty years younger than her more famous husband and probably cared more about working in the theatre than he did. No doubt needing the money, in the earlier 1920s she took some undistinguished plays and companies to South Africa, Australia and New Zealand, and teenage Jean acted in them, possibly tackling some quite unsuitable parts. Her first important part in London was as Sonia in *Uncle Vanya*, in January 1926, when she made a deep impression upon the more sensitive drama critics. Six years later, James Agate, no worshipper of young actresses, after faulting her Viola for speaking 'on one level note', went on to write:

> But the point about Miss Forbes-Robertson's performance, though one may fault it here and there, is that its sum is absolute and flawless perfection however attained . . . Viola's steel-true and blade-straight quality, her sticking to the spirit as well as the letter of Orsino's instructions, can never have been conveyed better. One spectator, who has seen this performance three times, is always at Viola's first entry brought to the verge of tears, with the rest a mere blur. What other tribute would any Viola have? . . .

Clearly an actress, still in her twenties, of rare quality.

She was unlike any other of her time. At first sight she suggested a handsome keen-edged youth – she had to play Peter Pan over and over again – but feminine depths in her could soon be discovered. I knew her fairly well, and she was the strangest leading lady I ever encountered. She never behaved like one. She never agonized, never even worried, never wanted to discuss details of her acting, and seemed to take on a part like slipping into an old coat. She appeared to be lacking the burning or ruthless grinding ambition so characteristic of many leading actresses. I doubt if she ever spent a quarter of an hour planning or building up a career. The actress and the woman in her were widely separated. So for example the spirituality that added depth to her best performances seemed to vanish every night on her final exit. There was not a trace of it in her eager lively talk, which might have been that of any youngish small-part actress happy to be on the stage and in work. The haunting Jean Forbes-Robertson effect might have been turned on with 'the floats' and the spotlights. It was all very strange.

As Kay Conway in my *Time and the Conways* in 1937 (seen opposite) she was a marvel to work with, so wonderfully quick and sure, as if she had known the part for years. I have never known since, and cannot imagine, her equal. (But it is only fair to add that Jessica Tandy gave us in New York a slightly diminished but very fine performance in this part.) However, early in 1940, spending two or three months in Oxford, I wrote specially for Jean a rather thin 'fey' piece called *The Long Mirror*,

which we produced there at the Playhouse. It was inexpensive to stage and to tour, and at odd times during the next few years Jean, who wandered in and out of management, would take it out on tour, so that finally I told her to forget royalties and accept it as a present. But the reason I mention this 1940 production is that although it was not two years since she had finished playing Kay Conway, I noticed a certain drift in her, a blunting of the fine edge of her work. She arrived at the theatre sober enough but she needed too much prompting. The wonderfully

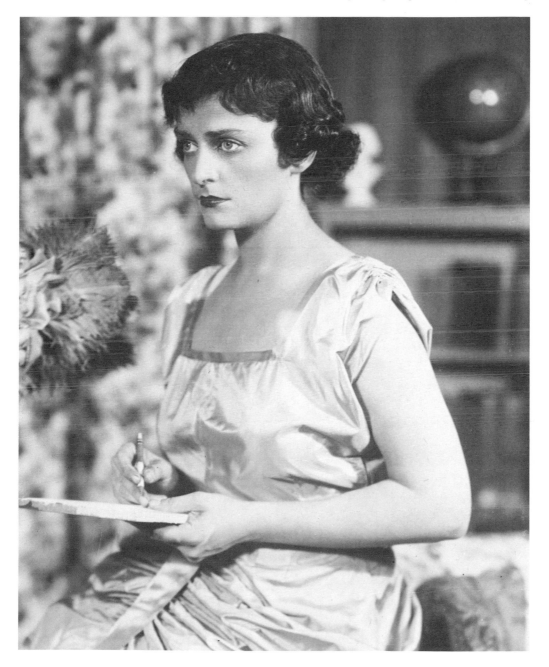

quick and sure Jean, who hardly seemed to need a rehearsal, had mysteriously stolen away and got lost. For some years after the war she was still working, but too often in smaller parts or in smaller places, still drifting away, as if one spring after another had broken, as if the end of her glorious youth, of her Sonias, Violas, Juliets, had brought burdens she felt were harder and harder to carry, as if even while going on she had already decided at heart to give it up. So she drifted out of the theatre altogether. I doubt – though I stand to be corrected – if there was one central and substantial reason for this drift that clouded and then ended ingloriously what had been once a glorious career: the failure of some personal relationship; a refusal to face middle age and the parts it offered; a feeling that she had come into a marvellous theatrical inheritance that had melted away; a lack in her life of the very qualities she suggested on the stage; too many stimulants in dubious company when everything became so grey and boring; probably not one but several of these, at work on her together.

She died in 1962, entirely forgotten by a new generation of playgoers and perhaps only dimly remembered by many of their elders. But there are still some of us who will never forget her, shining in our memory as if at one time spring sunlight illuminated the stage.

George C. Scott

Here is the newest-comer to my list of particular pleasures. A few notes on his career might be useful. He laid down the right foundation for it. After university, he played more than 150 parts in stock companies, but then, at about thirty, made constant appearances in New York in good fat roles. And this, to my mind, is just about right. Do the donkey work in your twenties but choose the right time to get out of it, before too many parts and too little study and rehearsal blur or standardize your acting. In 1965 he came to London, to play Vershinin (a fine part) in *The Three Sisters*, during the World Theatre season at the Aldwych. I missed it, just as I miss so much, because either I want to go to Peru, Canton, New Zealand or don't want to go anywhere at all, happy to sit at home. So I have never seen George C. Scott on the stage. The first time I ever noticed him, when he made me sit up at once, was when he was playing in a TV series about social work in New York, and might have been a sharp knife cutting through a hunk of Double Gloucester – clearly an actor to wait for and watch. Since then I have been able to attend some of his films.

So far I have seen four of them, and the trouble here is that by the time this book appears in print he will probably have arrived at further triumphs. The last I saw, the one about the dolphins, I enjoyed but didn't discover him at his best. This was partly because his role was rather negative – he didn't make things happen but had

things happening to him – but also because he was acted off the screen, as any man would have been, by the infinitely fascinating dolphins themselves. Actors used to be warned against playing scenes with children and dogs, but they can't compete with a talking dolphin. Up to now I think he made his deepest mark on my mind in *Hospital* as the raging, deeply despairing but grimly determined director of the anarchic establishment. You see him in this part in the photographs below.

I take him to be a fiercely independent prickly man – after all, he turned down an Academy Award, the coveted Oscar, for his performance as Patton – who is most at home playing other fiercely independent prickly fellows. This doesn't mean he is doing no acting. Probably working within a fairly narrow range of parts he has to act his head off. But he makes you feel that he isn't acting. You can't believe that a lot of lines have been written for him, that he has had to learn them, has had to deliver them while attending to various chalk marks on the studio floor. All the elaborate paraphernalia of filming seem to have vanished. There he is, snarling abrasively or heatedly uncovering his thoughts, a real man desperately trying to free himself from some bind or other, all of it with tremendous force. It is impossible to ignore him, to attend to somebody else. From his first appearance he captures and holds all your attention, which has to be almost as serious as he is. Other film stars have arisen during recent years, some of them praised at great length, but there isn't one whose future performances I look forward to with such eagerness. Indeed, I don't think of George C. Scott as a film star at all. I see him as the kind of man, nonconforming protesting fiercely eloquent kind of man, I want see and hear again as soon as possible.

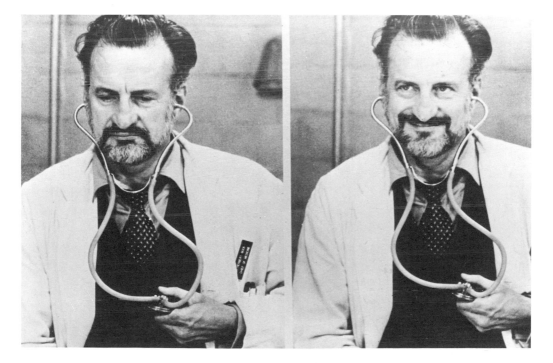

Alastair Sim

Even now I never catch sight of him without remembering, always with affection and regret, my friend O. H. Mavor (James Bridie). I have to put it like that because Mavor died as long ago as January 1951. But I was always seeing them together, perhaps discussing a new Bridie play and a fat part for Sim. They were widely different characters – Mavor burly and humorously aggressive, Sim slender, smooth, vaguely apologetic – yet together they always suggested to me a pair of Scots plotting against the half-effete English. Possibly the Devil came into their talk. After all, didn't they give us one of Bridie's best plays, *Mr Bolfry*, in which Sim finds his manse invaded by the Devil? (This should surprise nobody who knows the literature of Scotland, where the Devil arrived, still alive and kicking, after he had fled from England. Think of Scott, Hogg, Stevenson, Barrie, as well as Bridie, all of them intensely aware of some diabolical element!) And I can imagine a production of *Mr Bolfry* in which Sim swapped parts, playing the sinister visitor instead of the indignant clergyman – as you see him opposite.

Just a glance at Alastair Sim's entry in *Who's Who in the Theatre* will prove that he has in fact played a very wide range of parts. Yet when I think of him, summon him to the mind's eye and ear, he comes in one of two dominating roles. In the first he is a large innocent who, with many an apprehensive stare and perhaps a trembling lip, must prepare himself to face outrage. In the second role he is a rolling-eyed and rather sinister slyboots, ready to make mischief in the second act. I admit that this does less than justice to his range and reasonable versatility, but I can't help feeling that the stern Scots deity that called him to the English stage, from being Fulton Lecturer in Elocution at New College, Edinburgh, decided he should triumph in these two opposite roles. It was also decided – though of course the Devil, wanting to prove what he could do for a good Scot, may have added a brimstone blessing – that he should be a leading actor, not just another supporting character man. Whether he is facing outrage or slyly plotting, he demands and receives your full attention. If he merely carried on a letter in the third act – a very unlikely possibility – you would begin to wonder about this odd visitor from Edinburgh. Though he is, and has long been, a thorough professional, he brings on to the stage his own atmosphere, in which he can do everything his own way, never reminding us of anybody else. (There are leading actors encased within the ghosts of other and better leading actors.) He has for many years now, we might say, led a very successful Border raid, so no wonder he was elected Rector of Edinburgh University from 1948 to 1951. Up there he may be just another clever 'chiel', one of a score or two perhaps, but down here among us he is a triumphant original, to whom we owe many hours of delectable entertainment.

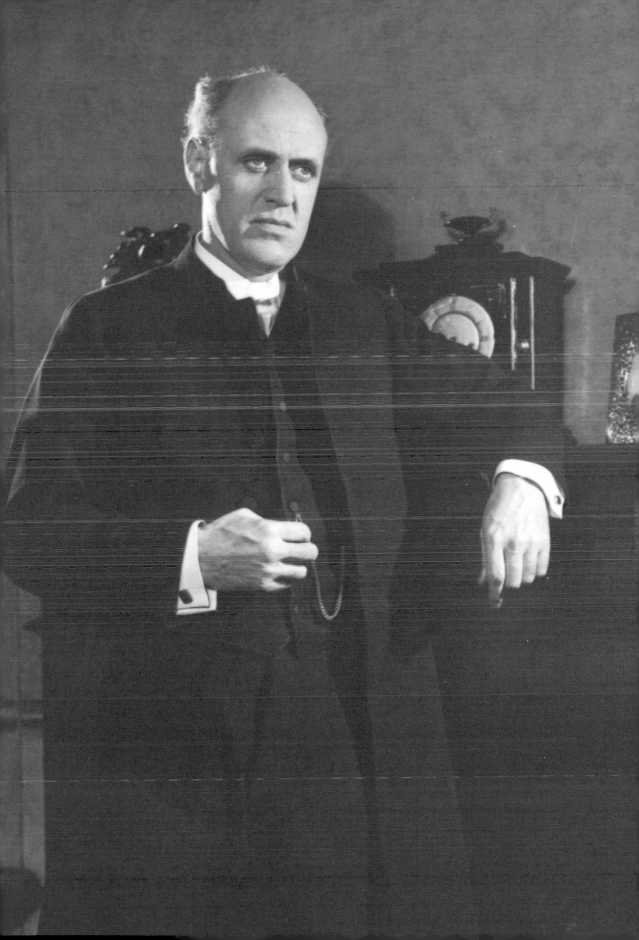

Arthur Sinclair

The last time I spoke to Arthur Sinclair, who had been in a company of mine at the Duchess, was backstage at a production of *Peter Pan* during the war, when I had gone to take a look at a young relative who was playing Wendy. He was Smee and dismissed it at once as 'Only a spit of a part'. And certainly, when compared with all those ripe whiskey-breathing Irish parts he had played for so long, that is all that Smee was. It is a mistake, however, to imagine that Sinclair played nothing else but these fruity Irish characters. He could be reasonably at home in a quite different variety of parts, and announced as one of his two favourites Puff in *The Critic*. The other was Irish enough, being the Blind Man in *The Well of the Saints*. But it seems odd to me that he did not include a part from one of O'Casey's three Dublin plays, *Juno and the Paycock*, *The Shadow of a Gunman*, *The Plough and the Stars*, plays in which he had performed many times and in many places.

I never saw the Abbey Theatre company when the great F. J. McCormick (who died at fifty-six in 1947) and Barry Fitzgerald (who defected to Hollywood) were its leading men. But Sinclair, born in 1883, must have shared the same training, for he did not leave the Abbey, to form his own company, until 1916. The Abbey Theatre and the Fay brothers deserve all the credit they have been awarded. So for that matter does Sean O'Casey, coming along later with his three Dublin plays. (Something was missing, for all their eloquence, from the plays he wrote after settling in

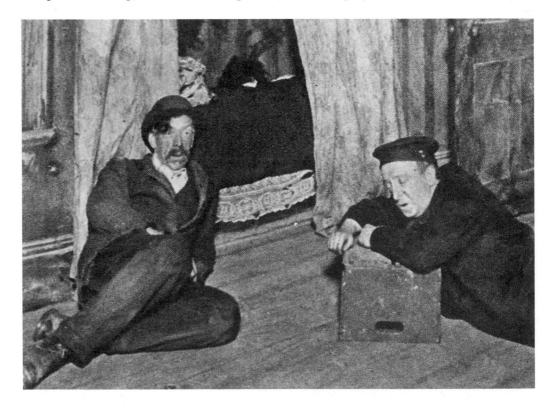

England.) But all the Irish players and playwrights were fortunate, except financially, in their native land. They grew up among people who had a passion for highly flavoured speech. We English of the theatre had to make do with people who would just as soon not talk at all. Or if they did, they would be imploring one another not 'to make a scene'; whereas actors and dramatists have to make a scene. So the Irish in the theatre start way ahead of us. Indeed, they hardly need a theatre at all because they are all living in one.

My most lasting and satisfying memory of Arthur Sinclair is of his performance, which I must have seen several times, as 'Captain' Jack Boyle, the *Paycock* of *Juno and the Paycock*, O'Casey's masterpiece. Barry Fitzgerald may have been better at the Abbey, but I must confess I can't imagine how he could be. I can hear again the solemn nonsense he talks to his sycophantic 'butty', Joxer Daly, about 'Sailin' from the Gulf o' Mexico to the Antanartic Ocean'. Or his immense gentlemanly condescension in Act Two when he is supposed to be coming into money. Or again his increasing wild despair as Act Three brings contempt and ruin and, now drunk, he sees 'the whole world' in a 'terr-ible state o' chassis'. (This is the scene illustrated on the page opposite.) It is all rich comedy on the edge of a black hole of tragedy, and Sinclair was the man to do justice to it in every variety of mood. Here was no 'spit of a part', and even after so many years and so much that has happened its huge daft Irishness winks and gleams in my memory.

Sybil Thorndike

Of Dame Sybil, a dear friend, I once said she was more enthusiastic about everything than I was about anything. I have been credited with a love of life, but compared with Sybil's love of it mine is merely a dubious flirtation. She swept into her nineties like a ship under full sail. But then ever since I have known her she has been under full sail or full steam ahead – or both. She was from every point of view fortunate in her marriage. Not that she and Lewis Casson were alike: in some respects they were quite different. Her natural tendency was towards expansion, enlargement, amplification, while he tended towards a rather grim contraction (though at heart amiable and generous minded), a determined and highly concentrated diminution; so that in their later years it was as if the Queen of the Upper Air were travelling with the Emperor of the Gnomes. But not only did they happily share a satisfying family life, they were also alike in wanting to bring the drama and poetry to people anywhere and everywhere. In March they might be starring in the West End and in June they might be playing to Welsh miners or giving recitals in Zululand. At a time when most performers would have retired to crossword puzzles and needlework in Cheltenham, they would send messages that they had

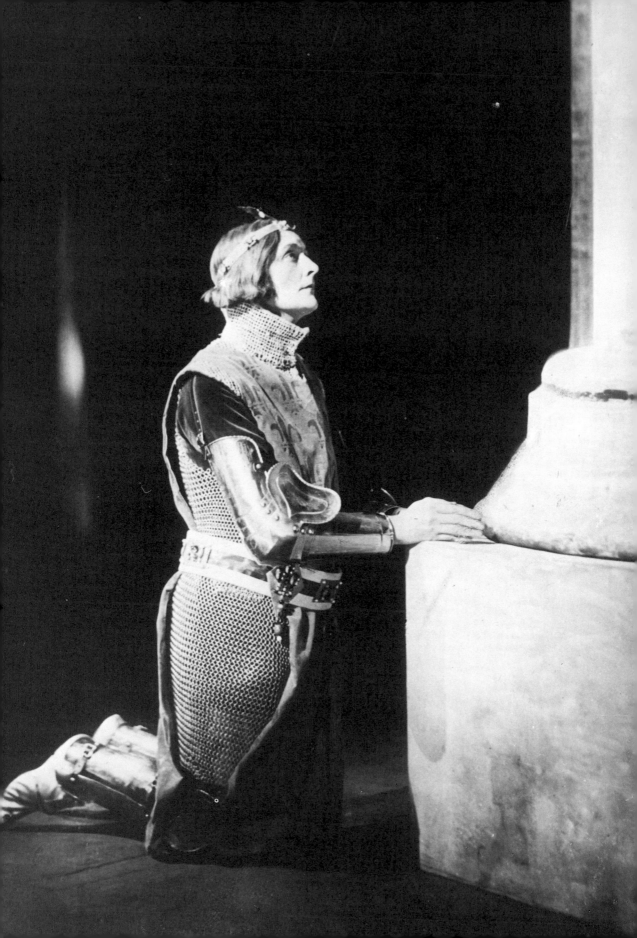

just done something of mine in Ballarat or Tanzania. There was no exhausting their enthusiasm. And they were not showing off, grabbing an audience at all costs: they were doing what they deeply felt to be their duty, communicating their love of their art and their zest, if necessary at the ends of the earth.

Sybil's career takes up six closely printed columns in *Who's Who in the Theatre*. Merely glancing at them sets my mind reeling. It seems like a whirlwind of roles, sometimes with three or four testing big parts played within a week, suggesting the courage of a lioness, the speed of a leopard. There she would be, marching in, handsome and zestful, with that curiously characteristic flexible voice, ready to enjoy the part and everybody connected with it, playing – and now I go back to the winter of 1922–3 – Beatrice in *The Cenci* and then April Mawne in *Advertising April*, clearly two extremes of dramatic art. But what she preferred to do was to tackle the heavyweight jobs, whether in *Saint Joan* (seen in the photograph opposite) or *The Trojan Women*. However, I am going to shuffle away from any attempt to cope with Sybil's career. She may be twelve years my senior but I am old too now, and in a hurry as well, so I close *Who's Who in the Theatre* and open my memories.

She played twice for me, first as Mrs Conway in *Time and the Conways* on Broadway, secondly, opposite Lewis, as his wife in *The Linden Tree* at the Duchess. I was very cunning about this casting. These were both weak petulant women, and of course Sybil was anything but a weak petulant woman. So she was often – perhaps too often – cast as a strong bossy woman, ordering everybody about. But when you are dealing with an actress of great talent, with a superb sense of character, it may be best to cast her dead against her familiar type and real personality, presenting her acting with a sharp challenge. This of course worked with Sybil, who, accepting the challenge, gave us wonderful performances I shall never forget. Who would have thought those two Lindens went happily home together as loving Sybil and devoted Lewis Casson?

The theatre, as you learn when you come to it from outside, has its share of bitchery and treachery. But there are times when eyes soften and tears and smiles are no longer performances. A supreme occasion of this sort was a Sunday night at the Haymarket, when the whole theatre staged a performance, to which I contributed an epilogue, to celebrate Sybil's ninetieth birthday. Never had the famous old playhouse been so warm with affection. That night her unwearying art and her enthusiasm for everybody and everything brought gigantic dividends – and a lesson too to carping types like me. Not quite as spry as before but still, we might say, under full sail, Sybil entered the cheering harbour, after too many voyages to count, an epic existence in the wonderlands of drama, poetry and zestful living.

Spencer Tracy

I never met Spencer Tracy and probably know little more about his character and career than the average filmgoer. Some facts emerge from reference books, notably that he had a more solid background of education, both general and theatrical, and more stage experience than the large majority of film stars. I know that he worked in Hollywood for fifteen years before returning to the New York stage in 1946, though why he waited so long I can't imagine. Nor do I understand why before and after 1946 he consented to appear in so many films, far more than I ever saw, even though I admired him enormously. Did he need the money? Had he a cast-iron demanding contract? Or, finding himself in or near Hollywood, did he prefer working to idling out there? I don't know, and because I am writing this book against time, I can't undertake any research. But then I don't believe that any such research is necessary. All we need to do is to remember him carefully, and then we shall discover the secret of his formidable and indestructible reputation.

A great deal of film acting depends on what we can call 'outer identification'. This calls for plenty of make-up, wigs and whiskers and perhaps nose paste. And even when it asks for little change in the obvious appearance, it will probably demand – and receive – a special voice, a marked manner, certain easily perceived tricks belonging to the assumed personality. The players *are acting at us*. They are saying in effect, 'This is me again of course, but notice how different this time!' And when there is a lot of this, especially if leading players are involved, the story that is being presented can seem thin and obviously contrived, so that it denies us any satisfaction.

Now though Spencer Tracy played many widely different parts, from monuments of integrity to comedy roles with Katherine Hepburn to the crooked chief cop in *It's a Mad Mad Mad Mad World*, he always seemed at first sight to be the same man we had seen before. Apparently he looked and sounded the same. We might almost imagine in our innocence that he wasn't acting at all, just making another appearance. Yet probably before the end of the first sequence this Spencer Tracy character, whatever he might be, seemed to be solidly and convincingly there, like a rock among shifting sands. The very absence of what I have called 'outer identification', so puzzling at first, helped to create this satisfying effect.

His secret was that he always deliberately substituted 'inner identification' in place of the usual 'outer' variety. He started deep inside himself. Before he began acting the character – and of course there had to be acting – he *was* that character. He worked from the centre outwards, unlike the usual 'outer identifier'. He brought to films the essential method of a fine stage actor. No doubt other men and women did too, but not one of them did it more successfully. The very risk he took, refusing the usual obvious aids, depending upon his initial 'inner identification', shaped and then heightened his triumphs. No wonder he was held in such respect by all the more intelligent members of the film colony, no matter what personal weaknesses he may have had, or delighted for so many years film audiences all over the world.

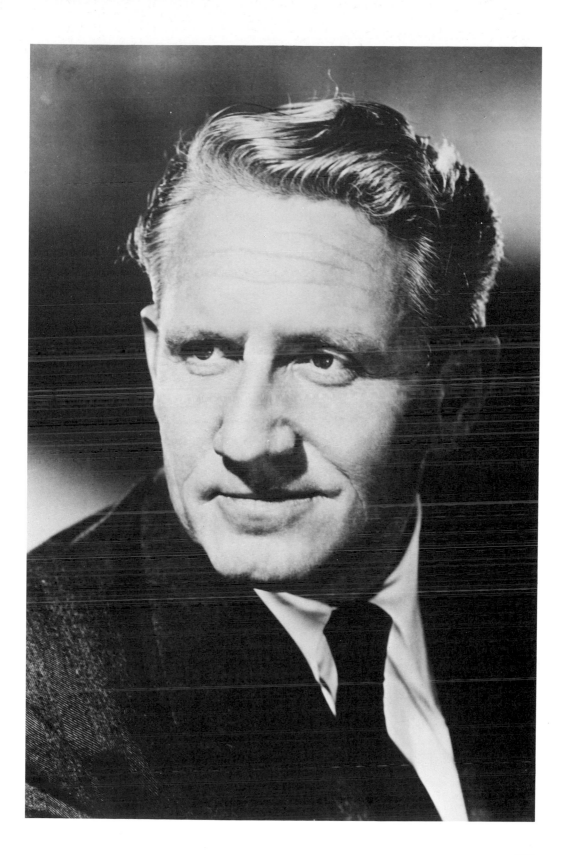

CLOWNING

This is not the easiest section to write, as some of my family and friends seem to think; it will be the hardest. How do you describe a very funny man? Most people don't even try: they simply tell us they fell about or laughed their heads off. But here I can't fall about and must keep my head on. And let nobody imagine it is a question of recalling a lot of jokes. The great drolls I celebrate don't *tell* jokes, they *are* jokes. And then there is another thing. With some examples here I must try to recollect impressions of performances that took place even before 1914 – in another world, we might say. But whether the comics belong to today or to some long-vanished yesterday, I shall try to make a choice between genuine clowning and what seems to me clever funny acting. Certainly the distinction between them may be fine drawn, and perhaps involves the attitude of the audience rather than that of the performer. But I shall assume that the clowner comes in and the actor stays out. All the men included here have never bored me, have always delighted me. When they are reduced to cold print I don't know what will happen, but I do hope that readers not unsympathetic to this section will try to keep their memory or imagination open and free.

The Aldwych Comedians

Here instead of another individual we have a troupe. True, three of them will emerge as individuals, but even so they must be approached as members of a troupe. It was generally believed at the time that although these Aldwych farces had scripts, usually by Ben Travers, their mounting antics owed much to what the troupe worked out during rehearsals. The period between the wars was favourable to farce, which works best in a society that is neither too restrictive nor too permissive. When anything is accepted, it is harder and harder to plot a good farce. A few years ago I amused myself writing a farce, basing it on the belief that nothing is taken seriously nowadays except money and death; but I never showed it to a management because Joe Orton got in first. But even with a promising plot it is an immense advantage to have a team of comedians who know how to work together, and this is why the Aldwych farces, while avoiding any wild originality, were so successful. More than half the secret is not simply getting laughs but building them up so that the audience is almost helpless, beyond any restoration to gravity. And this troupe at the Aldwych in London had the experience, the teamwork, and just the right balance of personalities.

In my own old farce, *When We Are Married*, I allotted importance fairly between the sexes, but in most farces, including those at the Aldwych, the males, both as intriguers and as outraged victims, take most of the spotlights. For this reason I remember the men better than I do the women in the Aldwych troupe. However,

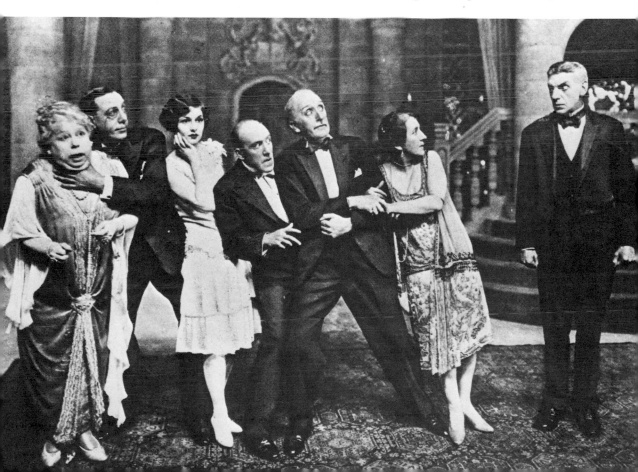

there was Mary Brough, whom I seem to recall as a daunting compact figure, hostile and implacable, a battleaxe. I also remember Ethel Coleridge (she played twice for me in farcical roles), actually an amiable and extremely intelligent woman who could create in a couple of minutes a memorably disagreeable harridan. Even so it is the three leading men of the troupe who dominate my memory.

There was Tom Walls, on the stage a dubious, dark, sardonic character, newly arriving on the scene, one always suspected, from some hocus-pocus on the race course or some fiddling with a roulette table. He was rarely, if ever, a victim, being far removed from bewildered innocence and only knowing outrage if some cynical plotting misfired. But he always had on hand a perfect stage victim in the person of Robertson Hare, a small man born, it appeared, to suffer indignities, lucky indeed if throughout the evening he kept on his trousers. He had a long face for his height, and it lengthened and lengthened as the night's plot thickened, and out of it came extraordinary wails of protest, once heard and then never forgotten. 'Oh – dee-ah!' he would begin, as some monstrous proposition would be put to him; and then, as the situation worsened, perhaps with trousers involved, he would rise, like an affrighted sheep, to 'Oh – cal-amitay!' He was not so ridiculous off the stage of course; nevertheless, I remember his arriving on the wrong week to do a radio show with me during the war, when I heard again his 'Oh – dee-ah dee-ah!'

Last but best of all, the farcical genius of the troupe, was Ralph Lynn. He usually played a rather vague monocled fellow who might have drifted out of a Wodehouse novel. But his value to the troupe could not be over-estimated. He was a wonder at building up laughs by absurd bits of business or acting as a kind of sticky solution in which the whole wild nonsense was held together. A man with an equal amount of talent, perhaps with a touch of genius, in any other branch of drama would have earned a great solid reputation, probably one of those knighthoods; yet once the long Aldwych season was over and the troupe dispersed, there was no starring in the West End and I seem to recall his association with rather humble provincial tours – the glory gone; older now; beginning to feel tired after all that farcical fussy business to build up our laughs. Well, one playgoer remembers him with admiration and affection: bravo Ralph Lynn!

Jack Benny

Probably there is much to be said for the idea that the comic should work at one extreme or the other: either he must be faster and busier than anybody else sharing the stage with him or he must do less and be much slower, as if existing in a time of his own. Which also means of course that he must take pains to avoid working at the same pace as everybody else. Most notable comics are faster and busier,

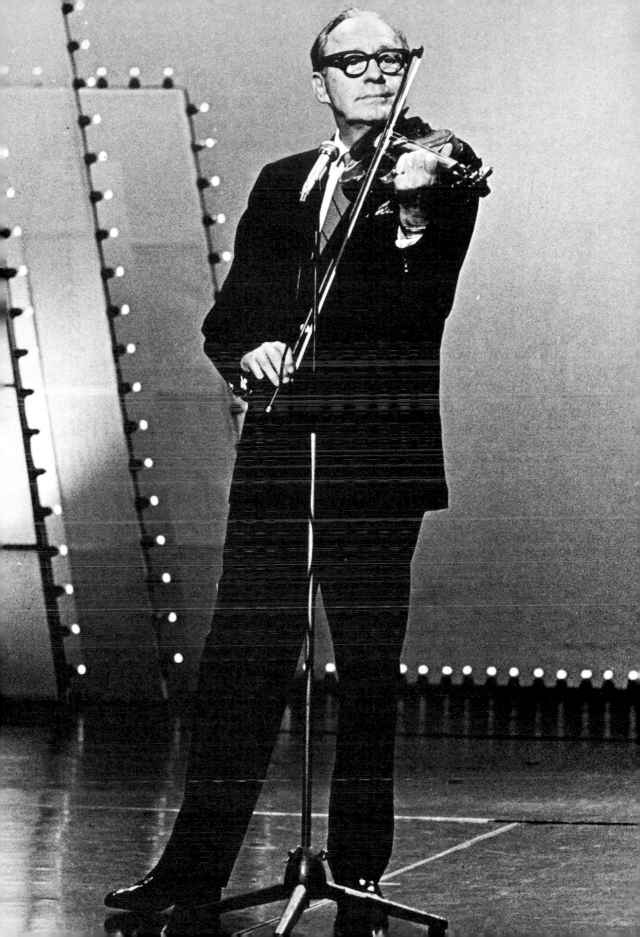

especially those who are involved in farcical situations, compelling them to struggle like half-demented creatures, and forcing us to laugh at their antics. There are far fewer who move towards the opposite extreme, who deliberately slow themselves up, taking their own peculiar time. And among these slower-uppers it seems to me that the supreme master, on radio, television and the stage, was Jack Benny. I always took a particular pleasure in watching him taking charge of the stage.

To begin with, he seemed completely relaxed, entirely calm and at ease. Apparently this was very much a part of his performance. Away from the stage he was not this kind of man at all. His wife has told us so, and she ought to know. According to her he was usually fathoms deep in anxiety; he worried and worried about anything and everything; he was – I think she said – 'a nail biter'. Also, his colleague and old friend, George Burns, has described how Benny could lose his self-control, dissolving into laughter perhaps at awkward moments, at the least suggestion of anything ludicrous. Yet on the stage there was no trace of this real self. The 'nail biter' or compulsive giggler was transformed into the most relaxed man in Southern California. All those Americans who have been told 'You *must* relax', which of course is idiotic because it cancels itself out, ought to have paid handsomely just to watch Jack Benny at work.

However, though all was well at first, and there he would be, entirely calm and at ease, very soon he had to suffer a sense of outrage – perhaps he had been committed to spending a few dollars, the age of his automobile was derided, or there may have been some doubt about his violin playing. There was no immediate noisy reaction. We were in Benny-time. He was really horrified – we knew that from his hollow look – but he turned away, probably put a hand to his cheek (a favourite gesture), and suffered in silence. He may have said nothing, he may have done nothing, but he still claimed our attention, never allowed to stray elsewhere. In fact he could probably claim more of it than some noisy busy comic bursting with rage. Benny compelled us to wait, to accept his time in place of ours. Finally, rising above his sense of outrage, in a voice completely under control, he made some mild protest. And somehow it was very funny, much funnier than if he had been bellowing at the top of his voice, purple in the face.

No doubt in many a drama-school lesson, students are taught to reply promptly on cue, to keep the table tennis of dialogue moving briskly. Jack Benny would have been barred from such schools. He could allow a question to fade away and almost be forgotten before deciding to reply to it. He might not have uttered a sound, have hardly moved a muscle, but we waited, still concentrating upon him. Certainly he was the leading man and we knew from experience that he was worth our concentration; but there was really more in it than that. What he was doing was a highly dangerous personal exercise in timing, an art in itself. What enabled him to know how long he could afford to make us wait? Was it instinct or experience or a combination of the two that created him a master of slow-motion drollery? Will there ever be another his equal? I ask these questions but I can't answer them.

Charlie Chaplin: Some Notes at Random

Charlie Chaplin, the most famous clown the world has ever known, can't be left out, yet, so much having been written about him already, he can't be given the same treatment as his fellow clowns and comedians. All I can offer here are some random and very personal notes. First it is worth while explaining why so many youngish film enthusiasts have moved away from him to make a cult of Keaton. Two main reasons can be discovered here. The Tramp was really an Edwardian archetype: you wrote *Enter a Tramp* then, and that was enough, everybody understood. Chaplin carried the character forward, successfully enough, but sooner or later it was bound to seem an outworn convention. Nowadays either there are no tramps, in the old sense, or our society has millions of tramps, though not reflecting Chaplin's character. It is the same with Chaplin's sentimental association, all too familiar, with the innocent pure young girl; it is long out of date, now that young girls won't hesitate to march boy friends straight to bed.

In Chaplin's early slapstick films, often rushed into production without a glimpse of a script, there is a great deal that is merely routine, hardly worth preserving. On the other hand, there are some nuggets of gold in them thar desert hills, little scenes that show us Chaplin's highly personal comedy at its best. (A superb example can be found in *The Pawnshop* when a man brings in a small alarm clock and Charlie takes a tin-opener to it.) And I suggest that the old master himself or somebody whose judgment he can trust goes through these early films and separates the gold from the rubble. The final product could be a film I would go a long way to see.

Perhaps Chaplin found his richest thick seam during the years when he was making his own long films and the talkies had not arrived to worry him. I have in mind *Shoulder Arms, The Pilgrim* and, perhaps my favourite, *The Gold Rush*, all hilarious and satisfying. It is easy to understand why the talkies deeply disturbed him. They were a menace not because they would force him to use his own voice – for indeed there was nothing wrong with it – but because, with their closer approach to reality, they put an end to the highly artificial fantastic world of silent miming, where all his victories had taken place for so long. Uneasiness set in, and this probably explains why we had to take a blind heroine in *City Lights*.

He did better, really his best for some time, in *Modern Times*, a film that is able to make its social comment pictorially, as part of the uproarious fun, not offering it to us in a forced speech. I may be wrong about this, but *The Great Dictator* seemed to me based on a bad idea from which it never recovered. Taken as black comedy, *Monsieur Verdoux* was not a bad idea but I can't help feeling that while Chaplin should have directed it he ought to have given the leading part to a good actor not necessarily known for his work in broad comedy. (Some of us, old admirers, felt Charlie was doing too much all by himself – dialogue, music, the lot.) On the other hand, I thought that many of the critics, restive by this time, did far less than justice to *Limelight*, which had in it a good deal more substance and thought –

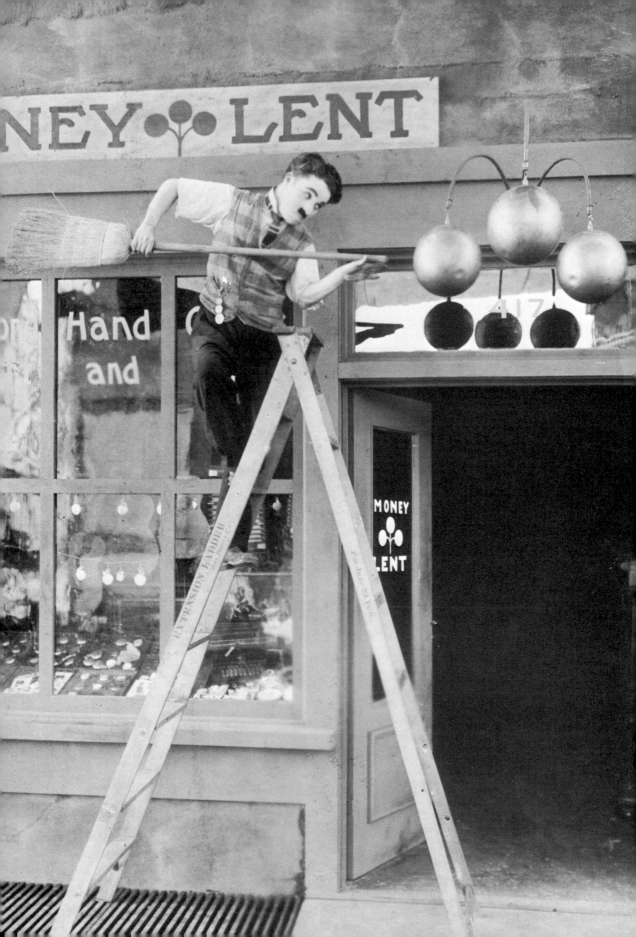

notably about success and failure – than they took the trouble to discover. And I for one would gladly attend a revival of it.

Now I shall repeat, more or less, what I have said elsewhere. I gather that Chaplin, like many another ageing man, often returns in memory to the years of his childhood and early youth, as well he might after more than half a century of world fame. And it is those years and the lost world of the London poor in the 1890s that ought to have provided him with a film, potentially a great film, and *not* Kings in New York or Countesses from Hong Kong, mere subjects that exercise no power in his own inner world. And now, I imagine, it is probably too late. But there, we old men easily make mistakes: no doubt I have just made several myself.

Tommy Cooper

I wonder if Tommy Cooper is old enough to have seen, even as a young boy, the wildly original act of the American, van Hoven. This man appeared as a conventional conjurer, solemn and immaculately dressed, but all his tricks went wrong. He was assisted by three sullen urchins, holding eggs and blocks of ice. By the end of the act, now deep in despair his voice was almost gone, his clothes were a wreck, eggs were falling, blocks of ice melting, the three urchins were hating him, and we were laughing until it hurt. I bring in van Hoven because I seem to remember that when I first saw Tommy Cooper he depended to some extent on conjuring tricks that were not coming off. Since then, however, his act has taken its own wild course, and he is an original too – there is none like him, none.

His appeal, though wide enough to bring him into television (but he is better on the stage, very much *in person*), is more limited than most of the clowns and comedians I describe here. I have an idea – and if I am wrong I apologize to Mr Cooper – that many women do not warm to his act, which is altogether too daft for them. On the stage or in cabaret, where he might be even closer to them, he alarms them, for a reason we shall discover. But if the *idea* of him amuses you, as it always does me, then he can't fail to make you laugh – and your laughter can be nearly as wild as his performance.

Perhaps the best brief description of Tommy Cooper would be that he is a giant zany. He is a big man, adding to his height by the tall red fez he wears, and he has a large-featured craggy face, suggesting the boss of some construction gang rather than any kind of entertainer. Seemingly he is never at ease. It is as if he is giving a trial performance in an amateur hour. At times he can be quiet and still, perhaps holding a short length of white rope, waiting for it to do something that it refuses to do for this bungling conjurer. Usually, however, he is very restless indeed, trying some gadget that fails him or hurrying off to bring on some bit of nonsense that he

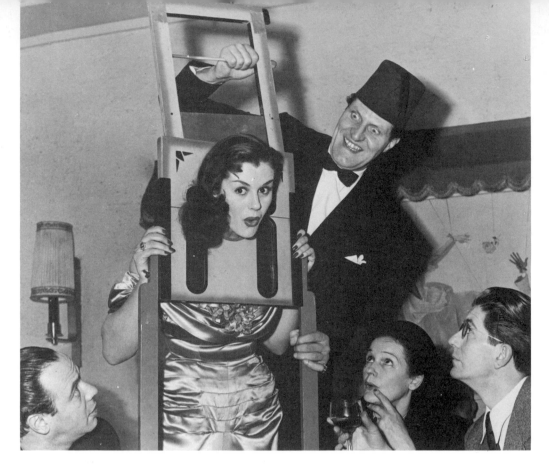

hopes will amuse us, all the while almost terrifying us with a half-mad high giggle, out of all proportion to his size and weight. He will do a sketch of sorts, playing all the characters by rapidly changing hats and finally desperately failing to keep it up. He may have one trick that works, a simple gadget, so he hurriedly includes this just to console himself and us. And, surprising as it may seem to anybody who does not know his act, he makes us laugh and laugh and multiplies his audiences.

Why is this? His jokes aren't witty, just silly; his tricks don't work; he is wasting his energy and our time running off and then on again to show us something non-sensical; and he never suggests anybody we have ever known. But he is, I repeat, a giant zany, not relating to commonsense at all, except in one particular: that he is playing a man, and a very large man at that, desperately anxious to entertain us but apparently shockingly equipped to do so. And there is something else. That craggy convulsed face, the sudden daft grin, those rolling eyes, and, perhaps above all, that almost insane high giggle, together make us feel, in some dark corner of the mind, that we might have here a dangerous lunatic capable of something appalling. Fear stirs and quivers in that dark corner but then in the lighted places of the mind we realize we are watching the performance of a well-known comic – and so we laugh and laugh. Is Tommy Cooper a depth psychologist? The odds are heavily against it. But even so either he or somebody masterminding his act has gone to work with some valuable intuitions.

Sid Field

In his excellent novel, *The Comic*, Brian Glanville has his comedian, Johnny Lucas, raving more than once about the idol of his youth, Sid Field. This is understandable. Wartime London needed a new broad comedian, and Field was brought from Birmingham and provincial touring to meet that need, turning an extremely noisy and undistinguished revue into a huge West End success. Within a week or so he was a star comic. This was in 1943, and seven years later he was dead, apparently only forty-five. I must say this figure surprises me because it means that when I first met him he must have been still in his thirties and he looked much older, with that big battered face of his. I came across him several times outside the theatre but was not really well acquainted with him. Something, I feel, went wrong – perhaps he was drinking too much, perhaps he was already a sick man – but he didn't really develop as he ought to have done after he left his revue. Possibly instead of staying in the West End he ought to have gone on tour, putting together and perfecting some new sketches. Potentially he was a great comic, but he needed more material, more time, to grow and ripen. (I can't help feeling he ought to have been born twenty-five years earlier.) In spite of that horribly noisy revue, I saw his performance in it several times and remember it reasonably well.

His most successful sketch, based on a golfing lesson, was not my favourite. It was really a jazzed-up roaring version of the old two-man crosstalk act, with the

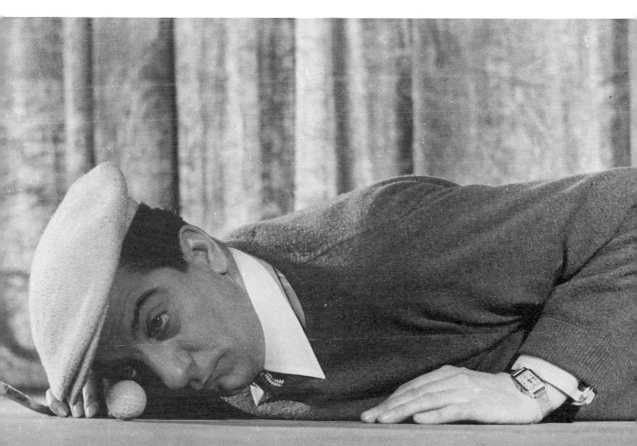

golf instructor the increasingly angry straight man and Field the bewildered innocent comic. So Field is told to 'address the ball'. '*Address the ball?*' 'Yes, go on – address the ball.' After a moment's bewilderment, Field stares at the thing and then begins, 'Dear ball – ' And so on and so forth, laughable when played for all it was worth, but not really worth very much. Field could do much better, and did.

He created two characters, larger-than-life of course and absurd, but characters, unlike the golfing crosstalker. The first was his musician, large and bland and utterly utterly refined. Some announcement about a fugue – drawn out into few-ew-ger – I seem to remember was broken into rudely by a voice from the gallery, the voice of one deaf to music and all higher things. Musical Field was taken aback but was able to combine good manners with a certain hauteur, and, staring upward, cried, 'I beg your very very pardon.' But the second character was even better and I would have gleefully accepted far more of him than the programme allowed us. This was an outsize pansy photographer, with an enormous tongue like a *Welcome* on a mat, who had an outlook divided between affection and snobbery. Perhaps I ought to have mentioned a Field character who appeared earlier in the revue, one Slasher Green (I think), a 'spiv' or 'wide boy' of the period; but he was well below the level of the musician or the photographer.

Poor Sid Field! No comic can ever have had a greater immediate success, going up like a rocket that exploded its gold and silver in the darkness of wartime London; yet it all ended in some years of bewilderment and then an early death. He never had time to secure a place among the very great drolls, but he brought laughter to many people during nights when they may have been in desperate need of it.

W.C. Fields

I never met him, and I ought to have done because when I was visiting Hollywood in the later 1930s I was commissioned to write the treatment of a film for him. The studio paid me handsomely but never made the film. Possibly he wanted to draft some huge absurdity of his own, or again perhaps his habits, which by this time included enjoying a pitcher of dry martinis for breakfast, brought their own difficulties. I had seen and appreciated his act many years before, when he was touring English music halls as a comic juggler, offering genuine great skill and elaborate tomfoolery with cigar boxes and a billiards table. I seem to remember he never really spoke, beyond a few muttered curses, in this act, but no doubt the germ of the famous comic character he afterwards became was already there. He went from vaudeville into Broadway musicals, where he played grumpy comic leads, and then it was an easy step to Hollywood films and new gigantic audiences. Not in good shape in his last years, he died, aged sixty-seven, in 1946. But not only

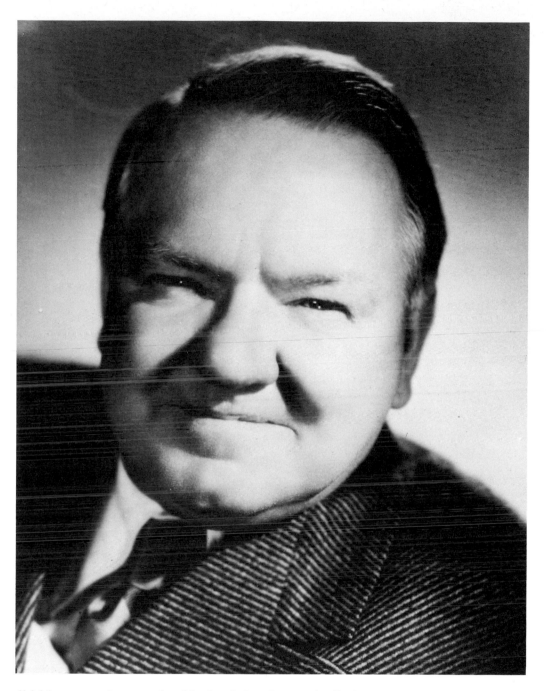

did his reputation survive his death but he gradually became something of a cult figure, his humour legendary to a new generation of filmgoers, eager to attend W.C. Fields festivals.

We can discover two different aspects of his comedy. In the first, the more general, he is really a figure out of American folklore. He is the man with a dubious background and no particular gifts, not determined but vaguely hopeful for a time

of making good at something or other. He is temporarily optimistic, though a deep-lying pessimism is always there. In the bars he haunts, rather desperately he tries to soft-soap or 'sweet-talk' men who could be useful to him, though he is almost always ready to meet any rebuff with a sudden snarl of disgust, abandoning at once his sickly approach. Here he is a larger-than-life comic version of men, notorious for never succeeding in anything, known in hundreds of American small towns, where their despairing wives have to run boarding houses. And though Fields was certainly never one of these men, he found it easy to play – and then sardonically overplay – such a familiar type, mocking its vague optimism, its bouts of slimy sycophancy, its fundamental sloppiness. He enjoyed it because he himself was not this kind of man at all.

However, the second aspect of his comedy takes us closer to his own life. His boyhood and youth had been very hard indeed, passed in a world that seemed either indifferent or hostile. The feelings that take possession of us during our most impressionable years rarely abandon us entirely, however different our later circumstances might be. This would explain Fields' suspicion and aggressive style, which can be heard in that extraordinary voice of his, something between a nasal drawl and a muted foghorn. When he came to develop his comedy, using the intuition of a great clown, he deliberately played a character haunted by the idea of a completely hostile world. Instead of suppressing his natural feeling, he enlarged it fantastically, blew it up to make it more and more ridiculous. So no matter where this Fields character goes, enemies are everywhere. What most men welcome, women and children and dogs, he regards as menaces. But this is only the beginning. An empty room can be a trap. Any kind of apparatus can threaten him. A table or a chest of drawers can be an implacable enemy. He can give a folded napkin or a couple of spoons an over-the-shoulder suspicious look. He can glance around and breathe heavily before trying a chair. Though not entirely without hope, for round the corner there might be a bottle of bourbon and a cigar and a haven at last, he is doomed to spend most of his time in a world continually plotting against him, for ever threatening him, down to its last empty tin or loose screw. And it is here, to my mind, we find his richest vein of humour. No wonder there is now – when our own worlds rarely feel safe – a W.C. Fields cult. He is more suspicious and more afraid of more things than we are. So we laugh.

The Fratellini

I may well have been a circus enthusiast when I was a boy, and I still have an awesome recollection of the vast Barnum and Bailey show, with its three rings and a big top that looked as if it could cover a small town. However, as soon as I grew up

I came to believe, as I still do, that 'Circus' has received a lot of lush romantic treatment that it has never really earned. Too much of what it offers seems to me either boring or embarrassing. If I clap the acrobats, trapeze artistes, tightrope walkers, it is because they are bowing and I am glad to be done with them. If the performing animals are natural show-offs, like dogs and chimpanzees, they are tedious; and if they seem to hate their humiliation, as elephants appear to do, they are embarrassing or saddening. The horses or ponies and their girl riders can produce a pretty spectacle, but only, in my eyes, for a couple of minutes. This leaves the clowns, and in a few, a very few, circuses there have been some great clowns. But these have always been hard to find. In the average circus the clowns are artisans, all grotesque make-up and routine gags. But soaring high among the rare exceptions were those three Italian brothers, The Fratellini, who brought me delight whenever I saw them in Paris during the 1930s. I would go to the circus only to enjoy them.

Unlike ordinary clowns they represented a social structure, as if visiting us from some Clowndom that had its own division into classes. (But were they mocking us? It is just possible.) All three were clowns of course but at the same time were quite different. Their whole appearance indicated the class to which they belonged in Clowndom. Number One was quite beautifully dressed; handsome, confident, full of authority and privilege; he was the only aristocratic clown I have ever seen. Number Two, sombrely if still clownishly dressed, obviously came from the professional middle class of the distant realm. He took orders from Number One

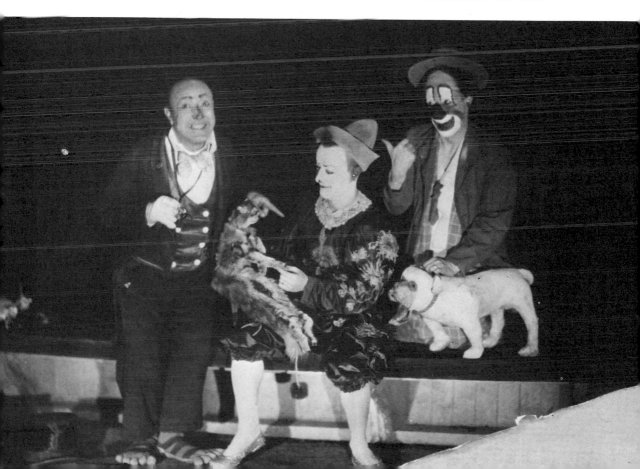

but soon passed them on, if any labour was involved, to Number Three. This last, an Auguste always nearly coming to pieces, had been imported from the most depressed and forlorn class in Clowndom, a dazed and hopeless proletarian if ever I saw one. And whatever work had to be done, muttering and stumbling, he did it.

I seem to remember quite clearly one of their acts. Number One arrived in the ring, fresh as a daisy, looking about him as if wondering where to settle. Number Two, anxious and conscientious, a good professional type, came in a moment later, to confer and accept any orders coming down from the upper class. Then he turned about to make an abrupt authoritative gesture, to bring on Number Three, not only about to fall to pieces but also weighed down with a monstrous amount of baggage. Number One, without deigning to speak, pointed to another part of the ring, and delicately began to move there, ignoring the lower classes behind him. Number Two gave an order, perhaps couched in legal form, to Number Three, who by this time, poor fellow, had divested himself of all that baggage and was trying to enjoy a rest while still falling to pieces. Muttering and groaning he took up his load again, to stumble after his betters. But no sooner had Number Three arrived with his burden of baggage than Number One, nothing if not arbitrary and capricious, had changed his mind and decided on another part of the ring. So it went on, though I believe at some point poor Number Three threw down all his trunks and cases and refused to move, whereupon Numbers One and Two, out-raged, turned on him and probably reminded him of the iron laws of Clowndom, under which he still served. I realize that all this seems sad rather than funny. But it was very funny and yet rather sad at the same time. Great clowns are able to mix our feelings in this way – and remember all three were indisputably clowns. Were The Fratellini mocking us as well as making us laugh? I suspect they were.

Grock

I saw him many times and to me he was the emperor of all clowns. He was a large man who looked even bigger because his trousers were so baggy. At one end of his face was a huge bald dome and at the other a long jutting chin, together suggesting intellectuality and determination, which in their own way, as we shall discover, were displayed in his act. His clown mouth offered an equally large and permanently ingratiating smile. He was generous to sight but not to the ear, which could only catch small whinnying sounds that might express satisfaction or dismay. He hadn't joined us to be funny – far from it – but to present to us a tiny concert, which would probably include the piano, a violin, and on occasion, for he varied his act, a small accordion that he liked to play while perched on the back of a chair. He made no use of elaborate gadgets, gimmicks, gags, for these would have been out of charac-

ter. Odd things happened, certainly, quite unexpected in a refined musical act, but these were not out of character, not at least as soon as we understood it.

The secret of Grock – over and above his inventiveness and wonderful timing – was that he apparently found himself in a completely strange situation. He wasn't one of us. Serious, modest but hopeful, he came from some distant alien civilization, perhaps from another planet. Our familiar arrangements baffled him. Ordinary things here challenged and defied him. So it was difficult for him even to begin the musical entertainment he had planned for us. No doubt in his home far away he could play the piano, possibly a very humble version of the instrument, but the grand piano provided for him here was strange and hostile. Just as he was settling down to play – after moving the enormous thing to the stool, moving the stool perhaps being forbidden in his country – the lid would fall on his fingers. (This always came as a surprise, not only to him but even to us who would have seen it happen before, such was his superb timing.) Finally, still hopeful but a little clouded by despair of that keyboard lid, he would climb up, remove the lid and come sliding down it, his long face illuminated by a sudden joy. Something, at least, had been achieved.

His violin gave him as much trouble. On some occasions, leaving the stage on a mysterious errand, he would carefully put down the bow to his right and the violin itself to his left, where it belonged. Returning, ready to play for us, the

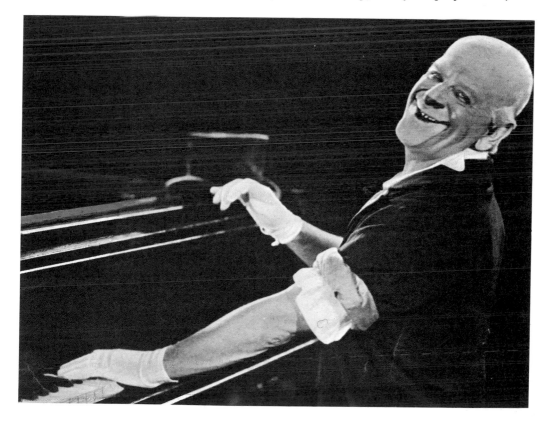

victim of our strange laws, he would discover to his dismay that the bow was offering itself to his left hand and the violin to his right, a bewildering situation. Again, on other occasions he would decide to show off a little. All set to play at last, he would listen to the orchestra giving him his introduction, then a spirit of bravado would tempt him to toss his bow in the air – only he would fail to catch it. He would then retire behind a screen and above it we would see the bow rising and falling, obviously being caught every time. Out he would come, beaming, face the orchestra's introduction once more, confidently toss the bow into the air – and miss it again.

But it is no use trying to describe how many things went wrong for this hopeful visitor, so anxious to make music for us, so often dismayed though never somehow completely humiliated. (There were times when he shared his act with a solemn musical partner, but he was better working alone.) It is my belief that even if a first-class comic had accurately reproduced all Grock's funny disasters, though we might have laughed we would never have laughed so long and loud. It was the atmosphere he created and in which his stage presence existed that did the trick before any smaller tricks had arrived. It was the idea that he was a visitor from some distant clown country, together with his beaming innocence and seriousness, that captivated us, then doubled the humour of everything. Here was a man who made us laugh and laugh and laugh and yet made us feel he was never trying to be funny. This is clowning at a high peak, where schools of philosophy might meet to consider it.

Tony Hancock

Let us have all the chief facts first. Anthony John Hancock was born in Birmingham in 1924 but grew up in Bournemouth. His father was an easy-going convivial fellow, a part-time entertainer, who died when Tony was eleven. His mother was a strong-minded energetic woman, with whom he had a close relationship to the end of his life. He came out of the RAF determined to become a professional comedian, had a hard struggle for some years, then delighted a large public on radio and finally reached his peak of popularity on TV. By 1961 his was a household name, rewarded by enormous fees. He began to behave badly; wrecked two marriages; drove producers and writers to despair; drank heavily; and finally, his act and his life in ruins, committed suicide in Australia in 1968. It is the story of a great but tragic clown.

I saw him first on the stage, before he became famous, and was so fascinated by his performance that I went backstage afterwards to talk to him. The material he was using was poor stuff – so-so impersonations, Shakespearean burlesque, that

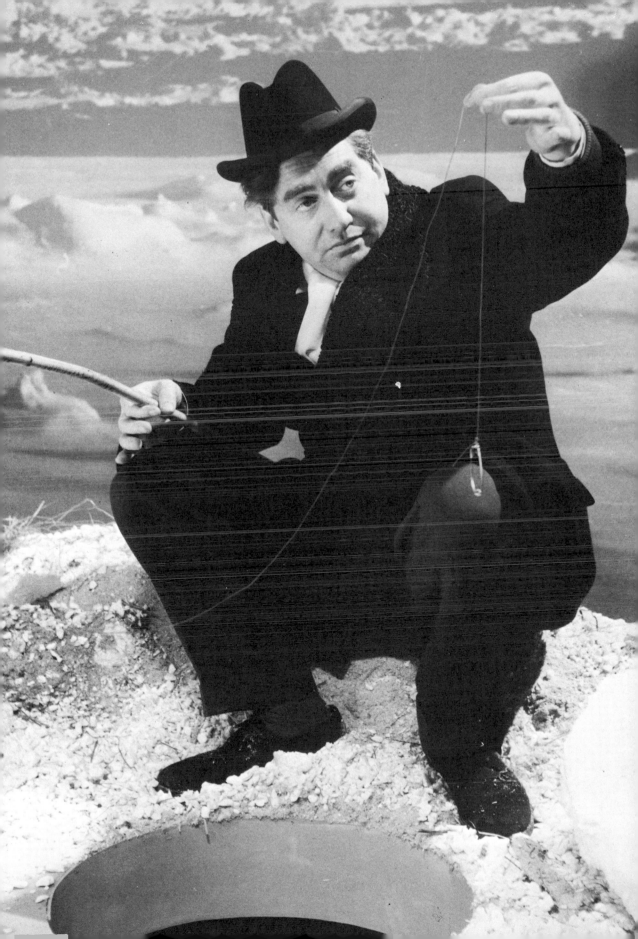

kind of thing – but what roused my interest was the psychological distance he put between himself and his act. He was not a routine comedian doing an act but another kind of comedian despairing of an act. The bitter smile and the gleaming eyes, reflecting one's own distaste for such stuff, created the real humour of the occasion. He was being funny on another deeper level. Here was an unusual comic – 'in depth' as people were beginning to say about that time.

In the close work of TV he came into his own. He was beautifully equipped for the job : a superbly controlled mobile face; expressive eyes, lighting up or darkening; a voice, always wonderfully timed, answering to every demand; he had it all. And though he deliberately avoided pathos, despising the 'little-man' appeal, there was still this suggestion of depth. His pretensions as this TV character were absurd, making us laugh every week (and would make us laugh again next week, month, year), and yet this was somebody close to mass man of today, coming out of the faceless crowd, hopeful, near to glory, for some minutes, before the lid comes on again, before he shrugs his way back into the dark.

With the aid of two effective writers – and this must be admitted – Hancock in these programmes could do more for TV alone in one room than routine comics, any half dozen of them, with expensive supporting casts and extravagant productions, British or American. It was here, though he didn't realize it, that he arrived at a creative balance he was never to reach again. And it is just possible that with less publicity, less money (not enough to indulge every whim), he might possibly have maintained that balance. But now the story goes that vanity soared to megalomania, that all the quarrels began, that when failure threatened there were more drinking bouts to blur reality. Superficially this fits the facts but it does not, in my opinion, do justice to a complicated personality, not even perhaps to the uneasy careers and the doubts and dilemmas of clowns in general. After all, to devote your life to making people laugh, to be menaced by shame and oblivion when a bit of funny business falls flat, is a fairly desperate enterprise, even to well-integrated stable types. And Hancock was anything but that. He was indeed the tragic clown.

Outwardly he was planning larger conquests, ready to talk all night about every aspect of the subject. But there was an inner Hancock, the one who drove him to buy large works on philosophy, which he had not the patience to master. This other Hancock, I am convinced, despised and detested showbiz. He was the dazzlingly popular comedian's implacable enemy. He was bent on ruining that career which was to be more and more impressive. If a marriage would help it, then the marriage went wrong. If efficient colleagues were necessary, then they were driven away. If too much drink made learning lines difficult or at last impossible, then there had to be too much drink. If engagements were broken, promises not kept, idle whims taking the place of serious business, then so much the better for the destruction of this outward Hancock. Deep down below, steadily at work with nothing else steadily at work, were distaste, disgust, and the awful power of self-destruction.

Did some intuitive perception of this flash into my mind when I saw him that first evening, when I had to go backstage – something I rarely do – to talk to him? Probably not: it is easy to flatter our perceptions. But certainly I felt obscurely that here was a man who might become the foremost clown for millions, who would be very funny indeed and yet suggest an unusual shadowy depth. But of course I never knew that the shadow would come up and spread until he was lost in darkness, lonely and lost at the other end of the world, and had to surrender his very life itself. There cannot have been any more notable and poignant example of the Tragic Clown. The final irony is that he hated pathos, and now seems nothing if not pathetic.

Leslie Henson

One evening in the winter of 1923-4 I had to provide a girl with an evening's very lively entertainment; for the time being, as people used to say, to take her out of herself. This was necessary because she was returning the next morning to hospital, and the future was already darkening. So we went to the Winter Garden Theatre, where the principal comedian in a musical comedy was Leslie Henson. He was then, still a youngish man, at the top of his form. So numerous and so irresistible were his antics, japes, grimaces and drolleries of every sort that all thought of the hospital was banished for the evening. They also serve, we must remember, who prance around, crack wheezes in wheezy voices, and pull astounding faces. If they are indefatigable and sufficiently inventive, comedians unknowingly may have their great moments, throwing a light into a dark place for two strangers. I had of course seen Leslie Henson before. Indeed, I had seen him first when he was very young, two or three years before the First World War, when he arrived in Bradford with a touring concert party. And he was very funny even then.

In his earlier and best years, his stage appearance was a gift from (and to) the gods. (He is on the right in the photograph overleaf, with Sydney Howard in *Funny Face*.) How to describe that face? I might say that it was a combination of the Frog footman and the Fish footman in *Alice in Wonderland*. He could goggle as perhaps no other comedian or clown has ever been able to do. This, above a mouth that dropped wide open, was important to him. He was essentially one of those comedians who are always victims. Unexpected and rather unpleasant things kept happening to him, if only to make him goggle away. As a rule the characters he played were either witless refugees from Wodehouse's *Drones Club* or members of a lower class who somehow found themselves, probably at bay, among their social superiors. In any event, the voice was always more or less the same – very hoarse, removed from all music, but appealing in its frequent despair because its protests

seemed to come from a shocking sore throat. But though often helplessly clamped into the idiot workings of musical-comedy plots, he was never an immobile victim. He was tireless in his efforts to escape his destiny. He goggled and wriggled upstage and downstage, hurried off, came on again in a greater hurry, often to make some final and humiliating disclosure two minutes before the curtain came down. And all this, I need hardly add, for my particular pleasure on many an evening.

But then a curious thing happened. I cannot put even a rough date to it, but it was certainly a great many years before he died, in 1957. Quite suddenly I discovered he was not only no longer very funny, a wonderful comedian, he had ceased to be funny at all. He was still working hard at it, just as he had always done, but now he never made me laugh. The droll magic had vanished. He wasn't ill, wasn't tired out, yet something inside him – a fiery comic spirit, a spring of tireless life – had gone, never to return and delight me. It may be that he had gone too deep into management: going to meetings, working out percentages, attending auditions; so drawing a veil of solemnity over his antics. Or perhaps it was middle age itself that took the zest out of his clowning. But if I am to be believed – and I would hate to be unfair to one of my favourite comedians – after playing the comic victim so often he became the permanent victim of some strange development in his nature. Perhaps he could goggle no longer, perhaps hated that frog-fish face that had kept us laughing throughout so many evenings now fading into the past. But at least there is one evening still bright in memory, the evening when he banished one stricken girl's dread of what the next day might bring.

Sydney Howard

It is now nearly thirty years since Sydney Howard died, only sixty, but many older readers must have pleasant memories of him as a highly original droll. He was not a solo turn, a music-hall comedian, and was best known for his performances in musicals and revues during the 1930s and the Second World War. Douglas Furber, who wrote dozens of these shows and was an authority on their comics, once told me that Howard was his favourite comedian. He was one of mine too, at least during his own era. It was proof of his enterprise and originality that while he was born and grew up in a small mill town in the West Riding he didn't take the easy way out and turn himself into a Yorkshire comic. He transformed himself into quite a different sort of character. You engaged him if you wanted a butler (the picture opposite shows him as Herbert, left, in *Funny Face*) or at least a stately but cynical personage of that order. Within this range he had a style and manner entirely his own. There was nobody holding the stage at all like him.

His deportment was impressive and he had a large solemn face. The eyes that looked out of this face, never with any enthusiasm, somehow looked as if they had been boiled or really belonged to some enormous dead fish. His speech was grave and slow, every word being weighed. His gestures were unlike anybody else's, for he illustrated his deliberations in a kind of underwater slow motion, moving his arms forward and then bending back his hands, almost as if he were now a live fish using its fins. You might be meeting a butler or steward or some such character somewhere at the bottom of the sea. To encounter him for the first time in a lively bustling musical or revue was a shock: he appeared to have been brought from far away, a creature existing in a different atmosphere. On the other hand, his conduct and general ethics were not at all otherworldly, and he was quite ready, if never showing any sign of eagerness, to take part and do his solemn share in all manner of dubious transactions. Moreover, if the scene called for it he could change his time and tune very effectively indeed. I seem to remember the following episode quite well, even though I have forgotten the piece that originated it.

Howard is the butler in a large house and answers an early call on the telephone from one of the guests. We hear only his end of the call. He speaks in his usual solemn manner. 'Tea, sir? Certainly, sir . . . Indian, Ceylon or China, sir Ceylon? Certainly, sir. Cream or lemon? Cream, with pleasure, sir. Now – biscuits? Bath Oliver, Cream Crackers, Thin Captain? Thin Captain, certainly, sir Cigarettes of course, sir. Virginian, Egyptian or Turkish? Virginian, it shall certainly be, sir. Anything more, sir? . . . Very good – a pleasure sir.' He puts down the telephone, comes downstage thoughtfully, then says, 'Now I wonder who the hell that was?' He died too soon. We could have done with another ten years of him, showing us that dead eye and those slowly waving hands.

Frankie Howerd

During the last twenty years or so a lot of routine comedians have tried to amuse us on the stage, TV and radio, but very few really funny men, genuine drolls, have claimed our attention. (Or so it seems to me, but then there are men who top the bill at the London Palladium yet never make me laugh.) Writing on this subject – and it must be more than twenty years ago – I happened to spot and to welcome two new men, two very different comedians, who seemed to me to be the real thing, in short genuine drolls. What does this mean? To me it means that they are funny in themselves, not greatly depending upon the material they have acquired. They are essentially comic personalities, at least as soon as they begin performing. (In private they may be gloomy and neurotic, dealing in humour not being a very healthy occupation.) Now one of these new comedians I welcomed was Tony Hancock, the other was Frankie Howerd. They have had very different histories of course. Howerd's career has not been all roses, but after some difficult years, when agents and producers must have been blind and deaf, he began to make his way to the top and now, unless he has the worst of luck, it seems as if he will stay there. As indeed he deserves to do, as an original comic personality, a real droll.

His act, whatever its setting, is much easier to enjoy than to investigate and dissect. His highly personal comedy does not lend itself to analysis. There is of course his appearance on stage or screen, never to be confused with how he may look in private. He has a funny face, very mobile, able to be contorted at any moment. His eyes can glitter or turn furtive and shifty. His mouth can leer, be compressed and bitter, or be turned down and down to suggest intense disapproval. His voice is a perfect instrument for intimate confidences, at times disreputable, or for many varieties of indignation, sometimes roused by the wickedness of the world. For the whole range of his act, from righteous complaints to lewd leers, he is superbly well equipped; and all this we must bear in mind. But we have still to come closer to the centre, the spring and source, of his comedy.

Some of it has changed. For example, when he had as a stooge that mysterious middle-aged lady at the piano, his appeals to us not to be hard upon her, to show a little sympathy for the poor thing, were funny because he spoke exactly as some kinds of women speak: we were listening to a parody of the feminine manner. But now, on his own, his comedy projects a type of character that in real life, well outside the comic frame, we would find intolerable. Heaven preserve us from having such a man sitting next to us in a pub or sharing a railway carriage! There he would be – one minute groaning or whining about the conditions of his employment, the next minute leering away and about to speak the unspeakable, then enlarging his suspicions of everybody and everything, then indignantly demanding we mustn't laugh when he is obviously making a fool of himself; and so it would go on. But then we are outside real life, enjoying the performance of a comedian with an odd voice and a funny face. Even so there might be a certain release in our

laughter when we keep remembering we haven't got a fellow like this on our hands, that it is Frankie Howerd entertaining us. He is, I think, a very clever man pretending not to be.

Buster Keaton

During recent years youngish serious filmgoers, in more than one country, have flocked together to applaud, admire, perhaps venerate Buster Keaton as a great film comic. His stock has gone up as Chaplin's, among such people, has gone down. Nobody would have predicted this thirty or forty years ago, when Keaton was hardly remembered. His two longest and best films had been made in the middle 1920s. When talking pictures arrived, Keaton could not cope with them and then vanished in the mists and fog of alcoholism. Chaplin was baffled by the same problem for some years, but he came through because he had far greater resources, both in the bank and in his own steely character, than poor Keaton could command. I

think it is worth while going down to the root of this problem, the huge challenge these silent comedians had to face. It was not a question of their individual voices, as many people seem to imagine. What profoundly disturbed them was the loss, through talk, of that silent world, highly artificial in fact, which they had understood so well, a world in which their art of mime could flourish. Add talk, even the barest minimum of rational discussion, to the silent scenes that Chaplin or Keaton dominated, and they simply won't work. Talking pictures demanded a very different kind of comedy. And a brilliant mime like Keaton was completely at a loss in their world.

However, by an ironical twist, it is the silent Keaton who has conquered the film enthusiasts of our time. The two films, his longest and best, that have worked this magic are *The Navigator* (1924) and *The General* (1926). Now about this time, Chaplin was making one of the most successful of his long silent films, *The Gold Rush*. All three films are very appealing and very funny today. But the Keaton appeal and the Chaplin appeal are quite different. Chaplin's may be said to be wider, richer, altogether more varied. Keaton's is much narrower but even so it may be all the stronger to these youngish enthusiasts, wanting a return to the strange lost world of silent miming. It might be said to be *purer*. It is outside any tangle of personal relationships. It offers us a figure always in deadly earnest, never

trying to be funny. Throughout these two pictures our attention is concentrated upon the extraordinary set face of Keaton, determined to overcome the next crazy obstacle.

This set face must not persuade us that Keaton never attempts a character, is always exactly the same. To my eye the rich and absurdly self-indulgent young man in *The Navigator* is quite different from the poor young man, struggling to cope with a war as well as a train, in *The General*. The differences may be small, but they exist, even if both have more or less the same haunting face, so determined, so sharply set, as one lot of monstrous circumstances succeeds another. These may be seen in the trade as elaborate 'gags' and 'gimmicks', many of them wildly inventive, little masterpieces of absurdity. (For example, trying to cook breakfast for one girl in a liner's kitchen, designed to provide a thousand breakfasts.) But Keaton's desperate concentration magically transforms mere 'gags' and 'gimmicks' into what we accept, even though we have to laugh (partly out of a kind of relief), at menacing or infinitely teasing circumstances. We can add that three features of Keaton's major films stand out in relief: the straight but all-embracing story line; the way in which Keaton acts with his whole body; and, thirdly, his response to the hostility and challenge not of people but of *things*.

Perhaps just to recall an image of Keaton is to begin to understand why there is a cult of him among more imaginative younger people in our day. There he is, his eyes glowing, his face a mask of determination, desperate but not despairing, battling *alone* against the perversity of *things* – and though of course we keep laughing, as we are meant to do, our heart goes out to him. Does this mean more to us now than it would have done fifty years ago, when life would have seemed altogether easier and *things* far less menacing? Does our laughter come from a deeper sense of release than it would have done then? Possibly, possibly not. But I think these questions aren't entirely foolish.

Jimmy Learmouth

I must begin this piece with a warning. The point is, I am going to write about a music-hall comedian who died a great many years ago. I don't even remember now – if I ever knew – when and how he died, and I can't find him in the Obituary section of older editions of *Who's Who in the Theatre*. He was still, I think, a youngish man when he died. He never became a West End star and was, I fancy, unknown in London, though provincial audiences adored him. Probably only a few older readers will remember him at all: hence my initial warning. But before any of you turn the page, let me add this. If I rule out two or three great international clowns, then Jimmy Learmouth was the funniest man I ever saw. He was a

droll of unique quality. And this is not simply my opinion. For example, I was well acquainted with Julian Wylie, in his day a most successful producer of revues, musicals, pantomimes and so a good judge of comedians, and he always swore that Learmouth was easily the best of them all. And thousands of tough North Country-men – half of them comedians of a sort themselves – would have agreed with him.

Before the First World War Learmouth, topping the bill, used to tour sketches. But the last one I remember came just after the war, when Learmouth, making his first entrance, created the loudest and longest laugh I have ever heard in a music hall. The scene was some sort of market square, empty at this moment, and facing us was a demobilization centre. From it, wearing a huge grin and a nasty new suit, came Learmouth. 'I'm out', he told us, and then simply walked round and round the stage, the yell of laughter going on and on. Given the circumstances, could any-body have done this? The answer is a firm *no*. He had, I repeat, a unique quality. And fortunately, during the first war, I had a chance to enjoy it at comparatively close quarters. This was in a camp theatre, where Learmouth was one of the visiting entertainers. He could be enjoyed there in intimate sketches, scenes with perhaps just one actress, usually half helpless having to cope with improvised passages of tomfoolery. Whenever he was with us, I sat there night after night, forgetting the war and those daily programmes that made service in the British Army such a huge damned grinding bore. This was in 1917 when I was back from France, now in the clutches of Home Front monsters and imbeciles.

So it was all a very long time ago, and what is the use of my declaring that Jimmy Learmouth was so amazingly funny? How can I suggest that unique quality of his

clowning? Like all great comics he didn't make jokes, he was himself one huge joke. He was a Tynesider but made no particular use of the odd local accent. (Perhaps he did when he was playing Newcastle.) He had a round face to which he attached a large improbable moustache, a solemn look but a wide smile. His manner, highly personal, unlike any other comedian's, was one in which innocence and impudence were somehow blended. But if you thought him impudent, then you noticed his innocence. Settling for his innocence, you were struck by his impudence. He made great play with odd words, which he might seem to taste before using freely. Among so much that has completely gone now, I can remember his earnest question to the convulsed actress: 'Mrs Woman, did you hear me *scrunching* up the gravel path?' But what's the use, my dear reader, if I was there and you weren't? I have to give it up. The locust-eaten years took him away, probably before you were born. He was no age when he died. Julian Wylie, telling me what an odd fellow Learmouth was, said he had a passion for continually washing his hands. Perhaps after that war he was washing his hands of us all. Perhaps after making us laugh so hard and so often, he got tired of us.

The Marx Brothers

They have been among my particular pleasures ever since I accidentally discovered their first film, *The Coconuts*, one afternoon, when I went into a cinema seeking shelter from a rainstorm. The only one of the four I never met, either in London or Hollywood, was Harpo. This never worried me because, though he made me laugh often enough, I never felt drawn to him. Also, I felt he was over-indulged and I never welcomed those harp sessions. But it was a stroke of genius on somebody's part to keep him mute, for this enabled him in the films to exist in the pre-talkie world of silent slapstick, where he could be as wild as he pleased. It meant also that he could represent modern man with the lid off, the uninhibited unconscious, the Id in full play. His companion and friend, Chico (underrated, in my opinion) was a Latin version of the eternal peasant, sulky and suspicious but not unhelpful. My own favourite, both off and on the screen, Groucho, was the dubious representative of an urban civilization, the fast-talking quack, shady lawyer, salesman, publicity man, daft manager, buck chaser. Working together with unusual zest, they made a wonderful team. I think the zest is important because when they lost it, towards the end, their films lost sparkle and savour.

Although some of their funniest individual scenes belonged to the period when they had moved from Paramount to MGM, which insisted upon providing them with musical heroes and heroines most of us didn't want, they had to do some out-of-character serious plotting, to keep the story going, and something altogether daft

and wild was lost. So the pure essence of this Marxism – so different from the other –
is to be found, for ever a wonder and joy, in their last fling with Paramount, *Duck
Soup*. If, in a grim situation, I were compelled to single one film of theirs, and only
one, with which to convert heretics and unbelievers, that film would be *Duck Soup*.
And here we come to the woman who might justly be called a Marx Aunt – Margaret
Dumont. I remember laying down the law – a weakness of mine at that time – and
telling two of them to their faces that they never ought to make a film without being
involved with this invaluable woman, who contrived to suggest at least half the rich
American women I have ever met, who rose above all manner of indignities, even to
being fired out of a cannon, to maintain a certain social presence and style. She was,
we might say, yet another member of the archetypal set up, the eternal hopeful or
bewildered patroness to the garrulous jeering Groucho, the suspicious Chico, the
daft wild gleaming-eyed Harpo, leaping out of the Id.

I think I have seen all their films more than once, and some of them I have seen
many times. No doubt there are people who have never liked the Marx Brothers,
people who find an anarchic humour disturbing or a breezy vulgarity distasteful. To
them I have nothing to say here. The various points I shall make are intended for
the people, of all ages, on our happier side of the fence. Though I can remember
many very funny scenes involving only one of the brothers, I think it safe to say that
by and large they have been most effective when working as a team. Their total
effect is greater than the sum of their parts. It is as if a fairly familiar respectable
scene were being invaded by the advance guard of an army of comic anarchy. The

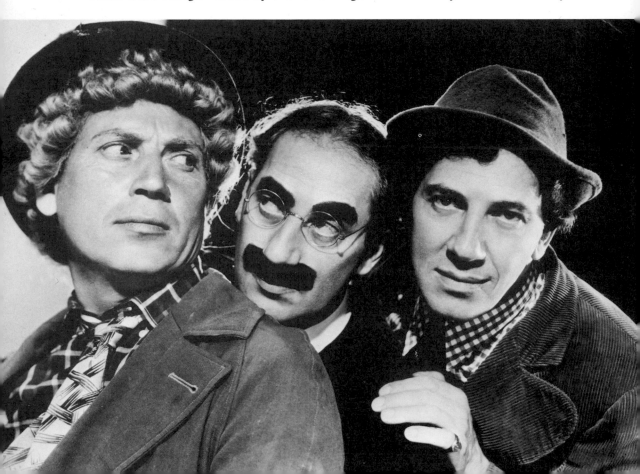

next point is that they are at their best when allowed to run wild and at their weakest when tied to an existing plot, as in *Room Service*, for example, which I preferred in its original form as a Broadway farce. A further point, enormously in their favour, is that if they are enjoyed at all, then they don't seem to 'date', to be faded by the years. A lot of humour, glorious in its time, will not survive a generation or two, as I know to my regret as a father and grandfather. But in my experience, the Marx Brothers have astonishing powers of survival, though possibly not appealing in exactly the same way to each succeeding generation.

This brings me to my last point. I don't believe that these men were conscious satirists. They were well-tried brilliant comedians who had succeeded in vaudeville and Broadway musicals and then accepted, with tremendous zest, the far larger and wilder opportunities that films offered them. Not of course without help from clever writers and able directors, they created innumerable scenes of wonderfully sharp or zany humour. But all for fun, with little or no satirical intention. Yet now their films are beginning to seem like sagas of grotesque satire, almost Rabelaisian: life on liners or at college; running an hotel or a convalescent home; the solemn rituals of opera or the race course; existence in a circus or Out West; even international crises and war; all these, and many more, are reflected in the odd mirrors of this humour and uproariously mocked. I added a tiny piece on the Marx Brothers to my book, *Delight*, and now quote what I said at the end of it: 'Karl Marx showed us how the dispossessed would finally take possession. But I think the Marx Brothers do it better.'

Morecambe and Wise

During the years when I saw a lot of variety shows I also saw a lot of two-men crosstalk acts. If I thought it worth while I could probably recall a dozen of them. There would be a blundering or wildly daft comic man and his 'feed' or 'straight man', who would soon begin to lose his temper and start shouting, which would give the comic a chance to score off him. They never seemed as funny to me as they must have done to agents, managers, and most audiences. I may have laughed but there was no delight, no joy, in my laughter, at the sight and sound of these routine entertainers. They never illuminated human nature as the great clowns and comedians could do. Perhaps I ought to make an exception of Flanagan and Allen, chiefly because there was a larger-than-life quality about Bud Flanagan, whose bulk, hoarse remnant of a voice, huge ruin of a face, should have taken him much further into clowndom than they actually did, Crazy Gang stuff not really being good enough for him. But if I mention these routine crosstalk acts it is because I am under the impression that Morecambe and Wise began by toiling in that galley and remained in it, still toiling away, for some years.

They are well out of it now, of course, delighting millions of viewers. They deserve their success because of the way in which they have developed their act and have taken immense pains with it. But though I enjoy them, there are two sharp points I must make. First, the competition they have to face is pitiful. They are bringing water into a desert. Had they been performing fifty years ago, up against some of the clowns and comedians I deal with here, they would have had to fight like tigers. Secondly, I don't admire and delight in all their act, only a certain part of it. The sketches, for example, only rate a few giggles with me, if only because I have seen too many of such sketches, from way back. Again, it seems to me just a showbiz weakness when they decorate their act with well-known names and then fool around with rather embarrassed distinguished visitors. All this merely offers us the watered milk of what we might call Morecambeness and Wisery. It is only the pure milk of it that refreshes me. And this is to be found – and nowhere else I will swear – only in their apparently offhand exchanges with each other. Here they have lifted the old routine crosstalk act out of its rut. They might be said to have taken it into a higher dimension of comedy, creating something precious that is all their own.

The old formula – the sensible man trying to talk to a fool – has gone. Ernie, once the indignant straight man, is now another fool. He may be the straighter fool of the two; he may sometimes return to indignation; but his huge innocent vanity belongs to Clown Number Two. Now Eric Morecambe can play it three ways. He can, if necessary, still be the comic against the straight man. He can reverse the roles, rejecting Ernie's gigantic daft vanity and so becoming a kind of straight man himself. Or he can accept and admire Ernie's rubbish and turn comic-to-straight-man on the edge of complete imbecility. And there are variations even within this shifting pattern. There are times when Ernie, back to straight man (who is also a fool), plays the highbrow, the intellectual, the thinker, disgusted with his partner's lack of interest in higher things and appalling mental indolence. But Eric in his turn has a special role of his own that bounces in and out of the talk. At these moments he is the North Country know-all, loud voiced, ruthlessly dogmatic and quite silly; and I must have overheard men just like him in scores of pubs in the North. Again, just when we feel that Ernie is being insufferable in his conceit of himself, and that Eric will have to sink once more into comic-on-the-edge-of complete-imbecility, Eric refuses to do this, turns sceptical and rebellious, and mutters to us, the audience, that Ernie is a fool.

All this is not easy to describe but it is certainly no easier to perform. It demands in its complexity very rapid but sure changes of expression, glances, tones of voice, and infallible timing. Just as it is easily the best part of their act it also requires the highest professional and carefully rehearsed skill, delighting any connoisseur of comedy. Yes indeed, Eric Morecambe and Ernie Wise have come a long way from the old routine crosstalk act. They deserve their ample rewards.

George Robey and Robb Wilton

Why do I bring two men into this piece? It will answer the question itself, as we shall see. But first, to consider George Robey. Two formidable *Manchester Guardian* men, C. E. Montague and Neville Cardus, have given us warm appreciations of Robey while leaving other and (to my mind) greater drolls unsung. I think this is because they saw him, probably more than once, playing a pantomime dame, combining hauteur with low vulgar abuse. I never saw him in any role of this kind but always doing his solo music-hall turn. But elsewhere I find him described as 'the greatest low comedian' the music hall produced, truly entitled to describe himself as 'The Prime Minister of Mirth'. Well, he doesn't get my vote. It is not that I am against him, that he ever offended me; he was a hard-working comedian of long experience; but he seems to me to have been over-praised. He could make me grin or chuckle at times, but that was all. He released no shouts of laughter because there never seemed to be in him or coming from him any wonderful springs and fountains of drollery. He offered absurdity, but no vast surges, all of it carefully rationed.

His famous get-up suggested a rather jaunty if defrocked Stiggins or Chadband, but he never really developed such a character, though occasionally rebuking the audience for unseemly giggling and guffawing. Much of his act was spent in hoarsely singing rather long comic songs, and I was always prejudiced against these, almost so many iron rations of humour. One of his favourites was *In Other Words*, which explained long words by short ones, as follows:

A coarsening of the auricular appendage.
In other words, a thick ear.

Which would have brought joy to me about the age of ten, and not very much later. Of course he could do better than that, and between songs or verses his byplay with the audience, as if he felt himself to be insulted, could be quite amusing, his looks, gestures, tone and timing being exactly right. But as a solo turn he never took off in high gear, never piled absurdity on absurdity, never brought laughter up to a kind of joy. I never forgot myself for a moment watching and listening to him as I did time after time with the great generous drolls and clowns. He lived to play Falstaff (not good; too dry and monotonous), to collect honours denied other comedians, and to go on and on until he died at eighty-five. Well, he was a decent hard-working pro of vast experience, probably earning everything he ever received; but he would never figure in any honours list of comics that I put together.

Compared with Robey in public esteem, Robb Wilton was 'small potatoes'. (He was not unlike one.) But I always thought him much funnier. Older readers may chiefly remember his monologues on radio from 1940 onwards, always beginning, in an emphatic Lancashire accent, 'The day war broke out . . .' These were good enough but the sketches he toured for years were better. My favourite was the one about the woman who came to give herself up because she had poisoned her husband. Robb Wilton was apparently running some kind of private police station, and not one prepared to keep open all hours. Clearly he was about to go home when this nuisance of a woman confronted him. He tried at first to ignore her and began irritably pushing around a lot of papers on his table, muttering that he was not going to be pestered. I believe he suggested she might look in some other more convenient time. But she was a very melodramatic woman, determined to confess she had murderously poisoned her husband. Such persistence wore him down and after more muttering and paper shuffling he consented to ask her a question or two and took down her name and address. 'And I have poisoned my husband', she shouted. 'Yes, yes, yes,' he said, half weary now under this load of overtime. But, with his pencil poised, he gave her a bored civil-service version of an enquiring look: 'Just the one husband?' And there I stop, though the sketch didn't. Some comic, wanting to do something better than standing up and rattling off a lot of gags he'd bought, might try resurrecting that sketch. But it's a thousand to one he wouldn't play it better than little Robb Wilton did.

Harry Tate

He was called Ronald MacDonald Hutchinson and he worked for Tate's the sugar refiners and he did a semi-pro act imitating music-hall stars. When Marie Lloyd told him he ought to change his name, he became Harry Tate. By the time I saw him, topping the bill, he had put those imitations well behind him, had developed a

larger-than-life character, and was playing uproarious sketches: 'Motoring', 'Fishing', 'Billiards', and others. This character was a burlesque of the Sporting Gent of the period. Types like him, though not quite so outrageous, could be found, boasting at the top of their voices, in saloon bars throughout Edwardian England. Tate's man had a large wobbly moustache, a loud voice, staring eyes, an enormous sense of his own importance, a hectoring manner, and an unfailing capacity to saddle himself with irritating people and a ripening anarchy. He – or Tate – was a master of what American directors call 'the slow burn', a gradual realization, purpling and bulging eyed, that events were getting entirely out of hand, that reason and logic were failing the world. His pursuits were usually sporting, but I remember that in one sketch this unfortunate monster was trying to run an office. After a minute or two he came roaring in, and when asked what should be done with a

parcel, he bellowed, 'Send it to Ra-angoo-oon'; after which there followed a daft bedlam. I never missed a chance to see these sketches and the inimitable Tate himself, and I delighted in them and in him, and I believe I realized early on, long before Parisian highbrows took it over in the early 1920s, that I was being shown the world of sur-realism, an uproarious extension of Alice's Wonderland and a Through the Looking-Glass existence.

Let us say, for example, that we are looking at Tate's 'Billiards' sketch. After making a monstrous fuss this pernickety Sporting Character has at last settled down to a game of billiards. But there now arrives a party of surveyors, apparently

bent on planning a road through the room. Taking no notice of Tate, who is staring at them in amazement, they get on with their work, one of them with his apparatus actually standing on the table. The fuse is now lit deep inside Tate; the slow burn starts and spreads; and finally there is a roar of outrage. There has not been a word of explanation and apology: we are in this other sur-realistic world. We are partly too in the world of early slapstick films, which owed a large debt – just think of Chaplin – to the old English music hall.

Tate's first and most famous sketch was 'Motoring', in which the proud owner of a new car that had broken down had to suffer all manner of indignities and insults, but while it was very funny it always seemed to me to lack the wild humour of the later sketches. But even these depended upon the relation of their astonishing events to this central Sporting Gent, so self-important, so loud and domineering at first but then inevitably so bewildered, so humiliated, so indignant at last, roaring like a maddened bull. And he and his misadventures shine in my memory.

Jacques Tati

It is hard to believe that Jacques Tati was born in 1908 and so has entered his later sixties. Even off the screen, being interviewed on television, he seems much younger. (As for the character he projects on to the screen, Monsieur Hulot, this man appears to me to be a permanent forty-two.) If it is hard to believe his age, it is also rather hard to be – as I certainly am – one of his English admirers. For example, there is such a long interval between his later films. We have to wait for years and years. And then – though here I speak for myself – we rush to London to see them, after which they vanish from our sight, however much we long to see them again. They begin to haunt our memory almost like distant fantastic holidays in France. I can imagine that Tati, in his managerial capacity as M. Tatischeff, might have financial objections to allowing his films to go to television, yet to my mind they would make wonderful TV viewing, seen cosily at home after dinner, well away from the more urgent and demanding atmosphere of the cinema, no longer competing with bank robberies, cynical 'private eyes', and slabs of raw sex. How we could enjoy their gentle smiling humour on the little screen in the sitting room! Please, M. Tatischeff!

There is something else. Every time, at long last, we have a new Tati film, many critics make haste to express their disappointment. The trouble is, they are at cross purposes with Tati. They blame him for not giving them something he has no intention of offering them. They still go expecting to enjoy great 'belly laughs', uproarious rough broad comedy that no longer interests him. He wants to make us smile, not bellow with laughter. And if this seems unambitious, we must ask our-

selves how many films keep us intelligently amused and continually smiling. This is the Tati style, and an excellent and highly original style it is too. And by no means typically French, for satire in France has tended to turn savage and destructive, to glare above the grin. Now Tati in his later films is a satirist, well aware of the growing imbecilities of our technological civilization, but he asks us to observe them with an easy irony, a smiling scepticism. Moreover, he is a master of odd little surprising effects. Here is a typical example from *Play Time*, which makes use of the odd construction and weird daft atmosphere of our large modern airports. We see a fussy businessman, hanging on to his attaché case of course, going down one of those long empty corridors that seem to lead nowhere. In the distance we see him sitting down and immediately zipping open his case. But it makes as much noise as if he were zipping open the corridor. The humour lies in the disproportion between sight and sound. It offers us a brief satirical glimpse not only of the fussy businessman but of the whole style of life that he and the airport represent.

It is essential that a Tati film should show us his M. Hulot, always the same character. He is one of those men who always seem to be wandering round the edge of things, mildly curious, never sharply enquiring, always vaguely hopeful that something interesting may happen, trotting about with his head in the air. He is on hand when the idiot gadgets keep functioning in *Mon Oncle*, when the holiday-makers are herded about in *Play Time*, when the cars are interlocked or go snapping at each other like furious monsters in *Traffic*; and he is always dimly surprised, never thunderstruck with astonishment, and is always trying to be mistily helpful, like the good soul he is. In his own eccentric way he is one of us, landed here once again in this absurd variation of the time in which we live, or try to live. He never smiles, but we do – continually. This is the Tati effect, and very welcome it is too and I wish there was much more of it, either in the cinema or – much better – cosily at home.

Little Tich

His name was Harry Relph, and he was the youngest of the seventeen children of a Kentish innkeeper and his Irish wife. He was no more than four foot tall – if as much – and had a good-sized head, with a biggish nose, a shortened body and tiny legs. (In other departments he was quite a freak, having an extra finger on each hand and six toes on both feet.) As some compensation for her carelessness, Nature provided him with a quick wit and any amount of intelligence. He was really a very clever little man. By the early 1900s he was an international star, almost as successful in New York, Paris (where Lucien and Sacha Guitry were his fervent admirers) and Berlin as he always was in London. He died in 1928, when, like many another enthusiast, I wrote a piece about him.

I saw him many times, always with delight. He had been famous earlier for the enormous long boots, when upright nearly as tall as himself, in which he could lean forward at a dangerous angle and even do a dance of sorts. However, as he grew older he made less use of these monster boots, and I for one was glad, because after all they were just a gimmick and he remained a great comedian without any help from them. He never appeared simply as himself but always as one of a series of characters – a 'masher' or 'toff', a lady in court dress (a favourite), a jockey, a barrister, a steeplejack (of all things), a grocer; and so forth. All these characters were seen as if through a diminishing glass, or as visitors from some society of gnomes, and you began laughing at the first sight of them, all the more because they looked intensely serious, often arriving in a furious state of indignation.

There were usually songs of a sort, sung at a frantic speed, delivered to you as if they were so much routine rubbish, perhaps a minor item in a contract. And anyhow you were still laughing at the sight of him. But when he stopped singing, perhaps disentangling himself from the steeplejack's gear or the lady's court train, and began confiding his troubles to you, it was then that his drolleries were inspired and irresistible. The tale of his grievances was illustrated by nothing less than a fury of movement and gestures. The energy of these miniscule characters, these infuriated and maddened gnomes, was astounding. It made you feel you had spent your life as a mere languorous and supine giant. He seemed to fill the stage with people like you, unable to face his burning indignation and furious gestures, always defeated and hastily retreating from his presence.

He had only to say 'I went in', and his tiny legs went hurtling across the stage and we saw him bursting through an invisible door. If he said he would show us what he thought about some obstreperous fellow, his dumbshow would almost explode into wild careering round the stage, punching and kicking away, defying men of any weight to come near him. If, as it frequently happened, things themselves were hostile and got him all tangled up, he would release for himself and for us the rising fury of the human spirit dragged down into such a world as this. Even without opposition his own wild eloquence, his determination to make a sensible point in a

daft world, could carry him away, so that as a barrister he not only thumped the table with his fist but also with his foot. There has never been such wildly energetic miming as this fiery little gnome showed us.

Yet that was not all – oh no! His act, for all its mad energy, kept moving into another and cool dimension, where we observed and estimated it with him. The clever eyes would give us a wink or at least a twinkle, asking us to join him as a sophisticated performer, pretending for our amusement to be an indignant jockey or outraged lady in court dress. He would suddenly take us behind the scenes with him, doing it with a single remark. He would offer us a joke and then confide that it went better the night before. He would drop a hat and be unable to pick it up, because he kicked it out of reach every time, and then mutter, half in despair, 'Comic business with *chapeau*'. As I said in my piece written just after he died: 'I think that was the innermost secret of this little droll's appeal. In the antics of this gargoyle there was all the time a suggestion of a companion spirit winking and nodding and shrugging at you over the crazy jumble and tangle of things. And the things remain, but he has gone.' But what I didn't say then, because it was so obvious, I will say now. Little Tich was a really great comedian, a star of the first magnitude for ever twinkling.

Illustration Credits
and Acknowledgments

Rose Fayer in the film *African Queen*, 1951. Mander and Mitchenson Theatre Collection, London
123 Charles Laughton (1899–1962) as Bottom in *Midsummer Night's Dream*, Stratford-upon-Avon, 1959. Photo Angus McBean, Harvard Theatre Collection
125 Noël Coward (1899–1973) and Gertrude Lawrence (1898–1952) as Elliott and Amanda in Noël Coward's *Private Lives,* Phoenix Theatre, 1930. Mander and Mitchenson Theatre Collection, London
127 Wilfrid Lawson (1900–66) in Strindberg's *The Father,* Arts Theatre, 1953. Photo Angus McBean, Harvard Theatre Collection
129 The Lunts, 1939. Mander and Mitchenson Theatre Collection, London
131 Marilyn Monroe (1926–62) and Arthur Miller arriving at the Royal Film Performance at the Empire, Leicester Square, London, in October 1956. Radio Times Hulton Picture Library, London
133 Laurence Olivier (b. 1907) as Archie Rice in John Osborne's *The Entertainer,* Royal Court Theatre, 1957. Keystone Press Agency Ltd, London
135 Jules Raimu (1883–1946). National Film Archive, London
137 Claude Rains (1889–1967) as Caesar and Vivien Leigh in the film *Caesar and Cleopatra,* 1945. Mander and Mitchenson Theatre Collection, London
139 Ralph Richardson (b. 1902) as Falstaff in *Henry IV, Part I and II,* Old Vic Company, New Theatre,

1945 (Photo by John Vickers, London)
141 Jean Forbes-Robertson (1905–52) as Kay Conway in J. B. Priestley's *Time and the Conways,* Duchess Theatre, 1937. Mander and Mitchenson Theatre Collection, London
143 George C. Scott (b. 1926) as Dr Herbert Bock in the film *Hospital,* 1971. National Film Archive, London
145 Alastair Sim (b. 1900) as Mr Bolfry in the play of that name by James Bridie, Westminster Theatre, 1943 (Photo by John Vickers, London)
146 Arthur Sinclair (1883–1951) (right) as 'Captain' Jack Boyle in *Juno and the Paycock* by Sean O'Casey, Royalty Theatre, 1925. Mander and Mitchenson Theatre Collection, London
148 Sybil Thorndike (b. 1882) as Saint Joan in the play of that name by Bernard Shaw, New Theatre, 1924. Mander and Mitchenson Theatre Collection, London
151 Spencer Tracy (1900–67). National Film Archive, London
153 The Aldwych Comedians in Ben Travers' *Thark,* Aldwych Theatre, 1927. Mander and Mitchenson Theatre Collection, London
155 Jack Benny (1894–1974), 1968. BBC Photograph
158 Charlie Chaplin (b. 1889) in the film *The Pawnshop,* 1916. National Film Archive, London
160 Tommy Cooper. Paul Popper Ltd, London
161 Sid Field (1904–50). Radio Times Hulton Picture Library, London
163 W. C. Fields (1879–1946). Radio Times Hulton Picture Library, London

165 The Fratellini. Radio Times Hulton Picture Library, London
167 Grock (1880–1959). Mander and Mitchenson Theatre Collection, London
169 Tony Hancock (1924–59) in a television sketch from *Hancock's Half Hour,* 1960. BBC Photograph
172 Leslie Henson (1891–1957) (right) as Dugsie and Sydney Howard (1885–1946) as Herbert (left) in a musical comedy by George Gershwin, *Funny Face,* Princes Theatre, 1928. Mander and Mitchenson Theatre Collection, London
175 Frankie Howerd (b. 1922) as Ali Oopla in *Whoops Baghdad,* 1972. BBC Photograph
176 Buster Keaton (1895–1966) in *The General,* 1926. National Film Archive, London
178 Jimmy Learmouth. Mander and Mitchenson Theatre Collection, London
180 The Marx Brothers. Radio Times Hulton Picture Library, London
183 Morecambe (b. 1926) and Wise (b. 1925), 1972. BBC Photograph
184 (left) George Robey (1869–1954). Mander and Mitchenson Theatre Collection, London (right) Robb Wilton (d. 1957). National Film Archive, London
186 Harry Tate (1863–1930) in *Fishing* sketch *c.* 1910. Mander and Mitchenson Theatre Collection, London
188 Jacques Tati (b. 1908) as Monsieur Hulot by Edmond X. Kapp. Barber Institute of Fine Arts, Birmingham
190 Little Tich (d. 1928). Mander and Mitchenson Theatre Collection, London